SLEUTH

SLEUTH PHILIP MOULD

THE AMAZING QUEST FOR LOST ART TREASURES

HARPER

HARPER

an imprint of HarperCollinsPublishers 1 London Bridge Street London SE1 9GF

www.harpercollins.co.uk

First published in paperback by HarperCollinsPublishers 2011

4

© Philip Mould 2009, 2011

Philip Mould asserts the moral right to be identified as the author of this work

Extract from 'Stopping by Woods on a Snowy Evening' by Robert Frost on p68 from *The Poetry of Robert Frost* edited by Edward Connery Lathem, published by Jonathan Cape. Reprinted by permission of The Random House Group.

A catalogue record of this book is available from the British Library

ISBN 978-0-00-731915-2

Printed and bound in Great Britain by CPI Group (UK) Ltd, Croydon, CR0 4YY

All rights reserved. No part of this publication may be reproduced, stored in a retrieval system, or transmitted, in any form or by any means, electronic, mechanical, photocopying, recording or otherwise, without the prior written permission of the publishers.

FSC is a non-profit international organisation established to promote the responsible management of the world's forests. Products carrying the FSC label are independently certified to assure consumers that they come from forests that are managed to meet the social, economic and ecological needs of present and future generations.

Find out more about HarperCollins and the environment at www.harpercollins.co.uk/green To Oliver, with apologies for the time spent writing that could have been spent with him.

CONTENTS

	Acknowledgements	ix
	NAME OF TAXABLE	
	INTRODUCTION	1
1.	A TASTE OF THE PAST	39
2.	READING THE STROKES	69
3.	PERCEPTION AND DECEPTION	111
4.	THE SCHOLAR	179
5.	THE POWER OF HISTORY	221
6.	DISCOVERING OPPORTUNITY	263
	Glossary	291
	Index	299

ACKNOWLEDGEMENTS

There is a host of helpful and long-suffering friends and acquaintances without whose collaboration this would not have moved from a sketched thought, suggested to me at a dinner party, into the book you may be about to read.

The dinner in question was given by Bruce and Lucinda Palling, who sat me next to Vicky Barnsley, managing director of HarperCollins. Had their seating plan been different, or their wine less drinkable, the consequences would not have developed as they did. Three months later Elizabeth Sheinkman came into my life as my agent and, with charm, perseverance and a Manhattan drive from which we all have something to learn, struck a deal which allowed me to unmoor myself from the gallery, get on planes and adhere to a laptop for more hours than I can dare count – time I would otherwise have spent buying and selling pictures and living a family life.

I therefore came to rely even more upon my wife Catherine, who also acted as a ruthlessly tactless critic of my prose as well as the illustration hunter; the forbearance of my son Oliver; and my gallery staff, who managed to get by unsettlingly well without me and who later all contributed to the book with words, ideas, responses and encouragement. As well as Catherine they are Bendor Grosvenor (a protagonist in two of these chapters), Emma Henderson, Sara Maskell and Tamsin Evernden. As well as those with whom I work every day I also owe thanks to those who regularly supply their expertise to our business and proved invaluable as sounding boards for this book — in particular Rebecca Gregg, who rose hearteningly to the challenge, and Katherine Ara.

Rachel Kaminsky gave me ideas, followed them up with leads and then acted as reader for the whole text. Although I take full responsibility for any mistakes herein, I would like to acknowledge with profound gratitude her punctilious questioning and professional responses, both as a highly experienced dealer and ex-auctioneer and as someone with a wry understanding of human nature in the art world and beyond.

Early on in my research, waiting for planes at Jacksonville in Florida that seemed incapable of touching down, I got into a long dialogue with a woman whose inspiration has remained with me. She coined the phrase 'perception and deception' and gave me a number of approaches that I then carried through the book: whoever you are, wherever you are, I wish I could acknowledge you other than by the coy epithet of my 'Jacksonville Muse'.

The kindness of those who have allowed themselves to be interviewed and autopsied, and who then went on to give yet more of their time and generosity in providing images and checking facts, has been profound. In this respect I would especially like to thank Toni Newton, who has given me more assistance than an author could dare hope or ask for. I count her as an ally in this project and am also indebted to the hospitality and kindness of her husband, Clark, and her perennially young mother, Jo. John Sundeman, Earle Newton's old friend and adviser, is also to be thanked, as is Barry Buxton of the Savannah College of Art and Design. Don Trachte has been a sterling supporter, and is another who has gone to unusual lengths to help me. In addition I would like to acknowledge the collaboration and help of other interviewees, including Linda Perot, Professor Ernst van de Wetering, Oliver Barker, Frank Dunphy, and Alfred and Isabelle Bader. At this juncture I would also like to thank Dr Michael Hall for pointing out the relevance of the Damien Hirst Pharmacy sale as an example of the quest for unseen opportunity in contemporary art.

Bob Pullen put me right on the Astor family, and Lucy Fenwick, a mainstay of Sotheby's British Pictures Department, on a number of facts and insights from the auction world. Thank goodness for friends who are prepared to give of their time and support.

Anyone who has written a book will know how important the backroom figures are in helping create the finished product. Jonathan Taylor of HarperCollins has effectively been my boss throughout this project and has been an inspiring and constant support. My manuscript was handed over to the tender mercies of Richard Dawes to edit; as befits this technological age, I have yet to meet him despite the fact that he has

applied himself to the task with uncommon personal commitment and sophistication, as well as a gentle hand, to ensure my words reach the audience for which they are intended. I look forward to thanking him in person. Simon Shaw, executive editor of *Antiques Roadshow*, has been a supporter of this endeavour from the outset and was one of the first reader guinea pigs. I would like to thank him also.

My father has been, as he always is, the perfect combination of pedagogue and pastor. Reading the drafts of my first two chapters, bolstering me with optimism, and then offering himself as unpaid editor to rectify what he described as my literal errors was exactly what a father should do, and I am indebted to him and my late mother for their encouragement and support throughout my career. Parents, particularly fathers, seem to surface rather often in this book and they need to be kept in mind as a valuable potential resource for navigation – even for the middle-aged.

INTRODUCTION

'Isuppose you've heard,' he began. 'In fact it may have been you.'

I had no idea what he was talking about. Responding to both my blankness and evident curiosity, he started to play me, alternately giving and taking line.

'It was even on the radio this morning. Surely you must know?' he pressed.

'Know what?'

'About the Rembrandt.'

'What Rembrandt?'

'The self-portrait thought to be a later copy or follower. The one with a lower estimate of £1,000. Oh, come on, you must have known.'

'Sadly not,' I replied. 'Where was it?'

'Up the road.'

Given that the man I was talking to, Mark Ransom, was an experienced and canny dealer and would award this type of

lead-up only to something of great consequence, he now had me hooked. He knew it, and I had no choice but to be hauled to shore at his own pace. I also detected his discontentment at having failed to acquire something himself.

'OK, where up the road?' I allowed him.

'At Moore Allen & Innocent in Cirencester.'

He now had me thrashing in the water. I had viewed in person two days earlier that actual sale at the auction house and definitely did not recall anything that could be deemed a great work of art. Certainly not one that approximated to anything by the most famous old master in Western history.

'They say it's the record price paid for a picture at a country auction, apart from anything else,' he added with contrived nonchalance.

'What did it make?' I asked weakly.

'With or without auction commission?'

He had toyed with me enough. 'Get on with it,' I snapped.

After a cruelly protracted pause he mouthed the figure for optimum impact.

'Two - point - six - million - pounds.'

The story becomes more stressful. Professor Ernst van de Wetering, one of the greatest art connoisseurs of our times, and specifically of Rembrandt in his capacity as chairman of the Rembrandt Research Project (RRP), got to hear of its emergence at auction and, unusually for an academic in his position, he issued an invitation to the unknown buyer to show it to him. He later pronounced it a genuine work, not, as it happened, a conventional self-portrait but more a generalized character figure (as distinct from a formal, recognizable

portrait), with the new title *Rembrandt Laughing*. As this book goes to print in 2009 it has just resurfaced in the art press in relation to a proposed export licence (essential for major works of old art leaving the UK) at a valuation rumoured to be £20 million.

I still don't know what happened. Damn it, I spent a good half-hour wandering around that Cirencester saleroom. I was on holiday, after all, with all the time in the world. Perhaps I did just overlook it – it was a small work on copper – but I also now wonder whether it was being confidentially inspected in a backroom while I was viewing. Or am I making excuses? I had also failed to flip through the catalogue (a cardinal slip-up), where it was illustrated on the front cover no less. All in all, hardly something which as a professional I am proud to own up to, particularly as over the next week I realized just how profoundly I had been out of the loop.

First a restorer told me that he had been sent down to analyse the painting's condition a week before the sale; then a dealer confided that in partnership with another he had been prepared to go up to £500,000; and later I met another who had prepared a bid for twice that amount but did not get his hand up at the sale because the price escalated so fast. The following month I talked with a major London auctioneer who told me that he had been tipped off by one of his clients and had taken the day off to travel down by train to view it. If you add the man who under-bid (the distinguished New York dealer Otto Naumann, I later discovered), the successful purchasers who apparently bought on behalf of a private collector and the runners (dealers without galleries who seize opportunities at

country sales) who had been aware of it, I can see now that I was naively situated on a distant outer limb.

This realization in part prompted me to write the present book. One of the most obvious ways to explain how the international art trade was aware of a diminutive painting in a relatively small auction house two and a half hours from London is the technological revolution. Ten years ago I wrote Sleepers: In Search of Lost Old Masters, which comprised stories about myself and others who had made significant discoveries at auction and elsewhere. I would need to reread it to be sure, but I don't think I even mentioned the word internet, and I certainly did not refer to it as an integral tool in the workings of my business. The situation has now radically changed. It is amusingly ironic that I, a dealer with a certain knowledge, failed to see something when physically present in an auction room while a shoal of prospective buyers, a large proportion of the informed old-master trade, had been frantically researching and preparing bids for some weeks before the sale after the illustrated catalogue was posted on the auction-house website. Sure, many would have come down to see it as a consequence of what they had seen online, but only as a consequence. And I knew of course that it would not just have been the fact that there was a high-quality digital image of the picture for all to find with their search engines, but that with a click of the mouse it could instantly be shared with others: curators, art historians, fellow dealers, prospective clients, all of whom could offer responses, no doubt some of them guarded, which would translate into the type of bidding fervour that was witnessed that day in Cirencester.

This is the culture we now occupy - a market which has a thousand eves on anything and everything of possible significance that raises its head over the commercial parapet. And it is not just the raw commodity that is so much more accessible, but knowledge too. The ability to research and compare prospective discoveries has developed at the same expansive rate. For the skilled researcher has within immediate reach myriad public collections, archives, articles, price records and biographies which can either shore up or kill a hunch with lightning speed. For a discovery to be established it has to work on paper as well as in paint. Crucial aspects of a picture's provenance (its history) can sometimes be instantly established which fifteen or twenty years ago might have taken days, if not weeks, of professional archival research. In a business fraught with auction deadlines the internet's power makes the dealing of the previous generation look like dark prehistory.

Yet it is not just information technology that has progressed discovery, but also technical analysis, the means by which the physical properties of a painting can be diagnosed and understood. Scientists in lab coats are now increasingly entering the formerly forbidden world of artistic attribution. To me one of the most valuable functions of science is to be able to establish a picture's terminus post quem, the earliest likely date that it was painted. Databases and other scientific tools still have far to travel in this area, but paint analysis has become more precise in establishing the physical compounds of pigments and the way in which they are applied and, when combined with the use of ever-growing records of when these pigments were first found to have been used and by whom, can add valuable

corroborative evidence. Scientific data is one of the bedrocks of the Rembrandt Research Project, the authentication panel chaired by Professor van de Wetering and based on exhaustive explorations carried out in Amsterdam and elsewhere over the past fifty years, which I describe in a later chapter. The RRP has helped create convincing arguments which have turned formerly overlooked copies into multi-million-pound originals – and also, sometimes very painfully for the owners, the reverse.

Scientific analysis for the picture hunter has also become much easier to commission. When I first joined the art business in the mid-1980s even organizing an X-ray (to ascertain whether an earlier image might be lurking beneath a painting's surface) was a palaver. It meant queuing up on a Monday morning at certain private London hospitals while the less fortunate with damaged limbs waited for the same service. Today a travelling team of professionals in a van not only call round to the restorer or gallery, but offer other functions, including infrared photography to enable under-drawing – the artist's sketch lines which can help prove authenticity – to be detected.

Dendrochronology, which dates wood by its tree rings and so provides the probable felling date of the tree from which a painted panel was cut, is now a very precise science, whereas it used to require a lengthy trip out of town for a verdict that later proved to be inaccurate, in many cases because of flaws in the data on which the calculations were made. Not any more. Men like Professor Peter Klein of the University of Hamburg make regular trips to London, magnifying lens in hand, to offer an

on-the-spot service that is both brilliantly precise and of inestimable value to the process of authenticating early works on panel. We now have at our fingertips investigative science that can transform arguments and rule out or bolster speculative claims.

I am constantly asked whether (and also told that) discoveries are no longer possible with so much air-born knowledge, technology and science; that nothing can remain hidden any more; that the art world's innocence was last known in the days when auctioneers tipped the contents of stately homes into generalist sales and if anything was illustrated that was a bonus. In a sense the reverse is true. The world is heaving with paintings that are either unattributed or incorrectly labelled. Certainly there are only a finite number of Rembrandts to uncover, but a discovery is dependent on knowledge that transforms something formerly unrecognized into something that is understood and valued. It also relies upon an art market that can then generate buyers. Our culture has new scholarship on all sorts of formerly overlooked artists, as well as a greater volume of retrievable knowledge than ever before, so opportunities for discovery have greatly multiplied.

The problem of course, as demonstrated by the Rembrandt, is that the elite hunters of a generation ago have swelled into heaving ranks and, although the potential for discoveries is more abundant, so too are those who can track them down. This does not apply just to dealers but to auctioneers as well, many of whom are considerable authorities in their chosen areas and will take pains to safeguard their reputations and corporate balance sheets. The modern sleuth has to have not

only the advantages of modern technology but something else too. One of the functions of this book is to give the reader a sense of what that might be.

The subject which interests me above all others is the conundrum of condition, and I have included a brief glossary of terms at the end of this book which covers some of the more frequently used restoration terminology. In the case of old pictures, although analytical science or academic knowledge helps, to me the test of a connoisseur is the ability to read what *should* be there but has been either obscured or even lost as a result of damage or intervention. It is an uncommon gift but one that characterizes a number of my colleagues, some academics and far from all restorers. Although it is also a product of experience and knowledge, it requires access to imagination and instinct, attributes which are not easily communicable; and as important as recognizing what 'coverups' and losses actually look like is knowing if, and how, they can be rectified.

Paint on canvas or panel is vulnerable to a hundred different types of onslaught and disfigurement. The most common – and rectifiable – is discoloured varnish. An oil painting is normally varnished by the artist to act as a homogenizing 'window' through which to view the tones, forms and colours beneath, as well as to provide protection. Varnish also acts over time as a sponge for dirt – anything from tobacco and smoke from a fire to kitchen aromas. Sometimes if these are venomous enough they travel through to the paint layer beneath. A splash of cola can cause irreparable damage to a painting, but nothing compared with many of the eighteenth–century portraits of the

British Raj I recently viewed in Calcutta that had been so damaged by petrol-engine fumes that the entire underlying paint surface had chemically changed, turning granular. This type of toxic pollution is rare, however, and cola normally remains in its receptacle until consumed. For the most part tarnishing is benignly confined to the varnish, which can turn as dark as a midnight eclipse: crucially, however, and sometimes more spectacularly than could ever have been forecast, what lies beneath this layer can be recovered.

In a London auction house I once came across a portrait which had been described as a copy of a Gainsborough. The subject was a conventional, middle-aged man who was an acquaintance of the artist and it looked like two centuries of chokingly dirty varnish had never been removed from the painting's surface. It must have been one of those ancestral portraits which was lodged uncaringly in some back corridor, its family connections and identity as neglected as its surface, which had turned mahogany brown. Three bright highlights in the hair and one in the collar were all that could be usefully read through the otherwise impenetrable shield of dirt. Speculatively, it looked interesting enough to hazard a bid and I bought it for £1,200. As it happened, I did so not because I was convinced that a recoverable original lay beneath (although I was hopeful that something of quality lurked in there somewhere) but because I knew that if it turned out not to be I could always sell the frame - high-quality, contemporary and hand-carved – and recoup some of my losses.

I hoiked my new acquisition around to my restorer and was then able to witness a graphic process of transformation that has rarely been bettered. In no time at all his worktop became a mess of filth-saturated cotton swabs as each application dissolved and soaked up more of the two centuries of human, vegetable and mineral accretions that had infiltrated the varnish. It took him less than an hour. One of the dirtiest paintings I have ever bought reappeared like a new-born lamb – a Gainsborough in almost pristine state (a feature of some pictures that remained untouched by early cleaning and restoration processes) gambolled from its confinement. It also covered my overheads for three months after I sold it to the American collector Earle Newton. It has never left my mind as an illustration of the scratchcard nature of some of our professional challenges.

Even mildly discoloured varnish can have a disfiguring effect, particularly for artists whose style relies upon glistening, delicate strokes to convey form. The painting on the front cover of this book, a portrait of an unknown lady by Lavinia Fontana dating from the end of the sixteenth century, is a good example of how dirty varnish can hide surprises, but this is gentle compared with what can happen. In extreme circumstances whites turn syrupy-brown, reds go dark brown, blues greenish and blacks turn to pitch. The subtle brush marks that are often found in sky and background and frequently distinguish the work of a master can be entirely lost from view. Assessing pictures in this (superficially) compromised condition requires both an understanding of what cleaning can achieve and faith in what the artist or his school is capable of.

I become frustrated to the point of irate when visiting museum exhibitions where no attempt has been made to explain or interpret the core condition of a picture. I am referring here not to pictures which are dirty but those which have, as happens all too commonly, been over-cleaned or mutilated. The sensory appreciation of art is governed largely by what remains rather than what the artist first intended, and guidance on how a work might have changed or suffered is as illuminating as focusing on a work that is in a transcendentally good state. Many of the great works of art that comprise the backbone of our visual history do so because of their condition, such things as the dazzling illusions created by soft glazes and flickering touches of colour and tone, highly vulnerable pigments which have managed to slip unscathed through the assaults of history to retain their affecting power. These are also often the pictures that make the greatest sums at auction, although there is a tendency to attribute this rather numbly to their quality rather than more accurately to their notably good condition. There are countless thousands of works of art which. had they not been corrupted, would offer a very different picture of our civilization's visual history. Spotting these lame ducks, which in many instances have been demoted by being attributed to lesser artists, and then going some way to reviving them, is another aspect of the quest for lost art treasures.

There barely exists a picture over fifty years old where the paint layer has not suffered, however minutely. The most common malaise is natural degradation. All pigments undergo chemical change over time, particularly when they have been subjected to light. An extreme example is the portraits returned to the great Sir Joshua Reynolds in his own lifetime by clients galled by the disappearance of the flesh tones in their hands,

cheeks and jowls as a result of his experiments with pigments. With the passage of years and insensitive cleaning many have got worse still. Healthy-looking sitters have taken on the appearance of corpses, ashen-white or sometimes grey-blue, left with only the bones of his vigorous characterizations and the normally better-preserved clothes to testify to their original impact.

My close friend the MP Tony Banks, now tragically deceased, was not just a vociferous and high-profile parliamentarian, an animal-rights advocate and the embodiment of enthusiasm for Chelsea Football Club, but an avid collector of political memorabilia. He managed to buy, miscatalogued in a Sussex auction house, a genuine Reynolds portrait of the eighteenth-century statesman Henry Fox, the 1st Baron Holland. It was knocked down to a few thousand pounds because of its unearthly-looking, washed-out face, which gave it the superficial appearance of an inferior copy, fooling the auctioneer and other buyers. It improved immeasurably when the background was cleaned, lightening the darks around his head which had so contrasted with the faded flesh tones to give him a ghoulish demeanour. Sensitive cleaning to the face also brought back a suggestion of modelling and contour. When its authenticity was further confirmed by Martin Postle of the Tate Gallery, Banks had a picture worth close to £,100,000 and, in the presence of football mates he happened to be meeting before a match, he celebrated its emergence in the Pugin Room Bar of the House of Commons. To the bewilderment of his onlookers he raised his glass to Baron Holland - the progenitor of what he saw as a great political dynasty - and then to

what he described as Reynolds's faulty painting techniques. After Banks's death it was acquired for the Commons' art collection.

Almost all painters working out a composition will modify first ideas, some slightly, others radically, as part of the natural process of travelling towards the artistic solution. Given that paint often becomes more transparent over time, losing its initial strength of hue, these changes of mind can become visible to subsequent generations. Pentiments, as the results are called, can have the effect of enlivening a composition (they put me in mind of the lines and jottings that cartoonists and draughtsmen sometimes put around their figures to express movement) but can occasionally confuse the later eye by introducing distracting shapes and contours. Sometimes restorers are bamboozled, revering the wrong line to the detriment of the artist's intention. One of the National Gallery's most famous pictures, Noli Me Tangere, painted by Titian in 1511-12, I believe to be a case in point. Although its authenticity has never been doubted, the picture's powerful emotional tension, achieved by the upward tilt of the recumbent Magdalene's face, is undermined by her uncharacteristically Grecian nose. Carefully examine its outer edge and it is possible to detect the very faint presence of a previous nose which has been incorporated. It would require no more than a minute glazy stroke to soften it back towards her original Venetian appearance and to heighten the painting's aesthetic and spiritual quality.

Again this is an area where the risk-taking professional can prosper. In a recent sale in New York there was – to my mind at least – a manifestly authentic portrait of an ageing lady by

the great seventeenth-century Dutch master Frans Hals. Examining it first from a digital image it was clear that Hals had originally placed the nose at a different angle - now a pentiment which gave her a mildly Cubist appearance. It had been cautiously catalogued as 'Attributed to' the master rather than certainly by him, with an estimate of \$300,000-\$400,000. All it required was a restorer to knock back the unintended earlier nose to return it to the artist's intended appearance (which we mocked up with Photoshop in the gallery before the sale). Someone else may have come to the same conclusion: the painting tripled the lower estimate to make close to \$1 million and we failed to buy it. The new owner is likely to have something still more valuable if he can persuade the appropriate experts that it is genuine - another aspect of the discovery process, to which I shall return. On many occasions over the past twenty years I have observed how the eye of the academic. dealer and auctioneer alike has been thrown by pentiments, so what is needed is to steer a confident course betwixt reading these marks wrongly and ignoring them.

The most common form of *inflicted* damage to paintings happens by over-cleaning – either by chemicals or over-enthusiastic scrubbing – or the process of relining (laying down a perishing old canvas upon a new one). The keeper of many pictures in less worldly country houses was often no more than the housekeeper, and the survival of hand-me-down recipes suggests the application of an alphabet of domestic solvents, including urine, lavender, ashes and half-potatoes. Egg whites were sometimes used as an alternative to varnish. More complicated jobs such as patching holes were sometimes given to the

estate carpenter. My guess, however, is that these home-spun remedies were nothing like as destructive as those applied by the so-called professional restorers through whose mills passed countless oils in the late nineteenth and twentieth centuries, a consequence of Europe and America's fast-expanding art market. It hurts me to recall the quantity of pictures I have encountered at auction that have been flayed, crushed and mutilated in order to service the collecting boom during this period. The appeal of a hygienic shiny finish, a swift and cheap process, and the unexacting standards of an unsophisticated market gave rise to innumerable acts of destruction. Picture surfaces were pressed so flat under hot irons that much of the paint and the expressive impasto (the thicker, prouder passages of pigment) are now reduced to enamelled flatness, their finish reflective enough to shave in Vicious solvents, ham-fistedly applied, have the destructive power of napalm and I have witnessed their indiscriminate devastation thousands of times: landscapes stripped of their vegetation, ships of their rigging, faces their eyebrows, figures their feet and delicate afterthoughts like flying birds and even signatures chemically dissolved into oblivion.

Although it still happens, restoration has advanced academically, scientifically and culturally, so that the wounding and murder of pictures is less common, but there are very many works that surface at auction and elsewhere that are by major painters but have been demoted because of lack of comprehension about condition. Even if a cataloguer does sense a painting is attributable to an artist, downgrading it can be a neat means of avoiding having to argue its authenticity, allowing the

market to 'make up its own mind'. Some of the most thrilling discoveries are made as a result of this practice.

As I write these words a vivid example is looking at me through the open door of my gallery's office, and it lifts my spirits each time I raise my head to meet his glance. The subject is Charles I a few years before his execution. The king's dignified but maudlin appearance was captured at the height of the Civil War, during which the English court decamped to Oxford. In highly congested circumstances, and in between battles, the sovereign and his royalists donned armour and silks and sat for their portraits. Even in these siege conditions the court was attended by its portraitist, and after the death of Sir Anthony Van Dyck the mantle had fallen upon an English painter named William Dobson. Only about sixty of his works are known from his short career - he died at the age of thirty-five in 1646 - but Dobson combined native empathy with poetic poise. It has been plausibly suggested that he ran short of materials during his twoyear confinement in Oxford and so was forced to work on canvases smaller than average and to eke out his paint, a trait that only adds to the realism of his portraits. These are movingly direct, recording the final years of an endangered social order that ended up slaughtered, executed, exiled or dispossessed after its defeat by the parliamentarians. He is one of my favourite painters, in many ways a starting point for a native school of British portraiture that surfaces again with beguiling clarity in the work of Hogarth seventy-five years later.

The portrait was being offered in one of the main London auction houses and we first came across it online, before the catalogue had been printed. I vaguely remembered the picture when it had been exhibited twelve years before at the Dobson exhibition at the National Portrait Gallery curated by Dr Malcolm Rogers. But since the emergence of another version of the portrait at Christie's a couple of years later, and the deprecating remarks of the late Sir Oliver Millar, the Director of the Royal Collection and the foremost authority on seventeenth–century British painting, the auction house had decided to play safe and describe it as a copy. From the illustration it even looked that way, and despite the fact that it had a compelling provenance that placed it in the collection of the Dukes of Hamilton, the first of whom enjoyed a close relationship with the King, its flatness and murky tones did little to recommend it. But even good–quality digital images are not the same as physically poring over a work, and this was one I was eager to see again.

We tracked it down in a back corridor of the saleroom and it took a couple of minutes of fierce torchlight scrutiny to establish what had happened. The painting had been assaulted by ham-fisted restorers. Some seventy-five years or more earlier it had been only part-cleaned and then relined, during which process the remaining fragments of dirty varnish had been crushed into the weave of the original canvas, much as dirt might be stamped into the weave of a rug. These ingrained flecks meant you could not properly read the paint, the modelling was obscured and a noble portrait had taken on the appearance of a table mat. Furthermore a later, now discoloured, varnish covered the surface.

Described as 'After William Dobson' – in other words a straight copy by another hand – it carried an estimate of

£6,000–£8,000. On the basis that the other version by Dobson had made £165,000 at Christie's ten years earlier, combined with the considerable increase in interest in this type of painting over the intervening period, even if it turned out to be a second version by Dobson (rather than the first from-life record) it had the potential to be an important and valuable picture. There was also its lustrous provenance, which we managed to add to.

In this book I explain how the history of a picture can colour its appearance. I show how provenance can completely blind eminent authorities into believing a picture is authentic when it is a fake, and also how provenance can unlock a picture's importance and stature. In the case of this painting provenance helped shore up the visual hunch. The portrait was known to have belonged to one of the most eminent families of the seventeenth century but the earliest certain reference was 1696—close to fifty years after it is likely to have been painted. With a few days to go before the sale, in the inventories of the Duke of Hamilton's pictures, which are archived at the National Portrait Gallery just off Trafalgar Square, we found a further reference to the portrait hanging in the Duke's apartment at Holyrood House in 1704, and reassuringly listed as the work of William Dobson.

After an auction skirmish we ended up paying rather more than was estimated at £39,000, but still a great deal less than I had mentally armed myself for. I had it delivered to Simon Gillespie, one of our regular restorers, who had cleaned two Dobsons for me before. Progress through the ingrained dirty varnish using solvents and the tip of a scalpel was understandably

slow, but over the course of a morning he was able to expose half the King's face. The contrast with the untreated area was remarkable – one eye and cheek were bathed in silvery light and showed soft, complex modelling. Within a month Simon had managed to unmask the whole image, a convincingly authentic, arresting and formerly hidden face of the executed King of England which was now fully accepted as such by Malcolm Rogers.

By far the most dramatic form of discovery is the removal of overpaint. Art has been deliberately obscured since the earliest times, and for various reasons. Sometimes there were religious or political motives to do so - ninth- and tenth-century Christian murals in the Hagia Sophia in Istanbul, for example, were covered over by the Muslim conquerors in the fifteenth century, just as countless exquisite murals in English and European churches were overpainted during religious purges from the later Middle Ages onwards. Sometimes it was done for artistic reasons. From previous centuries there are documented examples of professional artists who, when they were given a fine old master to restore, instead of cleaning and repairing it in the way we understand now, took a brush and repainted it, believing they were simply enhancing the appearance. As I demonstrate in this book, Rembrandt would also employ studio assistants to update his less saleable works, indifferent to the sanctity of his own brush strokes. On a rather baser level, over the past twenty years I have encountered countless hidden breasts, private parts and double chins, concealed for reasons of prudery or commercial enhancement.

But much the most common purpose of overpaint in the world I occupy is to disguise the scar tissue of damage and

restoration: patch-ups, tears, flaking and abrasion and the overly conspicuous cracking known as craquelure. It is the garment of disguise, sometimes cunning, often clumsy, whose function is to trick the eye into believing a surface to be unblemished. Given the fragile nature of pigments and supports, later paint has been applied to a greater or lesser extent to almost all old paintings, in its most benign and respectable form simply to fill and touch in losses. I defy the reader to find a picture more than a century old in the Metropolitan Museum in New York or Tate Britain in London that has never had any such attention at all, if only at its edges.

Where overpaint becomes contentious and, frankly, compelling to the hunter is when it has been used excessively or in such a way as to disguise the authorship or quality of the work beneath. It is easy to see how it might happen if you place yourself in the boots of a cowboy restorer from a previous generation. You have filled in a hole in the side of, say, a painted horse but the tone is not perfect. The indentation or bump from the filling or patching also catches the light. Rather than labour to match pigments and perfect the surface, there is a quick fix as practised by the restorer's equivalent of the builder from hell. By extending the overpaint, spreading and melding it over the horse's flanks it is possible to largely disguise the handiwork. In so doing of course you smother a large tract of the artist's undamaged work. But why give a damn if the client does not notice or care? The painting is still an 'original', and it will look superficially smart over the fireplace, particularly if you have cleaned and varnished the whole and left some pivotal areas such as the signature untouched.

Artistic defacing of this type has happened a million times and the most enthralling instances in my career - those times when the stress and uncertainties of running a business with punishing overheads are justified, when the resolution to live off wits rather than a cosy salary and a guaranteed pension appears not so bad after all, those moments which validate the decision to commit to a world that, however successful, will never get close to the rewards of the City tycoons I have often supplied - are when these tracts of overpaint are removed to reveal something of artistic value. Archaeologists must sometimes get the same buzz. Although with particularly early overpaint it can prove either impossible to remove without damaging the underlayer or too costly given the predicted value of the improved picture, in many instances it is viable. The next big question is, why is it there in the first place: is it applied unnecessarily or in fact there for good reason, covering irreparable damage?

This issue is thoroughly considered in a later chapter, using the example of a major portrait of Elizabeth I, but for me one of the most satisfying and immediate instances in which removal of overpaint caused an ugly duck to mutate into a swan happened a couple of years ago. I was scrolling through eBay in search of portraits. I can't remember what I had entered into Search beyond 'antique' and 'portrait', but amidst a gruesomelooking pack of offerings something caught my eye. From memory it was described as American School, nineteenth century, and consisted of a youngish man trussed up in a solid-looking brown jacket. When I clicked on a larger image I was instantly struck by the difference in quality between the head

and the body. The features were engaging, well modelled and arresting: the body was boring, inelegant and anatomically uncomfortable. Looking further at the way the paint was applied to the mouth and eyes, I could see it had all the hallmarks of an early Gainsborough. In a later chapter devoted to the discovery of a landscape by the artist, I talk about recognizing the strokes, which is another one of those essential attributes in sleuthing certain types of lost paintings. Given my focus, I have had to get to know the distinguishing style and techniques of a raft of prominent portrait painters. Paint strokes, pigment mixtures and approaches are as varied as fingerprints and similarly incriminating. But why, I asked myself, if the head was by the master, was the torso by what looked like a jobbing sign painter? Was it a hybrid copy? If it was by a copyist, he clearly had not found his true vocation if he could paint a face as well as that. The vendor was a dealer who had no useful information about its history either. Further deliberations were hardly necessary, however, as I found myself to be the highest bidder at under \$200.

As a (very) amateur naturalist I try to avoid the temptation of using zoomorphic images as they have a tendency to unsettle people when applied to art, but there is no more apposite way of describing the process that followed as that of hatching a pupa. When the unframed canvas arrived at my gallery by Federal Express two weeks later I was transfixed by the possibilities of what might emerge from its cuticle of overpaint; so much so that I shamefully admit to intervening. I took out a bottle of acetone secreted in my top drawer, together with a bottle of white spirit, and decided to play God. By now I was convinced that the head

was by Gainsborough and that there *had* to be a body match. I also have to admit to a certain degree of bravado, owing to the negligible price I had paid for it.

As they say on television, this is not something to do without an adult - in this case a professional restorer - but if I count the months that I have watched it done by consummate experts I consider myself to have had a better and longer apprenticeship than most first-timers; in fact, if I add it up, I must have witnessed parts of stages in the treatment of thirty or more Gainsboroughs. In idle moments I have thought how enjoyable it would be to be a restorer. Although I lack 90 per cent of the necessary patience required to achieve it as a career, you only have one life, and fantasies provide the ballast. Almost without exception I hand over potential discoveries to the professionals, like delivering the suspect for questioning, so why not live dangerously, I decided, and for once act as the authority. I am unlikely to need to take over the controls of an aeroplane, or to have to perform appendicitis upon a friend, but this is a world I live, breathe and occupy, and the new captive from America presented the opportunity for something exciting. Deeply aware of the risks, but also confident I could halt any damage should the operation go wrong, I laid the picture on my block easel and trained the powerful gallery lights on its surface. I put on a pair of magnifying lenses (the same as those used by our restorers), took out my hand-held halogen torch - invaluable for illuminating details - and placed it within easy reach. I was alone in the gallery and there was nothing to distract me; it was a winter evening, dark outside, and the telephones had stopped ringing.

I began cautiously and haltingly, first applying plain white spirit to the surface of the jacket to see if the paint would react. It was impotent, resting on the surface like rain on a windscreen. So I changed to acetone, the restorer's favourite tipple, applying it with a cotton wool bud to the portrait's right shoulder. I had observed these prudent beginnings a thousand times. Martin Bijl, one of Europe's most celebrated restorers, recounts later in this book the sweaty, physical feeling that engulfs him when he embarks on restoration surgery. Although what I was taking on was child's play in comparison with the technical challenges he confronts, I had something of the same sensation. It also gave me a wicked kick. My restorers loathe others touching pictures before they have treated them themselves, and although I pay the bills they can have a headmasterly way of rebuking me for so much as applying white spirit to a dirty surface - the most benign form of investigation. What, I thought with some amusement, will they have to say when I deliver them a fully autopsied body?

The impact of the acetone was instant. Whatever its makeup, the overpaint had also clearly been applied in the past fifty years and it dissolved like lard. Beneath, I gained through the lenses my first glimpse of the under-body of earlier pigment. I dabbed it with white spirit. Just a few millimetres in diameter, the area was too small to assess its quality, but under the halogen torch's penetrating beam it looked honest and early. To my relief it also appeared robustly resistant to the solvent.

It may have been the solvent's intoxicating fumes but my inhibitions began to lift. I realized I had reached the point of no return: it was not the progress of the operation that dictated this, but my own impulses. I found myself incapable of disengaging from the enthralling process of recovering the torso of a dismembered head. What was beginning to appear was clearly of infinitely superior quality, the strokes reminiscent of those in the face. Running throughout the middle of the coat was a series of tears, crudely sealed with white filler, indicating that the canvas had once been ripped. This was the smoking gun I had been looking for and it now made clear sense: the restorer had succumbed to the easy option and blanketed out his handiwork, but, not content with that, he had gone into creative over-drive and redesigned the subject's whole attire.

The floor was now strewn with coagulated brown swabs. An hour had passed and I had developed a steady rhythm - twizzling the cotton wool on to a stick, dipping it into a cup and rolling it on the picture. With every square centimetre that was revealed the portrait was cohering into a readable work of art. Areas which at first appeared dislocated and unreadable mesmerically joined with new ones to form lines and folds. Just as I was reaching the lower-right quadrant, by which time the operation would be complete, I was brought up sharp with a fright. I had hit an area of differently coloured pigment. It was pinkish-brown and for a moment I thought I had uncovered raw ground, the prepared surface of the canvas. Could I have done this or had I encountered the butchery of a previous restorer? I drenched it - and my alarm - in copious white spirit and then angled the picture towards the light. My relief was palpable. Through the spring-clear lens of solution I could read delicate, well-preserved strokes of flesh tone. I had uncovered the edge of a hand, demurely parked into the sitter's waistcoat - one of Gainsborough's neat compositional tricks to conceal anatomy that would otherwise distract.

The following day I sheepishly delivered the stripped-down picture to my restorer Rebecca Gregg, who compliantly agreed to pull it all together. I avoided all conversation about why it exuded the aroma of solvent, had been denuded of its restorations and was covered with the tell-tale white residue of dried acetone, but I have a strong suspicion she fathomed the reason. Rebecca got to work over the following week. The task involved fastidiously confining restoration to the tears and replicating Gainsborough's glazy finish on top. We ended up with a pukka Ipswich-period Gainsborough that sparkled with jaunty confidence. I do not know who the sitter is, perhaps a local businessman or friend of the artist at the commencement of his adult career. The artist's identity, and possibly that of the subject, had clearly become lost in the annals of time - the fate of many such escapees from these islands, which I touch upon in the first chapter. When it later hung in the gallery it was known simply as Mr eBay. Given the zeal of the overpainting, whoever restored it in America must have had no idea he was disguising a Gainsborough.

From my own point of view, having sated my need for risk and adventure in the realm of restoration science, and miraculously succeeded in removing the overpaint without damaging the layer beneath, I have no need to repeat the process. My therapy is complete. I also have no other option. Treating me like a drunk, for the past two years my staff have hidden the acetone bottles.

There is an even worse fate that can befall pictures than overcleaning. They can be chopped up. Sometimes thieves do this to disguise the identity of the stolen goods – it has happened most famously to paintings by Monet and Turner – but it also has been visited on works for commercial or emotional reasons, and I have been involved in a number of instances where, as if by some divine gravitational pull, the disparate halves have rejoined after centuries of separation. If the art of discovery is that of the sleuth, there is no better resolution to a crime than the one we achieved around the time we opened our new gallery in Dover Street in 2006.

My 30-year-old researcher, Bendor Grosvenor, whom I shall introduce more fully over the course of the following chapters, was carrying out his daily task of scrolling through the world's offerings. This is a crucial part of his job which he performs with youthful adeptness, scything through the multiplicity of available pictures at auction in search of opportunities, combining computer fluency with an incisive eye. He had come across a picture in a New Hampshire auction house and emailed it to me to inspect. Described as 'Circle of Hogarth', it depicted an engaging young woman in a green dress and mob cap, her attention fixed upon a book on her lap, and although half a century earlier, she had the studious introspection of a Jane Austen character. Even though I didn't know who it was by (the digital image was lacking in definition and was evidently dirty), I judged it to be of sufficient potential quality to be able to attribute it, particularly following cleaning, when such areas as the dress would with luck throw up clues. Drapery can be as illuminating as handwriting in expressing the traits of individual artists.

We bought it for \$7,500 and when it returned a couple of weeks later and we removed it from its crate, it looked more

in need of attention than I had bargained for. The colour of the dress, which had appeared green, hid another, indeterminable tone beneath, filtered by grimy varnish. Around the body was an accumulation of overpaint covering detail and possibly damage too. We decided to suspend judgement until the picture had been restored, again by Rebecca Gregg. A month later, after cleaning and restoration, our lady returned to the gallery a different woman. Her complexion had freshened into healthy pinkness and her dress, now freed from the yellow varnish, had become a dramatic, azurite blue, rippling with rococo folds; her left arm now alighted upon a table indicated by its elegant, pedestal-footed leg. But it was the human leg that had appeared from beneath the overpaint, partly stockinged, thrusting in from the bottom left, that really knocked us back. Midway through restoration Rebecca had telephoned us to announce the beginnings of this shocking emergence, and now it was plain to see. However one looked at it there was no mistaking, and it was too pronounced to be a pentiment. The conclusion was both depressing and intriguing: this limb belonged to a missing figure: not for the first time, I wearily concluded, we had bought part of a larger picture.

Examining the style of the drapery, the confidently described furniture, and the compactly constructed facial structure, I could see enough evidence to state the case for an artist. The one who immediately came to mind was Francis Hayman (1707/8–76). A leading portrait and subject painter in his day, he had recently made art-world news when the London dealers Agnew's had sold a major example of his work, a group portrait of the novelist Samuel Richardson and his family, to

the Tate Gallery for £1 million. Although this did not begin to advance towards the stature of that work, he was an artist people rated, with works in many public and private collections, as well as the subject of an exhibition and catalogue by the distinguished art historian Dr Brian Allen. Bendor immediately got to work minutely comparing Hayman's works with our new-found lady, looking for repeated motifs and comparable stylistic quirks to pin down the attribution. The following day he beckoned me into his office to show me an image on his screen. It was a self-portrait of the artist at the museum in Exeter, his city of birth, and it showed him in an artist's cap, palette and brush in hand. He was seated 'contrapposto', his head facing the viewer but his legs twisting out of the composition. Bendor then flicked up the image of our picture, mounting the two side by side.

Although not known to be half a painting, the emergence of this portrait from America indicated that the Exeter Museum's self-portrait had been cut in two. Some periphery canvas was still missing, but that his thigh joined the severed lower leg with seamless logic there could be no doubt: furthermore the easel and canvas in ours now made narrative sense, completing a formalized scene of a man painting himself and his wife in his studio (Bendor later went down to the museum with our picture and proved it conclusively after a thorough physical inspection of the paint and canvas weave).

As I looked into the young artist's life an intriguing hypothesis now offered itself. Hayman married twice. His first marriage ended in divorce, so why should this not be an attempt by him to edit his private history, perhaps on the

insistence of his next wife (whom he married in 1752), by removing the offending part? Not enough is known to be conclusive, but clearly something happened to cause what would otherwise be an act of mindless vandalism. We exhibited both halves at our opening exhibition and it caused countless pilgrimages from Exeter and elsewhere to see the reunited couple – a number of visitors questioning the ethics of forcing back together a husband and wife who had chosen to dissociate. Like it or not, however, the young couple are now rejoined for ever, following Exeter Museum's decision to buy the work for its collection.

When a prospective discovery is made it is of inestimable value to secure the support of a recognized expert to endorse your claim. I devote a chapter to how historians can add enormously to the elevation of early art, but art historians are even more relevant to this subject. However great the dealer or auctioneer's knowledge may be, and likewise his or her integrity, we occupy a commercial theatre and the reassurance of objective academia offers a further layer of comfort to clients. Almost all deceased artists of stature have a man or woman on earth who is prepared to act as an arbiter of authenticity, and they come in all shapes and sizes. Some have become so by dint of a formal position, such as the directorship of a museum or the curatorship of a major national institution, particularly if the institution's holdings include works by the artist in question; more commonly, authority comes from having published on the artist (there are few better places to have the last word than upon the platform of a scholarly book or two); and sometimes clout is derived simply from a consensus of regard among academics,

auctioneers and dealers. In France, the heir of the artist who has rights to the estate will sometimes assume this position, and Picasso, Matisse and Pissarro all have family descendants recognized by the art establishment. For all art experts, once their position is recognized by the leading dealers and auction houses, there are two tangible benefits: the opportunity to keep abreast of anything new in their sector, and the chance, in some instances, to be paid for their expertise.

I have an enormous regard for many of these experts, and devote a chapter to one whom I consider to be exemplary. There are, however, grave weaknesses in the system when the expert is not up to the task, and these have proved both frustrating and also, to make up for it, extremely beneficial. Take a hypothetical scenario. You are an academic who has decided to write a book on a valuable artist: I shall not name an artist for fear of offending someone. You have a series of well-regarded qualifications, if not a doctorate or professorship, and soon find a willing publisher. You decide to take an angle that will interest people - this could be anything from the painter's preoccupation with sex, attitudes to feminism (a common favourite), politics, or other artists, and so on. The book is favourably reviewed in the academic and possibly popular press and you are approached by a museum to curate an exhibition on the artist. You also give lectures, teach and write articles, and soon find you are the pre-eminent art historian on the subject.

Now take the prospective purchaser's viewpoint. You are offered by a dealer, or persuaded to bid on by an auctioneer, a newly discovered work by this artist. It is not in any of the established literature, it may have been dirty or with overpaint —

perhaps still is — and lacks any useful provenance. The price being asked is commensurate with those that the artist has achieved before, but it requires a hefty cheque, so you want some comfort that what is claimed is true. You have fallen for the painting, however, and would not like to lose the opportunity to acquire it. Unless the dealer's or auctioneer's expertise and reputation is such that no other endorsement is required, the most obvious thing is to go to, or ask for the picture to be seen by, the perceived expert. Googling that person's name, you find it ubiquitously flagged next to the artist's.

Imagine once again that you are the expert. The query arrives with you by email, together with an invitation to view the picture in the flesh. Quite right they should send it to you, given the large chunk of your life you have devoted to the artist: a man or woman whom you have studied with all the available means at your disposal, almost every recorded major work of whom you have seen (the rest as photos), and about whom you know every theory proposed.

The first hurdle is that you need to see the painting in the flesh – few if any experts would risk offering a conclusive view from a photograph. If the painting happens to be on the other side of the world there is an immediate logistical and cost issue: either it must come to you, or you must go to it. But even with the benefit of a full physical inspection, you know your limitations. As a result of your researches, you are aware that the artist has been faked in the past, that he had followers and studio assistants. You therefore heed an inner voice of caution. You could speak for an hour on the subject matter – if indeed it is by the artist in question – but what about the physicality of the

work of art? Can you really understand the condition? Do you really know the idiosyncratic traits of the artist, as opposed to those of people who were highly influenced by him or whom he taught? Have you fully understood his qualities in the context of the numerous apes, pretenders and copyists – the only true way of reading the fingerprint? The work is also atypical in both subject and style (which was why it was discovered in the first place), so it requires an even greater reliance on your eye and intuition.

You have to fall back on connoisseurship - the skill of defining and recognizing the strokes of the master on the basis of what is before you. Are you really the person for this? Your knowledge of the artist's life and subject matter is unparalleled, but when it comes to the minutiae of technique, can you confidently shift from the theoretical to the physical? Your acclaimed book did not require this type of insight, nor did your broader training in art history. Curating the exhibition was very valuable experience, but it was more to prove a thesis than provide an overview of the artist's techniques. What's more, do you sense this carries the risk of exposure, that there is money involved? What do you therefore say? The best course may be to vacillate: you could just describe it as possibly by - at least that way you will not expose yourself to the risks of a commercial transaction as much as if you say definitely yes or no. But there again perhaps it is right, and you are irresponsibly ruling out what could be a new work by your chosen artist. And so on and so forth.

Art history and connoisseurship are in my view separate disciplines which sometimes combine, but not always: a

military historian does not necessarily make a good general, a professor of economics a good businessman. They both have the capacity to be so, and can certainly talk the talk if required, but they are different fields of human competence.

The upside to this is that paintings that are manifestly authentic, but have been turned down, can sometimes be bought at auction for a fraction of their true value. They are the classic 'sleepers'. The auctioneers of the miscatalogued Rembrandt I mention at the beginning of this chapter state that it was checked out by the Rijksmuseum in Amsterdam and a major auction house before the sale. The downside is that if you do find something unequivocally genuine, the experts may not have the skills, confidence or time to endorse it. Of course you could say this is the moan of any would-be discoverer, but there are occasions when the proof is so plain to see, the characteristics so redolent of the artist in question, the circumstantial evidence so compelling, that even a blind dog with a stick can see them. These travesties normally have a way of sorting themselves out with time - art history moves on, new academics get involved, the expert develops connoisseurship - but time is a luxury in a fast-moving, competitive world with biting bank loans and gallery overheads.

I also know of experts who are erratic, emotionally driven, bombastic and political, some of them with prestigious publishing commissions, who can obscure the proper understanding of an artist by their limitations and prejudices. I know of one case where an academic told the incredulous owner of a picture, 'I know who painted this but why should I tell you so you can make money' (admittedly the academic was not in this

instance being paid for his expertise). There are also great art historians whose pronouncements close the case, even though convincing evidence to the contrary emerges, and I touch upon this later with a Van Dyck. Although technological and art-historical knowledge lessens the scope for cardinal errors, as long as the attribution relies upon the judgement of a human this phenomenon will remain.

I thought long and hard about how I could introduce some contemporary art discoveries to this book. The problem is that works created in the past few years have little chance of being lost and found – although no doubt in a century's time there will be many opportunities, as well as incentives, to sleuth them if the market appetite remains. The much broader definition of what constitutes contemporary art, however, does allow latitude in the potential for some dramatic transformations and representations. One of the more amusing examples of this was a picture by the graffiti artist Banksy which I noticed coming up in a sale of contemporary art at Sotheby's last year. It consisted of a genuine, bust-length, eighteenth-century portrait of a gentleman by the West Country painter Thomas Beach on to which the artist, with characteristic rebelliousness, had shamelessly painted an arm and hand with a sticking-up middle finger - a not atypical Banksy statement of crude defiance. Viewing it in the auction house, the longer I looked at it the more the underlying portrait appeared familiar. It was only when I checked my records back at the gallery that I twigged that he had used a portrait which had been bought in - a term used for items that fail to sell at auction - at another, lesser Sotheby's sale of old master and British pictures two years

earlier, after failing to achieve its lower estimate of £2,000. As a remarkable comment upon our times, with Banksy's subversive addition (that can hardly have taken him more than a couple of hours to paint), and in a contemporary sale at the same auction house, I watched it sell for £320,000! More a case of creating a treasure rather than sleuthing it, this was to be my only contemporary aside in the book until I started digging into the compelling story of how two men turned the interior of a soon-to-be-demolished restaurant into a multimillion-pound art sale. Pharmacy, which was entirely made up of fixtures and fittings designed by the contemporary art celebrity Damien Hirst, is one of the most significant examples of how contemporary artefacts can be radically re-presented to achieve the same results as the most startling sleepers. The final chapter returns to it in more detail. My timing was serendipitous because what directly followed from this, a month before I completed this book, has marked a new departure for contemporary art auctioneering.

I write not as a journalist but a practitioner limited to my own field. For the most part I have chosen examples in which I was directly involved, but there are also cases involving others that I seek to communicate with insights gained from what I do for a living. To the extent that the book deals with fact and not fiction (with the exception of where I slip up) and there are many corners in the art world into which I have barely peered, its scope is curtailed. But then it does not seek to be comprehensive. Its purpose, to use an artistic analogy, is to sketch a number of small scenes and figures by which it is possible to gain a sense of a much bigger composition filled with

innumerable paths, dramas, challenges and characters. Although the subject matter is art and the response to art, its discovery and the guile, risk-taking and competition involved in the sleuthing quest are all in the realm of familiar human behaviour. The book's other purpose is therefore to highlight the temperaments and motivations of the dealers, art historians, historians, owners and restorers who are drawn to the pursuit of art for reasons of truth, profit, or both.

My most lofty ambition here has been to use art as a support for brief character studies, including - in the time-honoured Renaissance tradition - a self-portrait or two. Art greatly lends itself to this function. In a secular world in thrall to the cult of genius, as evidenced by the commercial value and sanctity awarded to art by collectors and museums across the world, many deceased artists (and some living) have achieved the status of saints. As Marcel Duchamp put it, for some art is very sedative but not as good as God. Even so, it is tempting to think that art does respond to a crucial need for spiritual sustenance. To own an original Rembrandt (or, in the case of the New York collector Tom Kaplan, eight at the last count) or an authentic Rockwell has something of the allure that holy relics had for the medieval mind. This has spilled over into present-day art dealing, where, when it comes to the work of figures such as Damien Hirst, we have witnessed artefacts being competed for at auction as if they were splinters of the True Cross. Like art itself, the market for its products can be extremely eloquent about human behaviour.

settings their state as their attentions of the second

CHAPTER 1

A TASTE OF THE PAST

Par below I began to make out moving lights, uniform blocks and the relentless sprawl of an American city softened by snow. But any sense of relief at coming to the end of a day in the air was short-lived.

For a start, I had no knowledge of the city where I was landing. I also had little notion of where I was off to next. The gentleman I was travelling to meet had told me that the flight would be followed by a two-hour car journey into deep country. Of more concern, however, was the gentleman himself. Apart from that brief meeting in my gallery three months earlier when he appeared unannounced with a valise of books and a worn brown envelope of photographs, I had no idea who he was; since then we had only corresponded, and his last letter had contained my plane ticket.

I was now off to spend a weekend with him in the wilderness. As I write this close to sixteen years later I am struck by the

quaintness of it all. This was among the last art-dealing forays I

was to make in what could be described as the pre-internet era. I was on my way to survey a collection of paintings that this man had amassed in the 1950s and 1960s. As the photos he had shown me were mostly black and white and slightly blurred, it was difficult to assess their quality – I needed to see them in the flesh. But who knows, I thought, there may be something exciting there. So I had accepted the unknown collector's invitation on the basis of hunch, as well as a taste for adventure, which, as the plane touched down and I faced the realities of my decision, had already begun to pall.

Compare my situation with how we would deal with an 'unknown' who walked in from the street today. No sooner had he left the gallery, possibly while he was still in it, we would be Googling his life and career. It sounds ruthlessly cynical, but in a world full of trickery, duplicity and fantasists, quick access to biographical detail can be invaluable when it comes to apportioning your energies as a gallery owner. Not content with that, I would also ask him to send digital images of the pictures when he returned home - hardly a problem for anybody these days, even with a standard camera. If the quality of these proved good enough, from the comfort of my leather chair I would zoom in on the images on screen, studying them almost as closely as if the paintings themselves were there with me. Only then, once I had gained a strong sense of both the man and his wares, would I consider moving from the gallery.

Instead, as befitted the age, and mine also, I had crashed full tilt into the bleak unknown. The city was Burlington, Vermont, the date 23 November 1992 – the day after Thanksgiving – and

the cold air tore into my face as I left the airport and crossed the road to the bus stop where Professor Earle Newton had asked me to meet him. I had forgotten what the old man looked like until I saw again the slightly stooped gait and the compressed smile (which I later realized was an almost constant facial feature) as he walked over to greet me. His delivery was frail but measured, his longer sentences ending with noticeable pauses.

'Welcome to Burlington,' he said. 'You were right on time.'

So at least I had met my man. But I did not recognize the looming figure next to him in a duffel coat and jeans. He was heavily built, with black hair, a ruddy complexion and, at odds with the rest of his attire, a tight-fitting chauffeur's cap.

'This is Bill,' said Earle.

The big fellow offered me his hand.

'And he's going to drive us,' Earle added.' We have quite a journey ahead, so we'd best be off.'

Bill picked up one of my pieces of luggage and the three of us made our way towards a formidable but ancient white Daimler parked on the other side of the road, its great chassis spotted with rust. I sat with Earle on the back seat while Bill manoeuvred us out of the airport concourse and sedately into the night, heading towards the highway. It was late for me, I felt tired and displaced, and my normal art dealer's patter was not functioning. I kept my gaze fixed, beyond the outline of Bill's large shoulders and peaked cap, on the road ahead. Earle, brushing up next to me in a heavy coat in the darkness, occasionally pointed out sights on the city's skyline as it disappeared from view. By now it had begun to snow.

After we had been travelling for an hour we moved onto smaller roads. There was a distinct absence of traffic and houses, it was deep night, and I became aware that we were driving through a mountain pass, its steep, snow-covered slopes punctuated with irrigation streams.

'Is your home far from here?' I asked as I began to realize that the address I had been given – The Newtons, Route 14, Brookfield, Vermont – was as off the map as it sounded.

'Some way, I'm afraid. The weather isn't helping either,' Earle replied.

The wheezing windscreen wipers struggled against the splattering snow.

'You see, we don't live in a town or village, so it can be quite a hike when the weather is like this. The nearest grocery store is a half-hour,' he added solemnly.

'That must make shopping a problem,' I said as cheerily as I could.

'It certainly does. But there again we are not completely isolated. There are country stores within a couple of miles of our door where you can buy bait and ammunition.'

'Oh right,' I said, and we reverted to the soundtrack of the Bentley's rumbling engine and the groan of the wipers.

It was my boyhood friend Charles Glazebrook, who worked with me at my first upstairs gallery in Bond Street, who had got me to take my inaugural flight to America, two years earlier. He had spent five years working for two leading art-dealing firms before he returned to England, and after a spell as a gallery manager in London, he decided to strike out on his own and to share my premises. He dealt in landscapes, I dealt in portraits,

and sitting at adjacent desks in our brave new venture he would reminisce about his transatlantic experiences — both the good and the bad. As a very young gallery assistant he had lived in a shabby apartment on Manhattan's Upper West Side so infested with cockroaches that colonies of them scaled his bedroom walls at night. Occasionally, as they traversed the ceiling, he would awake with a start as gravity caused them to plummet down on his face and body. But he also told me of the artistic excitements, of the auctions, the dealers and the collectors, and above all of the chance to buy and find British pictures that had escaped our shores in the first half of the twentieth century. I had no choice but to go and find out for myself, he said, or opportunities would elude me.

Buoyed by Charles's anecdotes, I made my first trip in 1990, when I was twenty-nine. Arriving at JFK, I had only his instructions as to what to do next, which was to take a taxi to my hotel, the Barbizon, and then go to the five main auction rooms. My immediate experience of New York was of two natives of the Big Apple in a tug of war with the handles of my suitcase, battling like velociraptors over a fresh kill. Having failed to notice the licensed yellow cab stand, I had fallen foul of the touts. Rattled, I rode with the victor, paying twice the expected fare – my introduction to the land of opportunity.

My specialization then – it has since expanded – was British portraits from Tudor times to the present, and I had given my business the solidly descriptive name of Historical Portraits Ltd. Although portraiture was the height of collecting fashion at the beginning of the twentieth century, the Impressionists and contemporary art replaced them as the trophy aspirations from

the 1930s, and American museums, following the trend, had since then been regularly deaccessioning, or selling, old-fashioned British portraits from their holdings, as had private collectors. However, there were still some people who revered interesting portraits, as I did, and to put it crudely they could sometimes be acquired cheaply and sold at a decent margin. So, as a young dealer with very little money, I had the beginnings of an exciting niche. Although to date I had bought only in Britain, where mainstream taste for portraits had similarly waned for all but the best, my business was expanding and I was hungry for new stock.

I established my company on the premise that, with the right research, restoration and marketing, there had to be willing buyers out there, and I had begun two years earlier by offering antique portraits to the sitters' descendants which I had been able to pick up in minor London and country sales. Trade had since grown to include portraits of famous British figures – kings, queens, poets, politicians and writers – as well as works by the more major painters, whose styles I had begun to recognize. The most exhilarating opportunities were when I was able to buy them as sleepers at auction, miscatalogued lots where the artist or sitter had been entirely missed, and there was the potential to re-offer them at another auction, or sell them privately, for a substantial profit.

On my first trip to America I met three people who have remained close friends and trade allies to this day. Peggy Stone from Doyle's Auctioneers was the first. She was in her last few months in the job, having recently decided to join her husband, Larry Steigrad, who that month began to go it alone after working for ten years with Bob Haboldt, a leading old-master dealer in Manhattan. Peggy was intrigued when I asked her to show me all the unsold portraits from the auction house's racks – paintings that had failed to sell at previous auctions – and I ended up buying two in private deals from the unsuccessful vendors the following day.

Peggy wasted no time telephoning her close friend Rachel Kaminsky, who worked at Christie's, to tell her, 'We've got a live one here. He wants all our unsold faces,' and my next meeting was with Rachel in her auction room's storeroom, where I succeeded in buying two more BI's ('bought-ins', or unsold lots). Peggy next told her husband about this mug from London and he invited me over to their apartment. After protracted haggling Larry sold me his first picture as a sole trader: a William Wissing of two children in a landscape. (Gallingly, five years later he told me I could have got it for \$2,000 less had I not buckled first in the negotiations.) Having acquired more pictures in the main public auctions on the Thursday and Friday, at the end of that week I checked in at the airport with twelve hand-carried British portraits, and my love affair with America began.

I also realized that I had competition, although the gratifying outcome was that it paid for my trip while I was still in the States. I had managed to buy for \$2,000 in Christie's East (the then lesser arm of the main auction house) a seventeenth-century French portrait described as being of an unknown man but whom I recognized as Louis XIV. Even though my focus was British, there must be someone in London, I surmised, who would want a portrait of France's 'Sun King'. In my hotel room

the following day I received a message via Christie's to telephone a Mr Jenkins. I assumed it was the wrong number when it was answered by a man who announced himself as 'the sacristan'. He then pointed out it was *Father* Jenkins I wanted, but that he was currently taking confession. An hour later he telephoned.

'I believe you were the buyer of the unknown Frenchman.'
The voice was New York Irish.

'You mean Louis XIV,' I replied.

'OK, so you got there too. Would you take a quick profit? I had left a low bid and was hoping to buy it cheaply. I collect paintings, and he's a subject I admire.'

I sold it to him for \$3,500 and so not only sold my first American sleeper, but made my first American client – and a priest into the bargain.

In those days there was no choice but to go out and see the auctions, dealers and private collections, and while I still make regular trips to the States, so much more evaluation and buying can now be done remotely via digital images. Early in my career catalogue images, particularly when it came to portraits, were often little more than stamp-sized and furthermore my experience at reading authorship and condition from an illustration was nothing like as honed as it is today, given the deeply instructive experience of both failure and success. Our scope has dramatically increased too. Bendor Grosvenor, my researcher, a child of the technical revolution, can sift through hundreds of such items a day. His search engines corral offerings with luxurious ease from across America and the rest of the world, and we now buy anything up to three pictures a week without even seeing them.

In 1992, with limited staff and less technology than now, there was little apparent option but to travel and I found myself going to New York three times a year. Earle Newton, a bolt from the unknown, had found me after a recommendation from another dealer who, knowing of my specialization, had simply passed him on. Hence another voyage across the pond to meet the man. This time it was into entirely uncharted territories.

The Daimler made its steady way down from the pass through a long, flat valley laced with fast streams. I was increasingly weary and, given the antiquity of the car's heating system, by now rather cold as well. Looking at my watch and realizing that I was still on British time, I set the hands back to early evening. We had been on the road for two and a half hours and I was about to ask Earle how much farther it was when I felt the engine slow down.

'Home at last,' said Earle. The headlights shone along a snowy driveway upon a large, white-painted clapboard house adorned with green shutters, with the Stars and Stripes fluttering from the front. The porch door was already opening as I clambered out of the leather seats, to be greeted by a fine-boned lady in her seventies, the orange light of the house's interior shining through her permed blonde hair and outlining her slim body.

'Welcome to Vermont,' she said, offering me her hand. 'I'm Jo, Earle's wife. Come on in. We've been waiting for you.'

She ushered me into a large, low-ceilinged family room and as my eyes became accustomed to the light I noticed at the far end a table formally laid for a Thanksgiving dinner with elegant glasses, tureens and blue china plates. The house was book-filled and warmly embalmed against the elements by its wooden walls. As I sat in an armchair with a cup of tea I felt tranquillized by the heat of the room and by fatigue as twelve hours of travel and the time difference took full effect. Yet I still had enough wits in play to look around and, despite the relief of having arrived at my destination to such a pleasant welcome, I began to be aware that something was not quite right. My unease took a few minutes to form and then grew rapidly into a sticky sense of apprehension.

Every successful art dealer I know has mastered the reflex of surfing the pictures on entering a room. There is nothing particularly predatory in this, just professional survivalism, and as I had crossed the Atlantic to see a substantial art collection I was naturally expecting to encounter evidence of paintings from the outset. But, although the walls were decorated with ornamental prints and framed photographs, and the shelves with numerous ornaments and knick-knacks, there was not an oil painting, or even a frame, in sight. Had I been asked to guess the owners' professions from the interior of their home, apart from noting that they had an interest in reading as there were magazines, paperbacks and large hardback books everywhere, I would have hesitated to describe them as anything more than a modest, middle-class family, perhaps school teachers. Globetrotting art collectors they were not.

I tried to recall what Earle had shown me in that envelope in my gallery. They were definitely oil paintings, originals I remember him telling me. And I recollected studying the images and, despite their blurriness, thinking that they looked like genuine works replete with blemishes and original frames. After all, it was what I did regularly as a dealer in those days, reading through endless catalogues, assessing and judging potential opportunities from rudimentary photographs. Yet it now appeared that there was nothing that would even have passed for an original in the main downstairs room. What, I asked myself, if there were no paintings at all? What if they were no more than photographs or he had borrowed them from elsewhere? Had I just crossed the Atlantic and been drawn into the home of a (with any luck) well-meaning fantasist?

Earle showed me upstairs and along a narrow corridor to my room (again with no paintings) but suggested I come back down shortly for dinner, which, he stated with a touch of ceremony, had been delayed in honour of my arrival. I took my seat at the table and was wondering, in my agitated and exhausted state, how I could rally the appetite to eat, let alone speak at this late hour, when I noticed the extra setting.

'Are we expecting somebody else?' I asked.

'Only our son, Bill,' replied Mrs Newton. A minute or two later the front door opened with a gale of cold air and the chauffeur, minus his hat, took his seat at the end of the table. I suppressed my surprise and noticed him exchange smiles with his mother, which he continued to do throughout the evening. Clearly I had missed something at the introduction stage earlier, I tried to reassure myself. Earle took the seat opposite me and his wife brought in from the kitchen a large turkey and a bowl of sweet potatoes. Clasping her hands in prayer, Mrs Newton then addressed both God and ourselves with words I can clearly recall:

'Dear Lord, thank you for sending Philip to us. Over the next two days we hope there will be surprises and excitements for us all. May he not be disappointed, and may we learn from him.'

My amen could be heard above the others.

I can't remember much of the dinner that night, apart from my first taste of sweet potato, but with Mrs Newton's encouragement I disclosed something of my home life in London as a bachelor, and about my parents and siblings, a subject which seemed to animate her. As well as Bill, she told me, they had a daughter who worked in corporate business in New York. She herself had retired as a primary school teacher ten years earlier but now had an active part in the local church, where she played the organ. Her chatter was affirmatively maternal and I began to find myself reflecting that if this were some sort of setup, she surely could not be any part of it — or must at least be oblivious to it.

Nothing was said of the Newtons' own collecting, however, and when I found a natural moment in the conversation to ask where his pictures were, Earle merely responded by saying that all would be revealed in the morning. All the while I could not help observing Bill at the end of the table, who had cut up the turkey with dextrous strokes but remained largely silent. I fathomed that he lived in one of the upstairs guest rooms and had recently settled at home after finishing a job running, bizarrely, a milking dairy in Riyadh. He now helped his father and mother and made furniture as a hobby. A big-framed man I guessed to be in his mid-forties, he presented a curious figure in the family dynamic. When he took off his cap to reveal a

head of jet-black straight hair I looked across at him and could detect, despite his kindly, rubicund cheeks, an air of preoccupation.

All the while Earle's fixed smile rarely left his face and, realizing that my conversation was slowing, he suggested that I take myself off to bed. He anticipated, he told me, a full day of activity starting early in the morning.

I fell asleep immediately but woke with a start around 4 a.m. and it took me a full ten seconds to work out where I was and then to ask the question: what the hell have I got myself into? Peering out of the window, I could see barely anything except snow and darkness and the looming white shape of another building across the road. I also badly needed to go to the loo. The house was entirely silent except for the slight groan of floorboards as I made my way out of the small bedroom to where I recalled the bathroom was located. Groggily I pushed the door, felt for the light switch, and found that I had walked into an unused bedroom: unused, that is, for sleeping. I stood in front of an impregnable fortress of books, stacked in piles five feet high and covering the whole floor. I had never seen so many concentrated in such a small space, and accompanying this tonnage of ageing tomes was a sweet odour of decaying paper, which somehow seemed all the more pungent when I noticed an ominous water stain on the ceiling. Quietly closing the door, I found the bathroom and then returned to bed.

After dozing considerably longer than I had intended, I came downstairs for breakfast to find the day had already begun for the family. Earle was standing there in a light-blue tweed jacket, a large key in his hand.

'I want you first to meet India, my sister, who lives across the road,' he beamed. 'She's the most interesting woman and has a large collection of books. I know she will enjoy seeing you.'

What is it with this family and books, I pondered as a short while later we crunched out into the snow to meet India. The sun was shining and the glistening morning light began to revive my spirits, not least because I could see we were not as secluded as I thought. Across the road was a white clapboard church, its paintwork somewhat neglected, with a sign on a pole that read 'Museum of the Americas'. A little further down, in the direction in which we were walking, was a trailer with a large, somewhat makeshift extension attached to its rear.

'Are these yours?' I asked as we passed a large barn and garage on the other side of the road. But it was what was parked around the building that I was referring to. There, in varying states of rust and rot, stood twenty or more cars, mostly long-chassis period pieces from the fifties and sixties, including Chryslers and Lincolns like those reconditioned numbers still being driven around Cuba today. There was even a London black cab. Mostly with deflated tyres, they looked like decaying carcasses and nature was fast taking over; one even had a tree growing up through it.

'Yes,' Earle replied.' I collect them. There'll come a day when they are appreciated, but there's nowhere else to store them.'

He rapped on the door of the trailer-house and we were beckoned in by a lady in her seventies seated in an armchair. India had pronounced, linear features and her eyes suggested the same penetrating intelligence as her brother's. Around her neck was a heavy ethnic necklace of semi-precious stones, harmoniously matching the rest of the grotto-like dwelling, which brimmed with Oriental vases, figurines and ornaments. Behind, further into the recesses of her strange home, was a library of scrupulously ordered books to which she guided my eye. She did so with pride, gesturing towards rare and important items among them.

'I'm going to make sure Earle doesn't get his hands on these, else they'll decompose like the rest of them,' she blurted with unexpected fierceness. I turned to her face in search of irony or humour but, apart from a token softening of the extremities of her mouth, saw none.

Earle absorbed the slur, if anything appearing rather proud of his outspoken sister. After asking about her interest in collecting, I gathered she had obtained a degree in librarian-ship – hence the books – and had spent time in the Far East where, as part of a US government programme, she entertained and edified American servicemen. It was there she had started collecting Oriental antiques.

'I never married, though,' she said emphatically, 'because I have never seen a man as smart as I was.'

Earle had clearly been keen to demonstrate the impressive blue-stocking intelligence and connoisseurship of this blood relation; whereas his son he had been content to have drive us in near-silence for well over two hours. Our visit concluded, he promptly led me out of the trailer towards the church with the promise of something of his to see.

The key to the main door did not open at first and he had to go and get help from Bill, who then smartly returned to the house. Earle shuffled around to find the switches, discoursing from the cavernous interior.

'We call this the Museum of the Americas,' he began with pride and a touch of formality, as if this were a practised opening line. 'Our aim is to tell the story of America and how it grew out of its relationship with Britain. Everything from our culture to our legal system evolved from there.'

'Do you get many visitors?' I asked.

'About three or four a month at the weekends. That's when we're open,' he replied from the darkness.

If this was all a great hoax, I reflected, at least it now seemed I had arrived at the denouement. As I stood in the doorway of the church my eyes gradually became accustomed to the low light inside and I began to notice that there were chairs for the faithful - except that, propped against them and on the seats, instead of people, there were square and rectangular shapes. When Earle turned on the overhead lights I was presented with a sight which all these years later is still as fresh as yesterday. There was indeed a congregation: not of people but of seventeenth- and eighteenth-century portraits, close to three hundred in total, not only on the chairs but covering or filling every available hanging space, niche and corner. I walked slowly down the aisle. Works by Reynolds, Lely and Soest hung where the Stations of the Cross once were - it had been a Catholic church - and many others by lesser artists were propped against the perimeter wall, some in stacks. The chancel was double-hung with works by American painters such as Gilbert Stuart and Robert Feke. Everywhere I looked, faces of antiquity, some framed, others just canvases, blinked back as if surprised by the sudden flood of light.

This was not a museum collection, it was a hidden hoard; not least because the way the pictures were stored and hung, many without labels, gave it the look of a glorious stately house sale in which the untouched contents of the attic had been temporarily tipped into the reception rooms on view day. The condition of the paintings added to this impression. Like the cars, many were in various states of decay. Mildew covered the surfaces of a pair of portraits of a seventeenth-century nobleman and his wife which leaned against the wall: a whitish cloud ran from the top edge of each canvas and, like a lace veil, completely covered the features of the man save for his nose, which remained oddly untouched by the fungus. Canvases hung loosely on their stretchers like flapping sails, the prolonged effects of damp, neglect and lack of keys (the wooden pegs that keep a canvas tight) rendering the image unreadable unless angled towards the overhead strip lights. Others had not been cleaned for a century or more, their fresh Anglo-Saxon flesh tones fusing with the discoloured varnish to produce an ethnic hue which artist and sitters alike would have been taken aback to behold.

'Most of these I bought in the late fifties and sixties, when you could pick them up cheaply,' Earle explained. 'Sometimes I'd purchase them at auction, sight unseen, and on one occasion I managed to buy a stack of five for \$100 from a dealer who had bought them for their frames. You see, I'm not a wealthy man. I just did what I could with the means available.'

Propped against the altar, one picture in particular now lured me. It stood out partly because of its quality but also because it did not conform to the politer, better-behaved expressions all around it. An unashamedly porcine image of a middle-aged woman in pink taffeta, she had the unfashionable hint of a smile showing through her bulbous cheeks. Its candour was mesmeric.

'Who is she?' I asked. As I did so I knew that there was only one artist capable of pulling off this feat of originality. A savage satirist of society, he could not rid himself of the very thing that made him so great: an un-lowly but nonetheless compellingly honest response to his sitters. I had never seen this picture before and finding it in a deserted church in Vermont was reason alone for the journey.

'I'm glad you spotted that,' said Earle. 'That was my most expensive portrait from the early days – it cost me \$250. They told me it was by Hogarth. Do you think otherwise?'

'Not at all,' I replied. 'It's astonishing.' I was looking at a picture worth between \$400,000 and \$600,000.

For the rest of the days we went through the portraits one by one – me with my torch assessing them, he writing on his notepad. A large proportion of the paintings Earle had bought for their appearance, without secure knowledge of the artist, and given that this was what I did for a living I had the thrill of christening many of them with attributions. Although there were some very sub-standard works, as you would expect from his shrimp-net style of buying, there were also others, by artists such as Joseph Wright of Derby, George Romney, Jonathan Richardson and Sir Godfrey Kneller, which were entirely authentic, and I had the captivating sensation of taking the lid off a cache of lost heritage, an undisturbed burial site of English and American portraits. As he had been buying mostly in the

1950s and 1960s, when British art was in the extreme doldrums commercially and middle-ranking British portraits could be bought very inexpensively, he had been able to amass a collection of notable diversity and quality. Unless they were by major names like Van Dyck or Gainsborough or Copley - in which case there were people like Paul Mellon coming to the fore who were keen to add them to their more loftily ambitious collections - more obscure portraits, particularly if not obviously decorative, would struggle to find buyers, and at that time there was little incentive or expertise to catalogue them accurately. On frequent trips around America and to London and Europe, Earle had applied the same rationale to this genre of art as he had to other commodities such as cars, books and, as it later emerged, broken-down houses as well: if something was give-away cheap - and that was an abiding qualification - and had some connection to history, art, design or literature, he hoovered it up. On one occasion he noticed a beaten-up period car on the main street of the village and contacted the owner to ask whether he was interested in selling. 'Happily,' he replied. 'Except you already bought it from me a few months ago.' What appeared to elevate his purpose above that of the pathological hoarder was a greater ambition, to which he constantly referred throughout our cataloguing: the desire to bequeath his objects and collections to a teaching institution to help champion the history of his nation and, in particular, its relationship to Britain.

Over dinner that night I learned more. Bill was absent but Jo, retaining a lamp-like family pride and affection at the end of the table, began by telling me how she had met Earle at high school and they were married at the university chapel upon graduation. The man she was hitched to did not keep still: over the next half-century they would live in thirty different locations in pursuit of his career and interests. He, in turn, opened up about his desire to collect, acknowledging that there was a crucial distinction between himself and his wife.

'I collect things, and Jo collects people,' he grinned, enjoying the pithy clarity of his summation.

Earle's love of objects and craft surfaced when he was unusually young, and in an intriguing way. At thirteen he set up his own printing press at his parents' home. Although it remained small-scale, mostly for cards, pamphlets and letterheads, he continued to operate it during the summer vacations while he was studying at Amherst College in Massachusetts, where he came to the notice of the celebrated American poet Robert Frost, who granted him the first opportunity to print his poem 'The Gold Hesperidee' - a great accolade for the earnest young student. Earle's mother, an accomplished artist, illustrated the cover. In time not only did he become a Professor of History at Norwich University in Vermont, but over the next fifty years he held an extraordinary range of cultural posts, including ten directorships of preservation, historical and archival bodies and societies. Teaching history, Earle told me, had always been his calling, and he had been a Fulbright Scholar in the 1950s and attached to both Bristol and London universities in England, where he also picked up a diploma in museum administration.

It had struck me as rather amazing that a man with relatively little money had been able to acquire so much, particularly when I learned that he had managed to buy sixteen houses in America and England as well. His life was a constant mission

and in the past ten years he had been away from home for up to six months a year, his eye forever on property and collecting opportunities. He would find termite-ridden houses in run-down areas that no one would dare touch and slowly refurbish them, lived frugally, abhorred spending money on anything he could avoid, and by occasionally selling and always conservatively investing the proceeds (I later heard he had nineteen bank accounts and twenty-five little funds) he had managed to create the means to indulge his desire to collect. Partly because of his thrift, when it came to paintings and art objects he confined himself to buying things that others for the most part disregarded but which, in his view, would one day be of historical value. By seeking to predict future value rather than responding to present fashions he was able, despite a limited budget, to pursue a wide-ranging buying policy. As I also discovered that night, he was aided in this by a pronounced intellect. Although his delivery was slow and occasionally agedsounding, Earle had a deep knowledge of many subjects, both contemporary and historical, with a quiver of formulated views on any moral issues involved. Above all, he deemed history and its study vital for addressing the problems of the present day, and his collecting was an extension of this.

I spent the next day continuing to document the collection, and every so often Bill would be summoned to photograph a picture or its reverse if it seemed to hold further clues about the artist or the sitter for future research. We had occasional conversations and he led me to the basement to see an impressive piece of craftsmanship, a cabinet that he had designed and made himself. But it was clear from what he said that he did not

have a great interest in his father's collecting eccentricities and he explained that he simply needed to be around to look after the museum, his mother and aunt when his father was away. This, it became apparent, was now his life.

I had arranged to leave the following morning and, before they dropped me off at the coach station for the airport, Earle addressed the subject of my fee for cataloguing the collection — a task that was far from complete but which I had started by making thirty or so new attributions and confirming or deattributing many of the other works.

'I would rather not give you money, but instead would like you to take something,' he said, with what I was now recognizing as characteristic frugality.

That suited me and I began to consider the possibilities. I would happily have taken the Hogarth but somehow felt that he did not have that in mind. Instead he led me to the garage and when we had negotiated our way through the defunct luxury motors he heaved open one of the wooden doors. Inside were more vehicles but they were largely obscured by the incalculable quantity of objects which filled every shelf or were heaped in piles or falling out of over-filled boxes on the floor. At least, I thought, he is not intending to give me a car, but the more I considered the options the less thrilled I became. That same boundless ardour that he had directed towards acquiring his portraits he had also let loose on lesser things. Stuffed animals, dolls, pots and pans, typewriters, giant old commercial photocopiers and large cabinet TVs filled the foreground, while bath tubs, lavatories and shower heads provided the backdrop (these I later gathered were for his houses).

Peering into the box nearest to me I saw unopened pocket calculators, plastic talking parrots and toy cars.

'This is what I thought you might like,' Earle said, dislodging from within the confusion, between two old radios, a small painting. It was an oil sketch of the River Stour in Suffolk, with a streak of crimson sky and flecks of white paint to suggest cattle. I bought it for £12 in an antique shop in Windsor in the seventies. They said it had a chance of being by John Constable but as I don't collect landscapes would you like to take this?'

I scrutinized the strokes and noticed a chilled varnish, partly caused by damp, muting the tones. There were also crease marks running through the canvas, suggesting that at some time in its early life it had been folded to fit in a box or an envelope. It had potential and, looking at the rest of the possible items around me, I spent little time in deliberation.

'Done,' I said.

I felt a little nostalgic as I said goodbye. Jo stood on the porch and made me promise to return, saying she wanted me to meet her daughter too. I then called by the trailer to see India, who expressed similar sentiments and made another joke about the decrepitude of her brother's storage arrangements. Bill emerged from the house, this time without his chauffeur's cap, and once again I clambered into the old Bentley with him and Earle. This strange community with its hidden secrets had rather bewitched me. Later, as he saw me off, Earle said, 'I see all this as an undertaking, and I shall continue to come to London. Please be sure to come back too, as there's still a lot to do.'

I did return, over two years later, but in the meantime back in Bond Street we continued to catalogue the collection from

photographs in the National Portrait Gallery's archives, the Witt Library at the Courtauld Gallery and other repositories of art history indispensable to the rescue of lost information on artists' identities and works. The little landscape turned out to be a genuine Constable, an unknown plein air (outdoor) sketch of the river next to Dedham, the village where he lived and worked. I sold it to an American collector and it amply covered the time we needed to allocate to the project of bringing Earle's collection to life - something which, to my pleasure, I was later to discover bore fruit for his greater purpose. Earle visited me at least three more times at my first-floor gallery in Bond Street and I noticed that he was slower and more infirm on each trip. On his last visit I witnessed him crying. Bill, he told me, was suffering from advanced osteoporosis that was further complicated by liver disease, and although he was receiving the best medical help it seemed he had lost the will to live. Six months later he was dead.

But Earle's age and grief did not impede his indomitable will, and he had even managed to buy another house in England, at Horncastle in Lincolnshire, where he stayed in shabby circumstances for weeks at a time and made day trips around England by coach and train. We even swapped a few pictures. His collection lacked a Gainsborough and I exchanged one for a work by Jonathan Richardson, a fascinating portrait of his virtuosic artist son, likewise named Jonathan Richardson, with his pictures and sculptures around him. It hangs in my house to this day.

We rather lost touch in the last few years of Earle's life, but in 2006 I received an email from his daughter Toni, whom I had still not met, saying that he had died in Florida at his home after six months in a nursing home. I sent my condolences and in reply Toni suggested I visit her and her mother in Florida, where they now lived, to see what had happened to the collection. Totally unknown to me, Earle had gifted it all to the Savannah College of Art and Design in Georgia, together with his books and prints, and now there is a building dedicated to him. So in 2008 I flew to Jacksonville, from where Toni and her (relatively recently acquired) husband, Clark, drove me to the college, where I was able to witness for myself how the shambolic contents of a defunct church had mutated into a part of the national heritage.

It was difficult to comprehend how radically the collection had been elevated. I inhaled deeply as we drew up before the magnificent, nineteenth-century Doric-colonnaded Greek Revival building on Savannah's Martin Luther King Boulevard. Beneath the pedimented façade was a smart circular sign which announced: 'The Earle W. Newton Center for British and American Studies.' Inside, capacious rooms with polished pine floors created the atmosphere of a historical pantheon and, instead of hanging by nails from a tongue-and-groove wall or being stacked haphazardly in piles, the better portraits were mounted loftily beneath elaborate stucco ceilings in a scientifically controlled, museum-compliant environment; they were also labelled, carefully framed, and lit with institutional reverence. Gratifyingly, given their previous state, many of the paintings had been rejuvenated, returned to their former colours and contours by restorers from across America. The college - it claims to be the largest in America for art - had been overjoyed to receive the

collection, which, together with Earle's accompanying endowments, had been valued at getting on for \$9 million. At the inauguration ceremony in 1992, attended by the Consul General as proxy to the Queen, Earle and his family had received a standing ovation and the college's president, Paula Wallace, was suitably humbled by the donor's generosity. She talked of how the collection would give students an opportunity to study works at first hand which 'will enhance academic studies ... inspiring new research and creative endeavours', and the Center had been drawing 12,000 visitors a year since. Earle was also created an OBE (Officer of the Order of the British Empire) by Buckingham Palace for his cultural contribution to the history of Britain.

During the car journey to Savannah I had the opportunity to ask Toni some questions. Her husband drove, she next to him, me sitting on the back seat taking notes, trying to get a sense of how it all had worked. Although I knew Earle had a small amount of money as well as an academic's salary, it was still a mystery how he had accumulated such a bequest and, as it now turned out, had also left ample for his wife, who lived in a luxurious Floridian suburb. I wanted too to know what happened to the rest of his possessions. Toni rolled her powerful blue eyes when I recalled the cars. At the age of sixty she was a strikingly good-looking woman with a tall, statuesque figure, her mother's thick hair (in her case brunette) and vivid strokes of red lipstick that accented her upfront manner. Her recollections of her father were an uncomfortable revelation: a heady combination of genuine affection and unsettling honesty.

At Earle's death, she told me, the automobiles at his various houses had numbered some sixty in all. Some had become half buried under rotting leaves and the branches of trees, others had become infested with rodents, and for the most part they had rusted into the ground. In Vermont the leaking oil from disintegrating engines had begun to pollute the waterway, much to the consternation of local officials. Many of the books had not made it through the intervening decade either. Snow had collected in the roof of the family house, turned to ice, and when it melted it burst through the ceiling of the book-filled bedroom I had stumbled on that first night in Vermont, reducing most of them to pulp. When I asked about the houses, the story was similarly grim. Earle had rarely if ever finished a project before he was onto the next, and many of them stood around in dour states of decay or unresolved restoration, their roofs leaking and timbers collapsed.

'He was an amazing man, my dad,' said Toni. 'What he achieved was outstanding. I was captivated by everything he managed to attain. But he had his eccentricities.' The more I heard about these foibles, the greater the price, I realized, not he but his family had had to pay for the great cultural legacy to Savannah.

Earle was so blighted by parsimony that on occasion he had left the family almost destitute. Although I had gathered he was a man who abhorred overspending, I had not appreciated the extent of his aversion. She began by telling me about the little things — how he would always try to pay at pharmacies or restaurants with coupons which he avidly collected, presenting them even if they were out of date and scratching his head to feign ignorance when challenged. He rarely if ever tipped, once returning to the table to remove money that another family

member had left. At buffets he would trouser food and Jo would find pieces of pie and cookies in his pockets. What was more serious, however, was that he would avoid paying bills whenever he could get away with it, absenting himself not just when it came to settling up for a meal, but also when suppliers and builders came to the house. He was forever asking, 'Wherever shall we get the money from?' and when he took off on his sixmonth odysseys (only telling Jo a few days beforehand when he decided to return) he would never leave money to cover the family's needs. Jo would avoid answering the door in case it was a creditor or, even more alarmingly, an estate agent whom Earle had instructed to sell the house. Other times it would be someone seeking her husband after he had backed into their car or boat and then driven away.

'He didn't praise us as children,' said Toni. 'He only admired those who shared what he felt was his higher purpose, reserving encouragement for the occasions when we walked upon the road he had chosen.' It was a route neither child felt inclined or able to take.

Toni escaped to New York as a teenager to became a go-go dancer. She then set up a restaurant with her brother in St Augustine, Florida (Bill was apparently an excellent cook), where her speciality was to perform flamenco. Briefly married and then divorced, she later took up employment with IBM, becoming a financial operations manager, a job from which she had recently taken early retirement. She told me that she 'woke up and smelled the coffee' while still young and so managed to avoid being drawn into the 'relentless stress' of home life.

Bill was a different story. 'He wanted to protect my mother,' Toni explained. 'She had such a tough time when Dad was away. Despite her unqualified love for my father, and he for her, it was very difficult for her to get along alone. Mother also had to explain at the local church why her husband was always absent – although often not knowing where he was – and that hurt her too.'

'And what happened to Bill?' I asked. I'd never deduced what had destroyed him, but I was now beginning to suspect the underlying cause.

'Bill was not my father – he had other talents, he was such a kind, gifted and gentle man and I loved him dearly, but he never got encouragement from my father and he so badly needed his endorsement. That, combined with the terrible stress of coping at home with the absences, protecting my mother and the money issues, wore him down.'

'Did you see Bill before he died?' I asked, although I felt I was intruding further than was comfortable for both of us. Toni's face was turned from me, and after a few seconds she looked back from the front seat, emotion surfacing through her customary composure.

'Yes, Bill came to live with me in Florida while he was being nursed. Referring to the crushing home responsibilities, there's one thing he told me that I shall never forget. He said it would be "my turn next".'

Toni also spent the last six months of Earle's life nursing her father. Earle was too ill to travel and she used the time to get to know him better, recalling a turning point in the last few weeks when he told her, with salvationary simplicity, that she was 'all right now' – as if he now rated her value along with that of his other possessions. Toni now lives with her husband and her mother in Florida.

'Was it worth the price you had to pay?' I asked as we drove back to the airport.

Toni could not answer this easily. The death of a beloved brother and the stress her mother had to endure hardly made it a fair question either. She conceded that she understood why her father had done what he had, but could not go as far as condoning it. A day later I received an email. Attached was a poem by Earle's mentor as a student, Robert Frost, and she felt that the last verse was the closest thing to justifying his 'higher purpose':

The woods are lovely, dark and deep.

But I have promises to keep,

And miles to go before I sleep,

And miles to go before I sleep.

READING THE STROKES

A number of the lots from the Los Angeles art sale looked grimly familiar. Call it trade snobbery or self-preservation, but when a portrait that has previously failed to sell returns to the saleroom it starts to look sickly in the eyes of the art trade. And it does not just happen to the faces. As if sapped of their self-esteem, otherwise noble still lifes start to decompose, religious pictures go gloomy, and even upbeat, sunny landscapes will turn overcast.

Fresh pictures with a new story to tell, on the other hand, hum with seductive appeal. And one of them had just beckoned me. It was November 2006 and I had been flipping through an unopened sale catalogue on Bendor's desk and just come across a small colour illustration of a rustic woodland scene with figures. Catalogued 'Follower of Salomon van Ruisdael', it had an estimate of \$2,000–\$3,000.

'Follower' is a bit of a catch-all term used by auction houses to describe a normally later artist, of usually lesser ability, who follows the style of another. Ruisdael was an artist worth following. Something of a celebrity of the seventeenth-century Dutch landscape scene, together with a group of distinguished contemporaries he was esteemed for his picturesque, well-organized landscapes of trees, tranquil waters and grey-blue skies that touched the sensibilities of the Dutch bourgeoisie. So ideally conceived and constructed were Ruisdael's compositions that he continued in vogue long after his death, giving rise to a group of English followers eager to satisfy their more sophisticated patrons with a touch of continental class.

But this was no normal imitator of the Dutch master. Everything about the illustration triggered positive feelings of familiarity. The composition hit me first. The weaving row of oaks, ashes and beeches, the pool of dark water and the pair of pick-axe-wielding labourers followed choreography I had seen before but in a different mood. So did the foliage — a melody of light and dark greens held together with a wiry, serpentine mesh of upper branches. Artists who regularly need to create large areas of greenery in landscapes will often develop shorthand, and the fluent strokes and stipples that shaped these woodland trees was instantly recognizable. Great artists are also risk-takers; they constantly push the boundaries of illusion, like ambitious magicians. The painter of this wood knew that in certain lights the trunks of beech trees can shine like white metal, reflecting rather than absorbing light.

OK, I thought, relax for a moment. Although this had the first look of a master's work, why not a good copyist instead? For a few facile tricks is often all it takes to lure the optimistic. All too often I had been drawn towards the rocks by these

sirens, and had had countless catalogue and desktop dreams thwarted – mercifully usually before, but occasionally, and most painfully and memorably, after I had committed financially.

I took a deep breath and gazed again at the little image, this time employing as much jaundiced experience as I could muster. Come on, I told myself, get robust, seek out the weaknesses, signs of clumsiness, passages of crudeness or deadness; check the figures for their solidity and weight – anything to stop my excitement from dissolving into fantasy. But this exercise only succeeded in achieving the reverse: it allowed me to spot another artistic ruse, more subtle than the shining bark. It consisted of a flashing stroke of creamy-orange pigment on the trunk of an ageing, possibly dying, oak tree, a few centimetres from the exact centre of the composition. Ostensibly a shaft of sunlight, or freak reflection, it fluoresced like a small swarm of fireflies and lit the orange-browns of the turning leaves above. It was an artistic trick to enliven the glade.

I had found enough sleepers in my life to ration my emotions, but what now affected my breathing was not just the artist, but the subject. Anecdotes relating to a painter's child-hood began to flicker. As art dealers we are often asked what mental processes are brought to bear in recognizing a lost or miscatalogued painting: sometimes the trick is as easy as turning over the right card in a game of pelmanism – unambiguous and satisfyingly instant. On other occasions memories shoot through the dark like distress signals, barely long enough to allow their trajectory to be fixed. This beguiling image was a combination of both. I recognized the artist and the subject, but what was so extraordinary to me at that moment was that

this picture existed at all. Where had it been? How could it have missed the sweep of 100 years of art history?

I dropped the catalogue in front of Bendor.

'You see this little Dutch landscape. Doesn't it remind you of something?' I asked.

Adjusting his glasses, Bendor leaned forward. It took him only a few seconds to realize that he was surveying the familiar contours of *Cornard Wood*.

Thomas (known as Tom) Gainsborough was brought up among the clatter of a huge family. Although early biographical accounts can be contradictory, it appears he was the youngest of four boys; he also had five sisters, and the half-timbered house where he was born in Sudbury, Suffolk, in 1723 would have been filled with as much noise as in its previous incarnation as a coaching inn. How great an influence Tom's father was upon England's first great Romantic painter is difficult to measure, but from the account of one biographer he certainly cut a dash. A clothier by trade, he was notably tall, wore his hair carefully parted, and was remarkable for the whiteness and regularity of his teeth in an age when many other people's were rotting stumps. He wore a sword in the foppish eighteenthcentury manner, and although not recorded as dextrous with a brush, did have a reputation as a mean two-handed fencer. Tom's mother Mary, née Burroughs, was the sister of a clergyman school teacher and was both cultivated and artistically accomplished. Although none of her works has been rediscovered, she is known to have been a painter of flowers and still lifes, and Tom would have been brought up with the smell of

turpentine and the sight of his mother amid paint brushes, fruit and petals; she also actively encouraged his art from an early age. His mother's spirit seems to surface in some of Tom's early portraits, some of which include poetically observed English flora, worn, discarded or placed in the background and testifying to a notably independent sensitivity to the aesthetic impact of wild flowers.

Evocative glimpses of the child prodigy can be gained from early reminiscences. Tom attended the local grammar school, where his mother's brother, Humphrey, was headmaster. Clearly not a conventional academic. Tom demonstrated his natural leanings by adorning the covers of his exercise books with sketches and caricatures that went down so well with some of his school mates that they commissioned him to do the same for theirs in return for them doing his academic exercises. Matters came to a head, however, when he used his artistic skills to forge a note from his father to his uncle, the headmaster, saying, 'Give Tom a holiday.' Initially the forgery worked a treat and he managed to spend the day wandering around with his pencil, sketching scenes and details in the surrounding countryside. Later that day Tom's uncle uncovered the ruse and reported it at once to his father. That evening an extremely distressed John, the businessman in him having a particular horror of forgery, confronted his son, exclaiming that he would one day be hanged for such reprobate behaviour. When the boy responded by laying out the sketches, his father's temper changed, he forgave all, and in a mood of elation declared, 'Tom will be a genius.'

In England up until this date there were three main styles from which a landscape painter could make a living: topographical, which meant delineating a customer's house and land with a portrait painter's precision, possibly even including the occupants themselves as miniature portraits, sometimes on horses or in a coach; classical, for the cosmopolitan Grand Tourist who liked Greek and Roman arcadia, and a flash of toga beneath the trees; and mid-seventeenth-century Dutch, particularly favoured by the Suffolk business class, who liked their landscape pruned and raked, removed of its menace and conforming to mercantile notions of good order.

Although the young Gainsborough almost always incorporated figures into landscapes, he was not interested in experimenting with classicism at this stage in his life. He was also no jobbing topographer, and although the Dutch and continental painters provided his compositions with a sometimes formulaic structural template, the most impressive imprint on his work was nature itself. The countryside he recorded as a young man either as stand-alone landscape or the setting for his portraits is arrestingly fresh and natural, full of breezy observation to lift the spirit. Stems of corn and barley don't unbendingly stand, they sway; sandy banks, rocks and pools of light riddle the woodland with a naturalist's observation; clouds don't loiter, they scud; the larger trees in particular are animate and expressive each a separate biography testifying to the artist's deep attachment to a natural rather than a contrived beauty. In his intuitive records of rural Suffolk, the young Gainsborough demonstrated the skills and feelings of an early Romantic poet.

Response on its own was not enough to communicate this, however, and to impart his highly tuned insight he perfected a magical skill rarely practised with such distinction in

England since the death of Van Dyck a century earlier. The process of glazing was highly challenging. It required artists to judge and anticipate the effect of one colour glowing through another. An oil painting on canvas or panel requires a base of underpaint before the artist can embark upon the work. This normally acts as little more than an appropriate surface upon which to receive the brush strokes, although it will provide warmth and body to the final paint layers. The consummate glazer, however, allows underpaint (in Gainsborough's case it could vary from orange to pinky-beige) to partly shine through. Gainsborough's top pigments tended towards transparency, sometimes with unusual added ingredients like ground glass, increasing the possibilities for the depth, mood and refinement that glazing can achieve. When Gainsborough was presented for the first time with a fiddle it is documented that he became professionally proficient on it in days: the most potent way of expressing his particular brand of suffusing one tone through another is to liken it to the complexity of eighteenth-century musical harmony.

Around the age of fourteen, after his talents were recognized, Tom left Sudbury for long spells in London, entering an apprenticeship with Hubert Gravelot, a decorative painter and designer of European stature, and later studying with the leading portrait and genre painter Francis Hayman. He rapidly developed his art, thirstily absorbing the opportunities of a cosmopolitan city. In his early twenties, after returning to East Anglia to live and work in Ipswich, he launched himself upon the city of Bath, where society congregated to take the waters, parade, cross-pollinate and be painted. Within a few years he was the most successful

portrait painter in England, sharing the honour with his near-contemporary Sir Joshua Reynolds. Landscape remained his first love, however, and one painting above all others, which he completed in 1748 while living and working in Ipswich before settling in Bath, monumentalized this proclivity. Looking back on its extraordinary commercial success, Gainsborough noted towards the end of his life that the work had passed through the hands of twenty dealers, and at one point in this feverish cycle he had bought it back himself, for nineteen guineas. Appropriately, it now hangs in the National Gallery, where it can be admired in the context of some of Europe's greatest masterpieces, demonstrating just how proficient the boy from Sudbury had become by around twenty years of age.

It is a large canvas, around 120 centimetres (4 feet) high and 150 centimetres (5 feet) across, and although Gainsborough self-deprecatingly described it as not one of his 'riper performances' and having 'little idea of composition', it is a ravishing panorama of detail and atmosphere. The subject portrayed is a wood, its glades and clearings scattered with little incidents. A rustic is digging marl and making eyes at his seated female lover; another figure gathers wood; ducks are lifting from the water, a pair of donkeys exchange companionable looks, and, as an escape for the eye, through the centre of the wood runs a path at the end of which, in the dim distance, and towards which a traveller is walking, can be seen the spire of a church. The picture's scale, detail and expansive composition, combined with Gainsborough's relish for the recording of trees, make it one of the rustic masterpieces of the National Gallery, a painting never out of fashion, illustrated, referred to and studied

since it first left the artist's studio over 250 years earlier. It has two names. One is *Gainsborough's Forest*, as befitted the artist's momentous artistic achievement, but latterly it also came to be known by its location. This is a dense patch of wood in a neighbouring parish a few miles from the artist's boyhood home, a walk of less than an hour culminating in a long and gentle slope. In Gainsborough's day it was common land where villagers could freely graze their cattle, forage for firewood and walk. Its name is Cornard Wood.

It was three days before the sale and I woke up with thoughts of Cornard Wood pulsating through my head. The previous evening Bendor and I had taken a closer look at the picture on his screen (most auction houses post their pictures online) and although I had not been able to determine its condition, we were now as convinced as we could be of two things: it was an early work by Thomas Gainsborough – how early was difficult to establish at this stage – and, although more than half the size of the National Gallery picture, with less figures, detail and drama, it was definitely of Cornard Wood. Although the composition was narrower, lacking trees and a slope on the left, it was also undoubtedly painted from the same viewpoint.

Remarkably, the emergence of this new image suggested that the National Gallery's monument of English landscape painting was not unique, that Gainsborough, either before or after he had painted his early masterpiece, had painted this. That was thrilling in itself, but it raised the burning questions of why and when. Hard-bitten experience has shown me that you also need a cogent argument to launch a new claim, particularly

when dealing with the big names, and if we were going to represent this to the art world as a newly discovered Gainsborough it had to be understood and placed within the context of an artist's development. Find the missing pieces and we had the potential to turn an anonymous Dutch landscape, five thousand miles from home in Los Angeles, into a footnote of British landscape history.

On this type of occasion the day's agenda sets itself. Bendor dropped everything to read all published material on the picture, in particular anything that might include a reference to another painting of the same title. Given the picture's celebrity, the task would be substantial. In the meantime I cancelled appointments and headed off in search of an extremely scarce memoir of Gainsborough. It had been hurriedly written shortly after he died in 1789 and, although created for the author's personal advancement and to back up an implausible claim that he had discovered the artist, it was known to include some valuable fragmentary remarks about Gainsborough's early work.

The author, Philip Thicknesse, went from being an apothecary to a marine lieutenant in Jamaica, where he engaged in warfare with escaped slaves. He was malevolent and argumentative, once even imprisoned for libelling an army colonel, and in 1754 achieved respectability by purchasing the post of Lieutenant-Governor of Landguard Fort at Felixstowe, a day's walk from where Gainsborough was based in Ipswich. For rare books such as this the National Art Library – the country's greatest collection of art books – is one of the few places you can be sure to find a copy.

Having long been assisted by professional researchers, the last time I had visited the library was ten years earlier and I had forgotten the excitement that even inanimate buildings can engender when quarry has been scented, the chase has begun, and there is the prospect of finding transformative answers in books and records. This great resource is located on the first floor of the Victoria and Albert Museum in South Kensington, and as I scaled the imposing granite steps at 10 a.m. I felt a touch of adrenaline. At the same time I could not help but be encouraged by the row of sculpted artistic worthies along the façade, among whom, palette in hand, was Thomas Gainsborough himself, stonily oblivious to my quest on his behalf.

The library's main reading room is cavernous, its lofty walls of red spines and mahogany shelves dully lit by discoloured overhead roof lights. It is an academic cathedral of leather, cloth and polished wood of a type that is found (on a much smaller scale) in ancient London clubs. Halfway up the walls runs a continuous wrought-iron gallery; a level below a series of bronze and terracotta busts of historical luminaries gaze out across the readers, who are silently seated in numbered compartments along a chain of joined mahogany writing desks. Most of the readers around me looked young, casual and student-like, acolytes of the world of academic art history to which I myself had belonged at university, and it reminded me how big an industry art history has become. The innumerable articles, books, lectures, theses and doctorates testify to this, and every time a piece of scholarship is procreated, a new or known artist's work is emphasized or further classified. When this essence is fed into the thinking of museums and collectors it

can create market demand. It is also pivotal to the process of sleuthing works of art. As a painting can only be deemed lost if it is seen as worth missing, the process of making discoveries is reliant upon this alchemy of academia: it establishes status, provides evidence and underpins value.

A young librarian standing behind the central desk showed me how to complete the form, and when it came to filling in the book title he looked up.

'Funny that, for a rare book,' he said. 'You're the second person this week to ask for it.'

Here we go, I thought with a silent groan.

Often the only way you know that others are onto a sleeper is the evidence of activities similar to your own. I could recall with pained lucidity the occasion a rare sculpture purportedly from Westminster Hall came up in a country sale with barely a day's lead time. I asked my researcher to go to the London Library to seek out any books on the subject. Half an hour later he telephoned me from the library in dismay: the shelf was bare – all relevant titles had been loaned out the previous day to another member. It left us flailing in the dark, powerless to bid when the work was offered for sale the next morning. Business paranoia now returning, why, I asked myself, had someone else asked for so obscure a book on Gainsborough only a few days earlier? The librarian, whom I pressed on the subject, could not or would not tell me any more.

I was directed to the invigilation area, a segregated zone for the library's bibliographic treasures where the seated invigilator – on this shift it was a middle-aged female librarian with pendulous glasses – has the task of watching over the readers of the more valuable books. As books are stored outside the library I was aware that I had forty-five minutes to wait under her owl gaze and used the time to respond to emails on my BlackBerry.

One message was from Bendor. He had gone off to both the London Library and the Witt Library to research further, but said he had dropped some books on my desk. 'Read the letter from Gainsborough,' he added as a rather gnomic sign-off. Another email had come in the previous evening from the auction house, who at our request had promptly sent some close-up digital images of the picture, a standard service provided by most auction houses to prospective bidders. However, the speed with which they had supplied them suggested to me that we were not the first to ask, which added to my unease. The images were too small to usefully download from my small screen, and I would have to wait until I was back before our gallery screens.

Almost an hour had passed when the book was placed before me. Smaller and thinner than I expected, it was bound in the library's standard red cloth and it immediately struck me how well suited this natty publication was to being pressed into the hands of targeted acquaintances –Thicknesse's quick-fix social passport to cultural distinction in late-eighteenth-century society. I gingerly turned back the crisp, laid-paper title page, wondering who had been here so recently. The type was bold and old-fashioned, with S's in the form of F's, and it took a few minutes to calibrate the punctuation and style. I decided to leave the opening section till last, and began by attempting to speed-read the other four-fifths of the book, but after ten minutes I found myself mired in Georgian verbiage, much of it concerning Gainsborough's reluctance to get round

to painting his portrait, while the rest was tiresomely selfserving, the author's transparent attempt to go down in history as a noble benefactor and patron of the artist.

I turned to the beginning and after a few pages I was rewarded with a sentence that bolted off the page. The words, which I had seen quoted in abridged form in later biographies, referred to Gainsborough's defining love for his home surroundings. But seeing them now in their entirety, enshrined in Thicknesse's memoir, I realized they were describing something more significant — what could be called Gainsborough's photographic memory for nature:

'Though he had no idea of becoming a painter then, yet there was not a picturesque clump of trees, nor even a single tree of beauty no, nor hedgerow, stone, or post, at the corner of lanes, for some miles around the place of his nativity, that he had not so perfectly in his mind's eye, that had he known he could use a pencil, he could have perfectly delineated.'

Needless to say, the lines were in conjunction with something that showed Thicknesse in a favourable light — a group of drawings, many of them of trees, which Gainsborough had executed in later boyhood and which Thicknesse had had the implicit judgement and good taste to buy from him. The author described them as jottings from nature done on 'slips of paper' and 'old dirty letters', and they immediately put me in mind of the sketches that Gainsborough might have done that day he played truant. Among them was what Thicknesse described as Gainsborough's 'first effort', which he esteemed beyond the others: 'The first effort . . . is a group of trees now in my possession and they are such as would not be unworthy of a place at

this day in one of his best landscapes ... lots of other tree sketches too.'

I scribbled the quotations down and continued to trawl for further references, but there was little else to garner from the author's account of Gainsborough's very early days, which concluded with how he went 'very young' to London. Although there had been no dramatic revelations, it had got me thinking and as I made my way out of the museum - hardly registering half a millennium of some of the finest European sculpture en route to the doors - I continued to reflect on the artist's remarkable productivity as a child. One thing was clearer. According to Thicknesse, a decade or so before he painted Cornard Wood Gainsborough had harboured an intense interest in the picturesque possibilities of trees which he had obviously encountered in abundance either 'singly' or in 'groups' or 'clumps' around Sudbury. Seen another way, the artistic thought process which culminated in his great landscape at the age of around twenty had begun when he was almost a youngster.

Our own library began thirty years ago when I bought my first dictionary of artists – an art dealer's stock in trade – while I was dealing between Liverpool and Chester shortly before I left for university, and since then it has grown piecemeal, biographies, catalogues raisonnés and exhibition catalogues together forming a fit-for-purpose engine room of business. Most simple questions can be answered with a quick flick through our publications on British portrait and landscape (some of them now worn and grubby with frenetic use), the subjects which are the gallery's main, but far from sole, focus. The library also doubles up as Bendor's office, and given that he initially

organized the shelving when we moved in a year earlier, and did so partly to suit his own working methods as well as his own height – he is 1.93 metres (6 feet 4 inches) tall – I pretty soon accepted the futility of trying to find books in there on my own.

Which was why I was so pleased to find deposited on my desk the book I had intended to go to next. Entitled *The Letters of Thomas Gainsborough*, it was the last work of scholarship on the artist by Dr John Hayes. John, who had died a year earlier at the age of seventy-three, I counted as a friend. We had had many lunches together at the Arts Club and the Garrick Club, and Gainsborough was always on the agenda. John had written copiously on his beloved artist, including a formidable two-volume work on all his landscape paintings, becoming in the process as good an authority on a single historical figure as a biographer can be. He had served as Director of both the Museum of London and the National Portrait Gallery, and during his retirement continued to curate international exhibitions on Gainsborough with punctilious scholarship.

The book in question was a compilation of 147 letters and documents in the artist's own hand, starting from his early twenties, and as editor John had added throughout the text biography, insight, and in some cases Gainsborough portraits of the recipients. As I sat down at my desk to read the letter that Bendor had marked with a yellow sticker, I had a momentary tinge of sadness that John was not around to collaborate with me at this exciting moment. He had been invaluable a year earlier when I discovered a missing version of Gainsborough's *The Cottage Door* in a New York sale, and he liked nothing

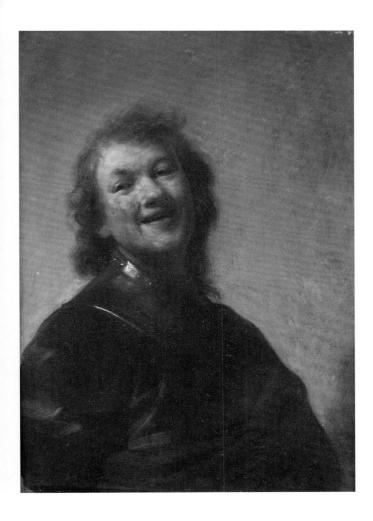

Rembrandt van Rijn (1606–69)

Rembrandt Laughing

Oil on copper, 23.75 × 17 centimetres (9.35 × 6.69 inches)

© Moore Allen & Innocent

Catalogued as being just by a follower of the great artist, and estimated at a mere £1,000—£2,000, this small painting caused a sensation when it sold for £2.6 million in a provincial sale in October 2007 and was later authenticated as a lost Rembrandt, despite the fact that the auction house had themselves taken steps to try to prove this before the sale. As this book goes to press in spring 2009 the painting has resurfaced in the art press in relation to a proposed export licence (essential for major works of old art leaving the UK) at a valuation rumoured to be around £20 million.

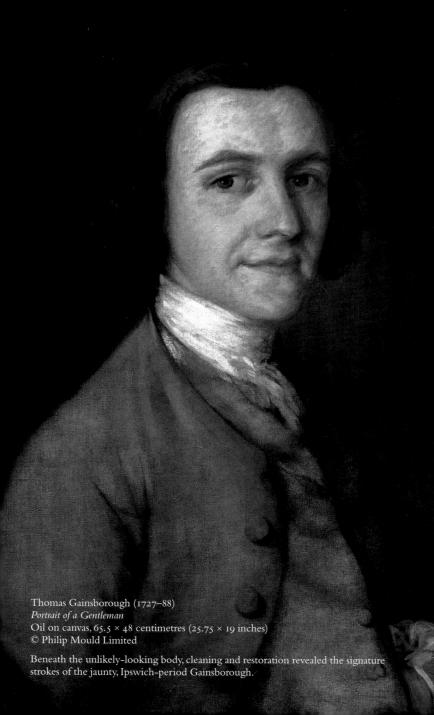

Thomas Gainsborough (1727–88), *Portrait of a Gentleman*Oil on canvas
65.5 × 48 centimetres (25.75 × 19 inches)
© Philip Mould Limited

Before restoration, this painting appeared on eBay without being recognized as the work of Gainsborough. For all the distinction of the head, the overpainted body was ludicrously solid, giving the portrait the overall appearance of a pub sign. Consequently it sold for less than \$200.

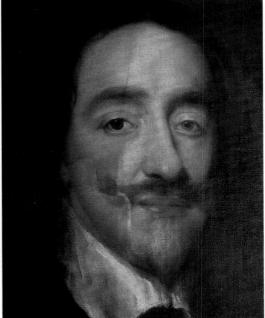

William Dobson (1611–46), Portrait of King Charles I (detail) Oil on canvas, 48.3×39.4 centimetres (19 × 15.5 inches) © Philip Mould Limited

Taken in the middle of the cleaning process, this photograph demonstrates how dirty, ingrained, varnish can disguise the defining subtleties of an original work. So obscuring was the varnish layer here that a subtly distinguished original work by the artist was described by the auction house as a copy.

Titian (1485–1576), Noli me Tangere (detail) Oil on canvas 110.5×91.9 centimetres $(43.5 \times 36.18$ inches) © National Gallery, London

A good example of how pentiments can disfigure and disguise. It is possible with the naked eye to read, on the outer edge of the nose, the pentiment, or artist's first idea, for positioning the nose, which has become visible over time. This was misunderstood during later restorations and inappropriately 'incorporated' by restorers (when it should have been knocked back), giving the Magdalene a Grecian nose.

Francis Hayman (1707/8–76) Self Portrait with Wife Oil on canvas Left side: 39.4×31.7 centimetres (15.5 × 12.5 inches) Right side: 62.2×43.2 centimetres (24.5 × 17 inches) © Philip Mould Limited and Exeter Museum

Research and deduction led to the conclusion that the portrait of the lady on the right, which came up unrecognized in an American saleroom in 2006, was in fact part of a double portrait of the artist and his estranged first wife, as evidenced by the portrait on the left. At some point in its history the painting had been cut down the middle and the couple had gone their different ways, Mrs Hayman to America. They are now reunited for eternity in Exeter Museum, in their native England.

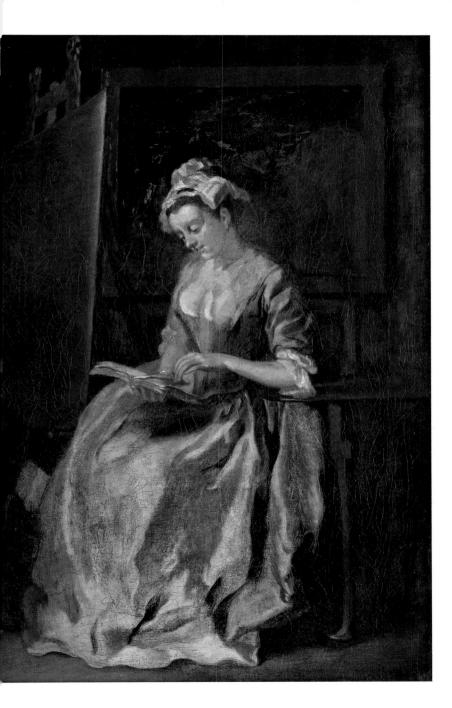

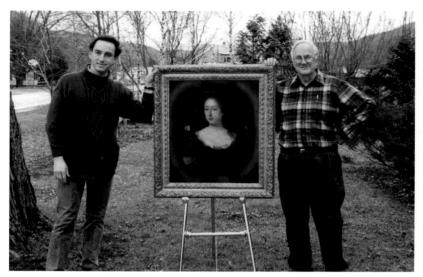

Museum of the Americas © The Newton Family

The author and Earle Newton in 1992 with one of the hundreds of portraits – this one is attributed to John Riley – that, to my bemusement, he had stashed away in a disused church in rural Vermont. The astonishingly large collection I encountered that day in Newton's 'Museum of the Americas' has since been fully catalogued and is now on display at the Savannah College of Art and Design in Savannah, Georgia.

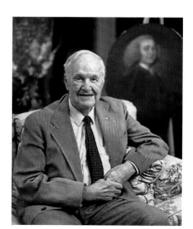

Unique benefactor © Savannah College of Art and Design

Professor Earle W. Newton, philanthropist, collector, indiscriminate hoarder and distinguished academic, inexhaustibly devoted his life to accumulating a body of paintings that would become a legacy for the teaching of art history. Here he is seated before a Gainsborough portrait in his collection.

A rural portrait gallery © Philip Mould Limited

Tucked away in a village in Vermont, this simple wooden church housed Earle Newton's breathtaking cache of British and American portraits.

Voyage of discovery © Philip Mould Limited

In this characterful if rather forlorn Bentley, Earle Newton, chauffeured by his son Bill, picked me up at the airport and took me on a journey that ended in a hidden treasure house of art.

William Hogarth (1697–1764), Lady in Rose Taffeta © SCAD Museum of Art, Savannah, Georgia, USA

By far the most important and valuable painting in Earle Newton's unusual gallery, this masterly work by England's greatest portrait painter of the period had been picked up by the collector for just \$250 thirty or so years earlier. Encountering this picture alone justified my transatlantic pilgrimage.

Banksy, Rude Lord Oil on canvas 88.6×76.8 centimetres (34.9 \times 30.2 inches) © Pest Control

A startling illustration of how an old work of art can be transformed in value by the intervention of contemporary artistic celebrity. This eighteenth-century portrait by Thomas Beach that failed to raise $\pounds_{2,000}$ was, two years later and at the same auction house, turned into a $\pounds_{320,000}$ work of modern art after Banksy added a hand and middle finger.

better than anointing a new work even when it meant revising his earlier writing – an openness not shared by all art historians. This new contender would have captivated him.

Bendor had drawn a bold blue arrow on the sticker pointing to letter number 104, dated 11 March 1788. It was written by Gainsborough the year he died and addressed to the Reverend Henry Bate Dudley, proprietor and editor of the Morning Herald. He was responding to interest about the circumstances of painting Cornard Wood (although writing forty years after he had painted it) but the most startling line, and the one where Bendor's arrow point fell, was the following: 'this picture [Cornard Wood] was actually painted in Sudbury, in the year 1748: it was begun before I left school; – and was the means of my father sending me to London.'

I knew there had been academic conjecture on the exact date that *Cornard Wood* had been painted, partly (and this I had forgotten) because of a rogue line – the one I had just read – by the 60-year-old artist looking back to his youth. Although Gainsborough had clearly recalled the execution date as 1748, therein lay a problem: in the same sentence he contradicted himself by saying that it 'was begun before I left school' and was 'the means of my father sending me to London'. As it is generally accepted that he left school for London at the age of around fourteen it implied – bizarrely – that it took five years to paint. Furthermore, on the basis of style, *Cornard Wood* belongs to a group of works that he painted in the late 1740s – breezy, silvery and slightly French in spirit.

That evening Bendor and I sat adhered to his superior screen, his cursor hovering over every centimetre of the image,

zooming in on details. The amount of ink that has been expended on the subject of Gainsborough's landscapes meant that he had been book-bound for most of the day and only now had been able to apprise me of his findings. As we digitally luxuriated in the picture I began to weigh the options and muddle through the scenarios.

It was of course possible that Gainsborough's memory was playing tricks, that he had confused his dates and the whole picture was executed in 1748 – he was, after all, recollecting an event that had happened at least forty years earlier and he might just have forgotten. But the letter sounded too precise for this and there was also no evidence that Gainsborough's mind was slipping at this date. So I then tried taking the words literally, devoid of any interpretation: how about if the picture had indeed taken five years to paint - that he had perhaps acquired the canvas as a child at school, mapped out the composition, and then gradually completed it over the next half decade? But I did not like this either, partly because it would have been most unusual for a schoolboy to paint a canvas 150 centimetres (5 feet) wide but also, more persuasively, because the picture had been analysed by the National Gallery and there was no signs of it having been painted in stages (with analysis and testing it is not overly complicated to determine if a painting has had a protracted evolution). For a work of this size to have taken over five years it would have been inconceivable for it not to have been painted in interludes, each new layer, addition or campaign overlaying, or at least partly overlapping, an earlier one. The National Gallery's prodigiously equipped conservation department would have been quick to

detect these different campaigns had they been present. It also occurred to me that if the painting was the 'means of my father sending me to London', it would have to have had impact – therefore have been at least largely completed at his departing age of around fourteen.

I then turned to the most convincing hypothesis of all, and for different reasons the National Gallery's curators had gone some way to proposing it themselves. Bendor had copied down their label beneath the painting in which they had suggested - no doubt with Gainsborough's letter in mind - that Cornard Wood may have been based on earlier sketches. I let this thought percolate for a few minutes, allowing the variant implications to suggest themselves. The Gallery seemed to be raising the idea that 'began' referred not to the moment he embarked on the big canvas but the moment he started thinking and working towards the idea. In the light of what I had been reading this sounded entirely plausible. Were not Thicknesse's juvenile sketches exactly the sort of artwork that might have erupted from this process of thinking? But if this were the case, I then considered, why not take this idea one stage further? For the work to have been sufficiently impressive for it to become the means – financial or otherwise – by which the Sudbury boy orbited onto the London scene it was likely to be more than mere sketches. A far more probable scenario surely was that young Tom had done something dramatically indicative of his genius to have brought about this change of fortune, and if this were the case, why should he not have employed a skill which we are led to believe he had been taught by his mother at a young age? Why could he not have produced an oil painting, a work of startling precocity that became not just his passport to London but the first stage towards his rural masterpiece?

When you buy a painting at auction from abroad it takes four weeks or more for the moment of revelation when, as the picture is unscrewed from the crate or cut from its bubblewrap, the truth is fully revealed beneath the ruthless realism of gallery lighting.

Deciding what to pay for a painting that you have not seen in the flesh is a perilous business, but one we have become increasingly used to, as well as the emotions. Looking back over the past three years of computer-screen art buying I would estimate a statistical hit rate of seven out of eight. A hit is something commercially resaleable, ranging from a major sleeper which can return a great multiple of the purchase price - to the close shave, which is basically a disappointment, but one on which, by judicious placing in another auction, we can probably get our money back. The miss is best defined as the unmitigated cock-up. It usually involves buying a picture that we have assessed from digital images on our screen to be the real thing, but which on arrival turns out to be either in ruinous condition or, as has happened a number of times, a cunning copy (on one occasion a picture even turned out to be a glorified painted photo). The hideous spectre of the cock-up naturally has the tendency to curb excessive commitment.

Looking at the digital image on my screen with twentyfour hours to go, I now had to start the thought process. It was impossible for either myself or Bendor to get out to Los Angeles at short notice, so it was going to have to be the usual game of long-distance risk. If this turned out to be a work of quality, as well as in good condition, given what we now knew about its likely function then it would be worth £,400,000. If it turned out to be a late copy, a mere £1,000. The problem with a screen is getting a grip on the painting's physical properties. Buying art through a computer is like trying to taste with a cold. An oil painting is in fact a three-dimensional object, its surface texture representing an important part of its age, authenticity and allure, and even though a good digital image or a detail can offer tremendous clarity, it cannot impart the full feeling and taste of an encounter in the flesh. We also did not know anything about the picture's history and how it got to America, facts which would have assisted our thoughts about whether it could be a recent fake. The auction house had covered itself entirely with the term 'Follower': if it transpired to have been knocked up in the past three weeks, they would not be obliged to return our money, so there was no comfort there. John Hayes's landscape volumes had also come up with the record of 'a variant copy' of Cornard Wood in a collection in Utah. Was this, I now asked myself, the same picture? If so, it was unlikely that he had seen the picture in the flesh, and possibly working from a black and white photograph. That would make his judgement understandable and would not have concerned me. But what if he had seen it in the flesh and deemed it an obvious copy?

There was one more port of call I had to visit, and I did so the following day, the morning of the sale. An obvious question that would hover over this picture if we bought it would be, how could a 14-year-old boy be more accomplished than most other artists become in their whole adult careers? Or, put another way, what proof was there that Gainsborough was painting so young, apart from anecdotal? Although it was not an issue that personally concerned me – juvenile genius was a phenomenon I had observed in other painters – it would be a question the incredulous would brandish. There was a woman, however, who had addressed the same issue a thousand times and it was her I telephoned that morning.

Adrienne Corri has had a mixed reception in the art world. She first came to my notice when she made the amazing discovery of an early self-portrait painted by Gainsborough when he was twelve or thirteen. I subsequently managed to buy it and was able to take it home for two years before the need for funds prompted its return to the West End for resale. Immediately afterwards it was exhibited at the Tate Gallery in a major Gainsborough retrospective, causing wonder and admiration for its certainty of characterization and skilful deployment of glaze at so young an age. The first moment I spotted the landscape it was the little face in that beguiling portrait that came to mind, and it had remained with me over the past fortyeight hours.

Speaking about Adrienne, John Hayes admitted to me that he was a little bit scared of this actress turned amateur art historian who shook the trees of Gainsborough scholarship in the early 1980s with a combination of relentless research and confrontational vigour. He was not alone in this trepidation. But John did add that what she had uncovered could not be ignored and he acknowledged that the self-portrait was a revelation. For her part this petite, dynamic Scotswoman, who

introduced Sean Connery to the game of golf while she was married to the actor Daniel Massey, was a little more forgiving at the age of seventy-seven when I contacted her at home.

Adrienne Corri first embarked on Gainsborough research in the late 1970s, when she attempted to prove that a portrait of the actor David Garrick in the Alexandra Theatre, Birmingham, was by the young Gainsborough. This was a diversion from her life as a serious career actress, which had begun when she was fourteen and went on to include innumerable stage, television and film parts, ranging from Desdemona at the Old Vic to Mena in *Doctor Who*.

She took to her new role of art sleuth with the distinction of a leading lady. It grew out of her burning desire to prove that Gainsborough could have painted Garrick when only sixteen, the likely date of that portrait, which involved following up a throw-away line by an eighteenth-century politician that a Mr Fonnereau of Ipswich gave young Gainsborough his 'first chance', by lending him £300. This led to the most arduous part of her odyssey, which was to try to find a bank record to prove it. It took her a year alone to gain access to the archives of the Bank of England, but in retrospect that was the easy part. She-went on to discover that eighteenth-century banks ran a hideously arcane system by which account holders did not have their bills paid directly from their bank but via smaller, merchant banks who acted as intermediaries. At the Bank of England ten ledgers recording these were in use at any one time, making linking payer to payee a Sisyphean task.

The whole project lasted six years and took in ledgers from other banks, including Hoare's, Drummonds, Barclays and the National Westminster. At that time there were no photocopiers, so she ended up filling thirty-six books with notes. Her findings, which she then published in the art world's eminent journal, the *Burlington Magazine*, coupled with her unswerving conviction in their implications, were so controversial that they caused art historians to take deep fright: she claimed that Gainsborough was receiving very substantial sums of money from the age of ten. Up until now, apart from owning the self-portrait, I did not have much reason to engage with this claim. This little landscape had changed all that.

'What I established was as a direct result of what I found,' Adrienne enunciated down the telephone in her powerful, actress's diction. 'You can go and see it yourself in the archives. The Handley account at the Bank of England indicates that the first money from Fonnereau to Gainsborough was in 1736 – when he was ten years old.'

'How much?' I asked.

'The hefty amount of £300,' she replied briskly. 'The same figure referred to by the politician. The money continues to be paid for the next twenty years, but from 1739 it seems to have been invested.'

'Why then?'

'I'm not sure,' she rattled on, 'but 1739 is when Claude Fonnereau died and Gainsborough went to London. That may be significant. In 1750 a large proportion was withdrawn. This may well have had something to do with his father's death and his move to Ipswich around that time.'

We talked for half an hour. At full tilt down the telephone Adrienne Corri was still formidable, and I could see how art historians would have run for cover from this woman who was not for turning. Her stance and argument had been vulnerable because the work she had done was exhaustingly arcane and not easily replicable; it required someone else to do the same in order to properly engage, but to date no one has, which has meant that her deductions have to be accepted – or in her case most often rejected – at face value. Others have also argued against her that if Gainsborough had had £300 per year he would not have gone to London as a humble apprentice, but a prince (although Adrienne would argue that it could easily have been held in trust).

By the time I put the receiver down, after mentioning coyly that I hoped to have something to show her soon, I knew what John had meant. Adrienne's findings cannot be ignored: I was aware that there was much more to the story of young Tom than we might ever know.

'So do you specialize in anything particular?' asked the good-looking lady on my left.

It is a frequent follow-on question when, at a first meeting, you reveal yourself to be an art dealer, and I have a fluent, forever evolving answer. It starts with reference to paintings of the human face – my historical stock in trade – and then spreads to cover my latest enthusiasm, or what I guess might be theirs. Tonight, however, I was too much on edge for gentle dialogue.

'Well,' I said, 'in the next half-hour in California I'm hoping to buy the painting that revealed the boy Gainsborough to be a genius.' Go for broke, I thought, and qualify it later. Pausing a second or two to digest the salvo, she responded with unexpected scepticism for the opening moments of a London dinner party.

'Prove it,' she said tartly.

So I began to tell her the whole story, starting from the beginning, leaving out very little. One of the reasons why I (and other dealers) sometimes enthusiastically download details of imminent purchases to strangers is that it allows us to hear and test the buying rationale. I have a tendency to become commercially blinkered by the latest obsession, sometimes forgetting the picture-buying public upon whom I rely. I take the view that if I cannot sell it to someone's imagination at this stage then I am hardly likely to be able to do so when it is hanging on my gallery wall.

Although the dinner party was being given by Tara Williams, an art-world hostess, there were no other dealers within earshot I could recognize. In any event I am always careful to withhold crucial facts about auction houses' names or cataloguing details – key words that could be later Googled and linked with the picture in question. I also had the warm feeling that we were as prepared as we could be: the bowstring had been drawn, the arrow was in place and I had as good as let loose across the Atlantic. A telephone line had been booked with the auction house and they had confirmed it in a fax. Emma Henderson had checked with me our dollar holdings and which of our bank accounts we were to use; these vary according to the amount and length of time the money is required. Bendor, whom the auctioneers had been instructed to phone for the bid, had arranged to stay late and was waiting in the gallery. My

mobile sat between my legs, discreetly turned to vibrate as back-up if they could not reach Bendor. And as a third string, if all else failed, Lottie Tate, my long-serving gallery manager, was ready on the end of a phone on a farm in Lincolnshire.

Despite all this, however, and ten minutes into relating the story of the young Gainsborough to my dinner partner, I started to feel anxious. Some of the smaller auction houses are not the efficient organizations they aspire to be and disasters do happen, particularly on sale days. The bidding staff, whose job it is to relay your phone bid to the auctioneer, sometimes fail to contact you, or with maniacal persistence repeatedly try the automatic fax line as you helplessly look on. It has also been known for the in-house electrical system, taxed by the day's excessive requirements, to collapse at the moment critique when the auctioneer turns on his microphone to call the room to order - causing the phone systems to die with it. International lines can become engaged, digits can be misread, instructions lost, and all these misadventures, at some time or another, have befallen us. On one occasion a saleroom in Boston chose to telephone both Bendor (the back-up bidder) and me in different parts of London at the same time and we ended up unwittingly bidding against each other. The auctioneer was delighted: his Jane Stuart portrait of George Washington, estimated at \$2,000-\$3,000, made a record sum of \$25,000 - and we were the only bidders. Fortunately we later got him to cancel the sale and re-offer it, and we bought it for \$4,000.

But it is the lost opportunities that really cut deep, not least because the auction house is not legally liable if they forget or do not manage to contact you. I once organized with a Californian auction house to bid in the middle of the night (British time) on a glorious, miscatalogued Sir Henry Raeburn portrait of a child. I rose the next morning with the sick realization that no one had telephoned. As the day progressed we pieced together the reason. An intern at the auction house, despite been given our fax clearly requesting that I be telephoned on my home number (which was boldly typed on the page), instead chose to telephone the number of our gallery printed beneath our company name; he tried to call the gallery five times, and by playing back the office answer phone we were able to listen to his increasingly desperate, dim-witted bleats for someone to pick up in the early hours of the morning. About one in fifteen of our telephone bids ends in calamity.

I was also concerned about the level. Weighing up the possible downsides, particularly as I had just had a particularly expensive mistake from a sale in New York, I had told Bendor to bid to no more than \$110,000 including commission. If it turned out to be a copy, or in a very poor state, it would be unpleasant, but not the bloodbath it would be if we had paid six or seven times that amount. But now, hearing my own sales pitch over the dinner table, I realized I had made a mistake. I started to dwell on the librarian's throw-away reference to the person who had sought the same rare book. Although I could count on one hand the likely dealers who would be able to work out what the picture really was, if they shared our convictions there was no room for risk-taking. I began to berate myself. I always have a tendency to give those who are bidding on my behalf a lower level than I would pay myself. It does have the advantage that in

the smoke and heat of commercial conflict I have been known to take the price twice more than I strategically planned. There is normally a reason when a picture takes off in this way, however, and I have rarely regretted it.

So, given the picture's prospective importance, why the hell was I not doing the bid myself?

Spurring my misgivings was also the fact that my companion was impressed. It may have been the candlelight, but her eyes were shining as I brought her back to the twenty-first century.

'And now I am sitting waiting for the gallery to give me the news,' I said, concluding my story, 'and talking to you.'

'What a thrilling discovery!' she said almost hoarsely, entirely rid of her former scepticism.'I do hope you get it.'

'Sorry to butt in, but I couldn't help overhearing the last bit. It sounds remarkable. When did you first see it?' A gamine blonde in pearls sitting opposite, who had stopped talking to her partner, had joined in.

Now that the landscape's allure was spreading across the table it only served to emphasize my agitation. Discovery of any description appears to interest people, but this was the first time I had appreciated the emotive power of this one: also, if my conjectures were right, when else in my career would I have the opportunity to find so critical a work at the commencement of so great an artist's career? I resolved to get Bendor substantially to raise the bid as soon I could artfully extricate myself from the table, which was looking difficult as the conversation had turned to the ethics of art dealing and I found myself in the dock. Now the man two down, married to my shiny-eyed dinner partner, waded in.

'Let's face it, like me you do your job for one primary reason: to make money.' I noticed a touch of mockery as he shot a grin at his wife. 'And art is a commodity, and you art dealers are just experts at talking it up,' he then added for good measure, looking to the table for support.

Wearily, for this was not the first time I'd had to cope with such onslaughts, I obligingly responded.

'That may be true but it can be the by-product that really gets you out of bed in the morning. For me, money is the evidence you have got something right: and in the case of a lost picture the proof that you have salvaged something of significance.' Ouch, I thought, does that sound a touch too worthy? Too bad if it did, I was in a hurry to exit, and anyway this man was annoying me.

At that moment my seat vibrated. Snatching the phone to my ear and apologetically catching the eye of our hostess, I withdrew from the fray and clumsily made for the sanctuary of the kitchen with the phone to my ear.

'You can sack me if you want,' said Bendor in a notably assured voice on the other end.

My God, I thought. He has failed to bid. This was another reason telephone buying goes wrong. Human error. The bidder goes to the loo, is distracted, or plain forgets to take the auction house's call.

'What do you mean?' I asked in an urgent whisper so as not to be overheard by the table.

'That the picture made approximately one hundred and twenty all in – ten thousand more than the limit,' he replied with the same impassivity. My worst fear now rose from the mire. I had not given him enough. How profoundly stupid was that?

'Now, taking today's rate of exchange,' he added in a higher octave, 'that's not as bad as it sounds.'

Bad for whom, I thought. And anyway, why tell me this now? 'So who bought it?' I fretted, staring down at the tiled kitchen floor.

'That's what I mean,' said Bendor. 'Fire me if you will. I took it on. We bought it.'

Thinking about it later, I don't think he had any intention of sticking to my limit anyway.

We were all in our weekly meeting when the door bell sounded and the picture was delivered. Although it had been paid for and picked up two weeks earlier it had taken a fortnight to be crated, to make its way across to New York, be flown across the Atlantic, clear customs and then be driven from the airport to Dover Street. Every Monday at 1-1 a.m. we meet to plan the week and review the previous one, and by sheer coincidence we had been discussing the Gainsborough only minutes earlier. News had reached us that the picture had been underbid by Andrew Wyld, a distinguished Bond Street dealer specializing in early English drawings, and the view around the table was that if you were going to end up paying fifty times the lower estimate, there were few better dealers to force you up there. The picture had already been un-crated but was swathed in paper and bubblewrap, and Bendor and I both moved in to finish the task. We cut and tore at it using scissors and fingers, and as we did so I got my first glimpse of the corner of a carved and gilded period frame. A good start, I thought – just the sort of mid-eighteenth-century, carved and gilded centres and corners style you might expect. The next foretaste, as we peeled away more wrapping, was a flash of green foliage from beneath a tear of brown paper. Even better, I now felt, noticing a tell-tale swipe of glaze on its fringes. Struggling to pull off the scotch tape, Bendor then turned it on its back to fully remove the final layer. Its dusty underside now revealed, amid the scribbled chalk auction numbers and backing paper, we saw a printed label, scraped and torn. We craned forward. It was for the London art dealers Agnew's, who have been trading since 1817. Beneath the company logo was some faded ink writing. 'Cornard Wood,' it read.

The back of a picture will often give you more information than the front ever can. Dealers, collectors and inventory makers often marked up the back of paintings with brief descriptive details, and half the time they remain in place. Some years earlier I had bought in a sale in Vienna a portrait painted on plaster believed to represent a continental king or emperor. With the aid of my then researcher we had worked out that it corresponded to a portrait of Charles II by Antonio Verrio, a visiting Italian artist, from the ceiling of St George's Hall, Windsor Castle, a building thought to have been entirely destroyed by George IV. It involved considerable research and sourcing of an image in watercolour taken of the ceiling before it was pulled down, and then developing a hypothesis of how this fragment might have been preserved (we think the architect who rebuilt Windsor Castle, Jeffry Wyatville, himself might secretly have held it back). When the picture - which we later

sold to the Queen amid a great fanfare of publicity – was delivered to our gallery we found a label on the reverse (not easily accessible as the plaster was so heavy). Having thought we had carried off a magnificent feat of independent detection, we saw the bland statement, in old handwriting, that this was a painting by Verrio of Charles II rescued from the old St George's Hall. As now seemed to be the case with the newly arrived Gainsborough, the auction house had not heeded the most obvious clue available. From this label behind the Gainsborough, we were later to establish through Agnew's early records that they had bought it from a British seller called Mr G.W. Grey in 1946 – about whom, to date, we have found nothing. At least, however, it suggested that it was highly unlikely to have been in America before that date.

One of the words most overused to describe attributing and judging a work of art is 'instinct'. There is certainly a place for it but it is too often a mere catch-all for the basic process of observation, releasing you from having to articulate your visual responses, which, in the case of an art dealer like myself, are in perpetual professional use. As I commit this to paper I have tried hard to analyse the optical and mental process that takes place when the moment of physical (as opposed to digital or photographic) assessment comes. Apart from anything else, the purpose of this book is to try to communicate why I and others take the risks we do. There are many dealers (I would not necessarily describe them as the 'sleuthers') who take no extreme risks, who at auction only buy paintings when they have clear, guaranteed attributions, which carry less hazard. The

principle is the same, however. If the price they end up paying is sufficiently advantageous it allows them to make an honest profit. As dealers we live our professional lives with the confidence that we can do it better than the rank and file; but when it comes down to it, just as the pure academics are, we are frailly human. There is one characteristic, however, that I genuinely believe gives the professional buyer the edge: few things bring oxygen to the brain better than financial risk. Admittedly this normally applies *before* you have committed, and in the case of this painting it was *after*, but the principle remains the same providing you can muster honesty of response. For me there are four distinct phases.

Bendor lifted the picture face down from the table and walked it over to the easel. The first look is often the most telling. It works on the same principle as a magazine cover, but in the case of landscape it can be more understated: does it draw the eye? The answer in this case was yes: as Bendor and I stood before Cornard Wood, although it did not heave itself towards you like some great old master, its subtle composition and technique were both appealing and captivating. The next look then processes the content and the artistic devices used to impart it – the 'clever' test, and this it also passed with merit: although the figures were quite chunkily constructed they were made so with certainty and clarity; the dash of light, the delicately observed tree trunks and dappled foliage had all the distinction and originality of a consummate artistic craftsman. Next comes a questioning of the evidence: is what I am seeing genuine or overpainted, is there damage which I have not noticed? Apart from a little flattening from a previous relining,

and some allowable thinness in the more glazy areas of foliage of the upper branches, there was nothing to concern me here either – all par for the course. Finally there is the 'further-away' assessment which is vital for determining a picture's value and placing everything just processed into place. This normally involves reversing a few paces. I am usually so totally absorbed at this point, so rigidly focused on the object before me, that I have backed into people, furniture and, in one instance, a seventeenth-century canvas (in my restorer's studio) with considerable resultant damage.

Cornard Wood was everything I hoped it would be. Once a yellow varnish was removed from the surface, I surmised, and the few localized passages of glaze repaired, it would revive into something compelling. Bendor was as pleased and relieved as I was, sharing in an enjoyment which can be likened to having played and landed a trophy fish, not least because under our halogen lamps the picture shone.

It took three months for the picture to be cleaned, relined and restored, and it returned with a confidence, poise and delicacy that could not fail to make one smile.

'You're too late,' said the lady at the reception desk of Gainsborough's House.'The bulldozers have moved in and the building has started. And it's not called Cornard Wood any more, either, but Chilton Homes – about 170 homes, to be exact.'

I could barely believe what I was hearing.

'We all tried to stop it. Everyone tried, including that famous Mr Attenborough man. I'm afraid you should have come last year. They're hard at it.' Although I knew there had been talk of developments around Cornard Wood, I had assumed it was one of those scary journalistic stories without foundation, reckless scaremongering to sell newspapers. On reflection, it was also because I could not realistically imagine a national treasure being allowed to be so savagely desecrated – the equivalent of placing a filling station on the site of Constable's *The Hay Wain* or a wind farm at Stonehenge. I turned to my 11-year-old son Oliver, and he too looked bewildered.

'Let's just go there anyway and have a look. At least we can see where it was,' he said earnestly.

We had driven three hours from London, so I decided to make the most of Sudbury before we left, and in a mood of some despondency took a rapid tour around the house. It had been ten years since I was last there and with recent restorations the old part had become more historically atmospheric, stripped of its leaflet dispensers and rid of the intrusive sound of passing traffic. The portraits too, a number of which I had sold or acquired for the collection in the past twenty years, were now better lit and hung, able to smile back with appropriate pride for having been painted by the house's venerated eponym. But they did little to exorcize images of ancient trees being bulldozed from the ground.

Great Cornard is a village on the south-west corner of Sudbury and we set off there by car. We passed a shopping centre and garage, turned right at a roundabout, then east up towards a track, at the top of which I could see a prominent chunk of woodland. A clear white sign stated that footpaths ended here, so we parked and covered the last few hundred

metres on foot, mildy disturbed by the thought that we were now probably trespassing.

Reaching the wood involved crossing the edge of two further fields, and as we followed the hedge line I could not help thinking what a considerable walk from the centre of Sudbury it was for a young lad – it had taken close to fifteen minutes to reach here by car. Apart from Abbas Hall, an ancient house behind trees that had been viewable from some distance back, we were also remote and alone. In between empathizing with Tom's adventurous wanderings I had been bracing myself for the pitiless sight of building works, at every turn expecting the trauma of broken earth and the discordant shapes and colours of machinery, Portakabins and company logos. To my growing surprise there were still none to be seen; it was a scorching June day and the only shapes and tones were those of old Suffolk – a Prussian-blue sky, the infinite greens of foliage, and scattered among high grasses the dab-marks of red campion and cow parsley.

As we rounded the last hedge Cornard Wood dramatically appeared before us, a block-like citadel of trees at the top of the final stretch of slope. It was broader than I was expecting, and unsure where to gain entry I turned to find my bearings – to be met by an unfurling view across Great Cornard. It was blindingly spectacular and immediately suggested to me why Tom would have enjoyed the tree-house experience of perching himself away up here as the truant. I looked down at the photograph of my picture which Oliver was holding. If I could only spot Great Henny Church, I thought, then I might be able to orientate myself to where he sat, but this was more

challenging than I had reckoned. We squinted into the horizon for a whole half-minute and just as I was wondering whether we were in the right parish, let alone the right field, the solitary, sentinel shape of a church spire in the far middle distance materialized into focus.

'You go left and I'll go right,' I instructed Oliver as we climbed the fence to enter the wood at what I calculated to be roughly the angle from which the steeple could be seen.'Let me know if you find water.'

'But, Daddy, where are the bulldozers?' he asked, and alarmingly I could not help detecting concealed disappointment at having missed a drama.

'It appears they have yet to arrive,' I replied, feeling increasingly blessed that we had got there just in time. I was later to establish that the housing development was planned not for the wood but further down the slope towards Great Cornard, but not knowing that at the time, and as I pushed through the outer branches, it was as though we had been miraculously granted a respite from reality, a feeling that greatly increased as we entered the muffled silence of the wood. Surrounded by timeless growth, I was struck by the idea that everything was now as Tom would have seen and felt it: the same coolness in contrast to the outside heat, the thicket of mare's tail and enchanter's nightshade around our feet, the stained-glass play of sunlight through broad leaves. I had been wandering only a few minutes, passing between the trunks and heading in no particular direction in search of anything that could be likened to a watery hollow with distant view, when Oliver alerted me

'I can see it!' he bellowed from some distance away. 'Quickly, come over here!'

He had run on a couple of hundred metres and I found him next to a high bank, beyond some pheasant pens, triumphantly gesticulating to his discovery.

It was much broader than I expected, and looked strikingly like the remains of an ancient, square-edged carp pond. On the far side it was bordered by a slope so densely covered with trees and nettles that it was impossible to detect its gradient or contour. To the right, through vegetation, lay the distant view of Great Henny we had been surveying earlier but the undergrowth was so painfully thick it took a good fifteen minutes to negotiate our way around the pond, Oliver gingerly following, to an area at the water's edge that I felt equated to the position in which Tom had been sitting. While Oliver nursed his stings I cleared a place for us to sit on the damp, uneven ground and asked him to pass me the photograph that had remained clamped in his hand. I looked up through the canopy to the sky. Since we had entered the wood the sun had moved a few degrees to the west, and both the temperature and light had dropped. Although it was difficult to see clearly through the branches, I began to realize that the buildings and objects on the horizon and in the middle distance were now better delineated, as if the sun had conspired to cast them into relief.

Pushing aside some of the leaves in my immediate eye-line, I then found, to my sudden surprise, that the spire of Great Henny Church had transformed into an artistic baton, its express function, it now appeared, to orchestrate the composition. Moving outwards from its tip to the foreground, I could now

guess exactly where the marl diggers had been at work, where the orange-brown bank had been, where the path had once run, and where the great, ageing oak – now long gone – had been supplanted by a cluster of smaller trees, any one of which could achieve the same monumental distinction in centuries to come. The pond was much bigger than it appeared in the picture, but whether this was because it had been extended, or Tom had used artistic licence, was unimportant: water completed the powerfully lyrical pattern of ground, tree and sky.

I turned to Oliver, passing him back the image.

'Look, I think we've done it!' I exclaimed. 'Can't you imagine how this would have filled Tom Gainsborough's head – the water, the trees, the distant view?'

He looked at the photograph and then to the thicket of stems that now surrounded us.

'It's a good place to hide,' he replied, and returned to rubbing his ankles with dock leaves.

I could fully comprehend the deep draw of this location, particularly in the eighteenth century, when it had been common land. Had I been Tom, I too would have sought a hide-away like this, a place of distant refuge remote enough to be an adventure, but within striking distance of home, a place of ancient growth and rustic activity where I could be embalmed in the ecstasy of giving some sort of artistic permanence to the experience with the technical skills I had been gifted. Painters of the next few generations would seek inspiration – and risk their lives – by voyaging to such far-flung places as the Swiss Alps and the Middle East, and by scaling remote British mountains. For Gainsborough there was no need for such exotic exer-

tions. Within the joyful concealment of this woodland, and by looking back across a distant landscape towards his home in Sudbury, he had found his own version of the sublime, and, most remarkably, he had found it when a child.

We met Lindsay Stainton outside the staff entrance to the National Gallery. She had just rung on the bell and was waiting with Diane Perkins, the new curator of Gainsborough's House, under whose directorship the museum has noticeably advanced in the past two years and who had come up to town for the day from Sudbury. Bendor stood next to me holding the picture, wrapped in brown paper, under his arm. Lindsay's reputation as a connoisseur is deeply established in the art world and she assisted John Hayes in the preparation of a number of his publications, so when some months earlier I had invited her to see the picture and she had proclaimed it an indisputable early work, on her suggestion we sought permission to see it next to Cornard Wood in the National Gallery. Another notable expert on the artist, Dr Brian Allen from the Paul Mellon Centre in London, who had called around to my gallery earlier the same month, had been unable to attend that morning, but we did have an eminent host, Dr Susan Foister, head of British Art at the National Gallery, as well as the past curator of a significant exhibition on early Gainsborough.

Susan had helpfully agreed to allow us to view the two pictures in the Gallery's conservation studio, which meant we could survey them at close quarters in optimum conditions. Having signed in at security, and been greeted by her, we made our way along the high-ceilinged back corridors and then by

lift to the upstairs studio, where the door was opened by Martin Wyld, acting Director of the National Gallery and the much-admired head of conservation. This was not without irony, for a fact unknown to Martin until I told him was that his brother Andrew had been my under-bidder on this picture.

I had forgotten how magnificent *Cornard Wood* was as I encountered it there on the easel, morning light pouring upon its surface from the overhead windows as if the view were appearing at first dawn. Devoid of its frame, it looked very different from the aloof image hanging half a metre (20 inches) above another painting on the Gallery's busy walls. I could appreciate its subtleties and incidents with new-found intimacy. Despite fading and abrasions, it certainly deserved its reputation for greatness, its panoramic glamour and rustic observations working their magic on us as they had done to others over the past 250 years. While Martin went to prepare us high-grade coffee Bendor carefully unwrapped our picture and walked forward to place it on an easel, a few paces to the right of the other. Taking care to fix it in place, he then stood back.

For myself and others there that day it was a coming together of memorable poignancy. On the left was the great operatic masterpiece, one of the most admired productions of its day, its complex, winding plots making it a work of epic accomplishment. On the right, something altogether meeker and less contrived, but inextricably linked: a youthful precursor of the great things to come.

A sleeper had awoken as satisfactorily as it could do in my lifetime.

PERCEPTION AND DECEPTION

Next time you go to an exhibition, spend some time looking at the people looking at the art. One of the most telling features of visitors to a gallery is that they will study the labels before they look at the pictures; in other words, facts are required before the visual process can kick in. More than that, however, the information on the label often dictates how the work of art is perceived, enjoyed and esteemed. This truism lies at the heart of many discoveries – as well as deceptions.

An extraordinary happening took place in the Norman Rockwell Museum in Stockbridge, Massachusetts, in the summer of 2006 that will remain for ever in the annals of American art history. The incident is perhaps best expressed by Julie Brown, a museum guide of eighteen years' service, who arrived that fateful morning to discover her normally quiet museum, tranquilly set among woods on the outskirts of the town, to be overrun by press and television reporters. She wondered initially whether her employers were organizing

some event, but quickly saw from the body language of the invaders that this was no academic symposium. A devotee of Agatha Christie, Julie was not intimidated by high drama in unexpected quarters. Nothing, however, had prepared her for the front-page international news story that had broken within the precincts of her own museum that morning, and which turned out to be every bit as sensational as one of the crime writer's greatest mysteries. Furthermore, this was non-fiction, in which she and her fellow staff had had an unwitting part to play. The felony was one of mind-blowing fakery. The victim was the art establishment. And the prime suspect was dead.

A little background is required. Julie and her fellow guides had been thrilled to receive on loan to the museum four years earlier Norman Rockwell's masterpiece Breaking Home Ties, a picture that had delighted the readership of the Saturday Evening Post when it had first been reproduced on its front cover in September 1954. Voted the second most popular image in the Post's history by its readers, the painting had played a prominent role in Rockwell's growing celebrity ever since, one of the iconic images that place him among America's best-loved painters and affirm him as his nation's greatest popular illustrator. It is easy to see why the readers, and indeed the guides, responded as they did: not only is the picture deftly constructed and painted, it is packed with pathos. A weather-beaten farmer, cigarette butt in mouth, waits with his bright-eyed son for the train that will take the boy off to college. There is the sense that by boarding the train and breaking his home ties the youngster will leave his agrarian roots and childhood for ever. This poignantly crafted domestic scene is underlined by the family collie, which rests his head adoringly on the boy's lap, completing the perfect allegory of socially evolving post-war America.

As an art dealer, to me it is abundantly clear when a picture possesses what is sometimes crudely described as the 'X factor' - a work of such communicative power that even a passing barbarian would throw it a second look. The 'X factor' work can be any subject from, say, the Massacre of the Innocents to a bunch of irises, any style from painfully detailed to broadly abstract; and when to these soul-touching images you add commercial scarcity, and the name of a great artist, even the hard-boiled, self-made billionaires who never make a decision without a spreadsheet will allow emotion to rule. It is the time the art journalists love, and art dealers wait for, when these often shadowy financial titans come out from hiding for trial by combat at auction, variously in person, via agents or by telephone, and when the next day's headlines of record-breaking sensation write themselves. Breaking Home Ties could be described as just such a picture.

What had prompted the media invasion that day, however, was not its sale but something journalistically more spectacular. In a single stroke of revelation this emblem of midtwentieth-century American art hanging on the museum walls, labelled by experts, esteemed by the public, famed for its history, and sitting among other imposing paintings by Rockwell, had been revealed as a fake. What was more, the unequivocal proof was obtained not by some process of deliberation and analysis, or some symposium of academic or scientific experts, but by something laughably simple. The real picture, from which it had been secretly copied, had reappeared.

My friend Rachel Kaminsky – whom I had met on my first trip to New York when she was a director of Christie's and who is now an independent dealer and agent – first told me this story by telephone after reading it in the New York Times online. I responded with incredulity that so famous a picture, with so celebrated a history, could be harboured in the main museum devoted to the artist and yet turn out to be no more than an inferior copy. It sounded almost as farcical as being told that the Mona Lisa had been knocked up by a Montmartre street artist. Rachel, audibly amused as she reread it to me from her computer screen, suggested I should check it out. I agreed. From what she had read to me this sounded like the most revealing example of the type of art-world blindness that goes to the heart of many great discovery stories.

Every January there is a migration from London and Europe of dealers in old masters to one or more of the major old-master sales in New York. As one of those who regularly make the journey I organized my 2008 visit so that I could spend a day or two extra on the Rockwell quest. A couple of years had passed since the big revelation, but a few emails and telephone calls suggested that those involved were disposed to talk, so I decided to spend no more than a day and night in New York, view in the flesh the pictures we had already studied online, and then take the early flight across the state to Burlington, the same airport where seventeen years earlier I had encountered the late portrait collector Earle Newton.

There was only one sale to view, but it was a big one, over three hundred lots, and having spent three hours in the auction rooms with a halogen torch poring over the following day's offerings to establish condition and hunches, I called Bendor to discuss and arrange bids, and thus concluded the day's formal business.

Many of the New York dealers time exhibitions and parties to coincide with the sales, and later that evening I found myself on Upper Madison at the gallery of Larry Steigrad and his wife Peggy Stone, their picture-filled emporium packed with figures from the art world. It was also a welcome escape from the street, where the temperature had dropped to below freezing, and it was good to see them prospering in the warmth. They had come a long way since I had encountered them on my first trip to New York with now annual shows, regular trips to exhibit at Maastricht and Palm Beach, and a lavish art-world soirée each January. Throughout the evening I was able to swap notes with a raft of colleagues - the Londoners such as Dave Dallas working with the old-master powerhouse Johnny Van Haeften, the nimble generalist Toby Campbell from Rafael Valls, and the native New York light cavalry such as Peter Schweller and Robert Simon, both specialists in finding lost. pictures. Milling in the throng that evening were also restorers ready to ply their trade to the successful buyers, art historians who had lent their expertise to cataloguing, art writers and journalists, and even the auctioneer for the following day, George Gordon, who gave me honest insights into some of the pictures that were to fall beneath his gavel, including a curiously speculative Frans Hals I had decided to bid on (the one referred to in my introduction).

Just as I was leaving I noticed – to my surprise, given that Larry and Peggy are generally known for earlier works – a Rockwell

on the wall. It was an illustration of army life, and a young art journalist, whose name I never obtained, was ardently explaining its merits to a compliant female listener. He was lecturing and gesticulating to it with no-nonsense Manhattan directness and this was too good an opportunity to miss, so I weighed in.

'You clearly rate Rockwell,' I interjected, in retrospect a little heavy-handedly.

'Hard not to,' he said, throwing me a mildly irritated look. 'As I was just explaining, no artist could tell a story better. And for what it's worth,' he added, turning back to his companion for emphasis, 'he is the greatest illustrator in American art history. I have said so more than once.'

I detected that, as well as adding the finale to a thoughtfully crafted lecture, he had decided I was an Englishman in need of educating.

'But easily faked?' I provoked.

'Not really,' he responded curtly. 'He's too good, and all his works are recorded and reproduced. The books and catalogues on the artist are legion.'

'Even *Breaking Home Ties?*' I enquired. He looked less sure of his ground now, and I could see he was working out whether he had walked into a Rockwell scholar (though he needn't have worried).

'OK, that was an exception. But let me tell you something. There is stuff that does not add up there. I mean, frankly, how can you kid so many experts for so long? Then there was the discovery – can you really believe they found it the way they did? It is all too *Scooby-Doo*. Take it from me, there was funny business out there.'

'Funny business?' I replied with contrived innocence. 'How fascinating. I shall have to ask the ex-owners when I see them on Friday.'

Another momentary look of disquiet crossed his face as he wondered whether he had doubled his *faux pas*. When I explained I was merely writing a book and had neither vested interest nor academic superiority, he remounted his platform.

'Mind yourself out there – it's not London down there. It's wild country!' He sought the eye of his companion and winked at her, and she compliantly smiled.

This little insight indicated that breaking through the perplexities was going to be more of a challenge than I had forecast. As I walked out of the gallery in the direction of the Waldorf Astoria (the large Art Deco hotel on Park Avenue, where I now always stay when in New York) I found myself musing on the possible outcomes of my meetings over the next two days. Perhaps there was a degree of funny business surrounding this, and if so, was an ingenuous, plodding English art dealer on a two-day trip to the country the right person to try to fathom it? I was also mindful that I was returning to the scene of the drama two years after it had happened, and this could prove both a drawback and a benefit: the protagonists' recollections may have faded; but equally, I consoled myself, they may be more revealing with the sedative of time. Any further reflections of an investigative kind abruptly ceased, however, when the chill factor of Madison Avenue blasted me back to the mundane realization that my coat was back in the hotel, as was my wallet, and I had forty blocks to walk. It had also begun to snow.

I arrived at Burlington armed. In my bag, apart from my halogen torch, were two fat books on the artist and his work. But you don't need to read art history to appreciate why Rockwell is a towering giant of narrative or illustrative art. *Breaking Home Ties* is as good as picture as any to demonstrate why a jobbing illustrator turned genius. There was nothing accidental about Rockwell's capacity to perform miracles of artistic entertainment. He staged the set, cast the actors, arranged the figures, chose the props and forever retained a balance between artistic ingenuity and the message for which he was being paid. It is no coincidence that the film director Stephen Spielberg is a collector of his work, for both are masters at reaching a mass audience with a type of American story-telling that can enwrap depth, humour and fantasy.

Rockwell took infinite pains with *Breaking Home Ties*. This period of his career saw him at the height of his artistic powers and gave rise to two other great works: *Shuffleton's Barber Shop* and *Marriage License*. The subject of *Breaking Home Ties* was particularly close to his heart as all three of his own sons had recently left home – the eldest had joined the Air Force and the others had gone away to college. Trying out different ideas with a camera, in the same way old masters used sketches and drawings, he experimented with a range of concepts, settings and models before he latched on to the pictorial solution, at one stage nearly losing hope that he ever would.

As the representation for the boy he first tried his son Tom, but soon felt he did not quite express the specific sentiment he was seeking and then, by chance, in 1953, on a trip to the Philmont Scout Ranch in New Mexico, he plucked from obscurity the

perfect physique and visage in the form of one Robert Waldrop. He assiduously coached his new model to assume the appropriate facial expression of expectancy and surprise, just as a film director might. Waldrop had the ideal combination of characterful youth and sturdiness; of particular note were his large feet and heavy hands, which Rockwell subtly used to accentuate an agricultural background. The model for the father came from closer to home in the person of a cousin of the Rockwells' family cook, a ravaged-looking Vermont farmer called Floyd Bentley. For the painting's setting he used photographs of the run-down train station in Thoreau, New Mexico, details of which he subtly enhanced in preparatory charcoal drawings. The fastidious image maker left nothing to chance.

It took a couple of hours to drive along sparsely populated highways to Arlington, Vermont, and it had started to snow again when I wound down the window to ask a local where the centre of town was. He replied that I was in it. Given how little was going on it was an easy mistake; there were remarkably few shops, a more than average amount of churches and big gaps between the houses more reminiscent of an undeveloped village than a town centre. When Rockwell arrived here in 1939, soon to be joined by other artists, he would have been drawn not just by the clapboard simplicity and elegance of the town but the dreamy allure of its surroundings - the postcardwhite winters, the verdant arcadia of trout rivers, dry-stone walls, pastures, mountains, and woods in spring and summer, and the ecstatic orange hues of the Vermont fall. The core of the Arlington art group that gathered around their uncrowned king shared for the most part two attributes: they lived in

handsome farmhouses, sometimes with considerable land (property was cheap), and they provided art for the Saturday Evening Post. Until rival journalism, particularly television, took over, the Post was the most influential magazine in the country and offered the best vehicle a graphic artist could wish for, with a circulation of millions and a taste for commissioning high-quality art. Rockwell was the art group's cohesive force and also set the tone, not just by dint of his towering artistic stature but-by what some have described as his humble, honest good nature and regard for community. Rockwell relied upon the residents to pose for him – he eschewed professional models early in his career in favour of real people - and his knack for getting the best out of them added to the pleasure of a process that often ended with their faces achieving national recognition on the cover of the Post and other publications. With exposure bordering on celebrity, the good folk of Arlington became passive role models in the emotions of modern America, and in return their artistic creators were esteemed.

Don Trachte, the picture's first owner, also worked for the *Post*, not as a painter but as a cartoonist, and settled in Arlington with his wife, daughter and eldest son Don in 1949. Trachte's syndicated cartoon strip *Henry* was among the best known in America and centred on the exploits of a speechless child who in each narrative adventure manages to overcome adversity by a combination of luck and guile. Although not a front-cover virtuoso like his neighbours and colleagues Mead Schaeffer (from whom he bought his house), Jack Atherton and Gene Pelham, Trachte, with his height, charismatic appearance and crisp Germanic features that reminded some of Ronald Reagan,

cut a dash in the community and he quickly became a prominent part of the social scene, developing a strong friendship with Rockwell, for whom he sat as a model. Like most artists, particularly those living in close proximity, they would buy works from one another, and in 1960 when the Southern Vermont Art Center held a retrospective Rockwell exhibition Trachte made the substantial financial decision, with his wife Elizabeth, to buy *Breaking Home Ties* from Rockwell for \$900. Apart from spells at exhibitions, it remained with Trachte for almost all his life, a consecrated family artefact that every year became more valuable with his friend's ascending artistic stature.

Don Trachte had died in 2005, and his son Don, who was three when his parents established themselves in Arlington, had arranged to meet me at the Arlington Inn, a snug skiing lodge set back from the road. This he had firmly recommended as the place to stay in town, though on driving through the town I got the impression it was the only place. It had been quite challenging to locate Don Junior and it was only after the Rockwell Museum forwarded my requests that he contacted me to say he would be happy to talk. It was he who had negotiated the loan of his father's picture to the museum. Don and his siblings, with his father's knowledge, were thus the prime suspects. Could it really be that at no time did they have any inkling that they were duping the art world with a fake? What sort of people were they? Guileless victims? Chancers? Subversives on a mission to undermine the establishment (the profile of certain fakers)? Don was certainly more than happy to meet once he knew what my purpose was, responding with faultless directions on how to find him; and when I walked into the reception I found him standing in readiness before the log fire, offering his hand with unguarded enthusiasm. After I had checked in he suggested I ride with him to a diner further along the main street, fittingly close to the defunct Green Mountain Diner, where the Arlington artists had met in the days of the town's creative distinction.

When we entered, two elderly locals with lined, winterbitten faces and expressions of animated curiosity lifted their heads, requiring no more than a subject title to mutate into a saleable Rockwell painting. Looking around at the other patrons, most of whom looked tied to the town, I sensed that, although the artists may have moved on, the weather-bound neighbourhood had not. Don led us to a window table and ushered me to a chair, positioning himself opposite, and as he did so I tried to remind myself of his father's appearance. His dark eyes and faintly Teutonic features were reminiscent of a photograph I had seen of his father, but no more than that. He was clearly a good few inches shorter, and in his cordurov trousers, Guernsey jersey and loafers suggested more off-duty New York than bohemian Vermont. Don Junior now lived an hour's drive away in Burlington, close to where he had worked in military engineering, but, judging by the cheery greetings he received from the diner's proprietor, they had not forgotten him in Arlington. With native insight he guided me to the local speciality of chicken soup with packet crackers.

'I sat for Rockwell myself,' Don reminisced over the strangelooking bowls of broth that appeared from the kitchen. 'I was four years old and asked to sit on Santa Claus's knee with a girl of the same age. I behaved so badly that he had no choice but to paint our backs only. My father was furious and I never got asked to pose again.'

I began to notice disquiet in Don's manner. He wanted to tell me the whole story but insisted it would take time. The journalists and film crews had come and gone but with them, in the ruthless stampede, had also gone his side of the story, he felt. 'I suppose in a way I have been perceived as the guilty part in all of this,' he had told me the previous day when I rang to confirm my arrival time, and I now guessed he had been doing so to pre-empt a perception he expected from me. After lunch he suggested we go directly to his father's studio, where he had also arranged for his younger brother to meet me.

We drove for fifteen minutes past snow-filled gullies and fields with ponies draped in winter coats, and all the time he reminisced about the delights of his Arlington childhood, the neighbours they had enjoyed, as well as his favourite haunts and the rivers he swam in the late 1940s and 1950s. His recollections were occasionally tinged with darkness about present-day neglect, and as we drove past Rockwell's sedate clapboard farmhouse and outbuildings he excoriated the way the surroundings, in particular an old school, had been allowed to degenerate.

Sitting next to him I began to reflect on how best to approach the next few hours. I am sure I would have made a feeble police inspector for the simple reason that I empathize too much with my suspects. I found myself liking Don, who struck me as one of those sensitive, regular, quiet Americans with an earnest desire to live, prosper and, where possible, do the right thing. Perhaps he *had* just unwittingly found himself

at the centre of one the most extraordinary national art stories of the decade and was seeking to make sense of his and his family's part in it? Or was I just being well and truly duped, as the art world had?

Psyching motive is to my mind central to successful business. The ultimate parable for me was when I went with my wife and 7-year-old son to the souk in Marrakesh in search of an old rug for our London house. The word went around the market that we there to buy something of significance, and with telepathic speed six or more competing rug dealers fell upon us, tugging us in separate directions like a pack of hyenas, and forcing us down a side alley. It was in danger of turning nasty when we were then rescued by a very tall, noble-looking Berberdressed in a traditional kaftan and fez, who dispersed the mob with sharp words, wielding a wooden staff. He spoke perfect English and took us to the refuge of his house, gave us tea and profusely apologized for the reprehensible behaviour of his fellow citizens. Just as my optimism in humanity was reviving, and we were considering returning to the hotel, he told us there was something we needed to see. From a corner of the room behind a curtain he produced fifty rugs and would not let us leave till we had bought one from him.

The need to read body language and register motive is certainly elemental to my business, particularly with sellers. It involves assimilating all the available evidence and signals combined with courteous prodding. Marrakesh apart, it is something I am good at. As I was going deeper into the wilds I bolstered myself with the thought that I could resort to the same survivalism with Don: buying a story can hardly be different

from buying a picture, I considered. It gave me, if nothing else, the illusion that I could cope.

'Up there is where it all took place,' Don declared five minutes later, turning off the main drag. We ascended a steep, pine-filled slope that was clearly leading us to a vantage point of sorts at the head of the valley. It felt remote, as if we were pushing up and away from the basin of civilization.

'My father's studio – the place it all happened,' he announced portentously.

We had drawn up in front of what could have once been a modest, cube-shaped Vermont farmhouse that had subsequently hybridized into a home-made seventies artwork. A substantial concrete platform divided by water channels thrust out on one side, wooden and glass structures on the others. The Vermont winters had done their work too, and some of the paint beneath the eves and windows was peeling and stained. This mild sense of dereliction had also pervaded the surrounding gardens. Riddling the slope and pushing through the snow like the archaeological remains of an ancient settlement were crumbling stone walls, bridges and rockeries. Don guided me around to the back door.

'We kind of left it as it was when he died a few years back, and nothing has been done to patch it up,' he said, unlocking the door, his voice filling with sentiment as he led me into the hallway. 'The more I discover my father, the more I am amazed by him. He poured his own cement and basically built everything around us with his bare hands.'

There was an odour of dampness, only adding to the aura of what was beginning to feel like a paternal shrine. On the walls were constant reminders of his father's life and acquaintances – photographs of fellow artists, a framed letter from an American president, and numerous paintings and drawings by a variety of hands but mostly his artistic neighbours and contemporaries.

'I really am astonished by what he did,' Don outwardly reflected as he began to walk me around the house.'He crossed so many areas of creativity and just look at these paintings ...' Don had taken me into a side room filled with crates of Wild West scenes, portraits and landscapes painted in soft, brushy colours testifying to his father's feverish desire to find a language in paint, although, as he pulled them out one by one, try as I could I was unable to imagine them causing a stampede in a New York art show. Trachte's first calling was clearly to use a pencil rather than a brush.

We then moved to the huge studio room and Don sat down on a worn leather sofa, apologizing for the condition of the upholstery as he offered me the armchair opposite. From where I was sitting, and over his head, through the immense studio windows I could see unfurling trees and a valley, at the end of which, almost as a landscaped focal point, were the sloping fields of Norman Rockwell's farm. The room was huge, natural light flooding through the large windows as brightly as if we had been sitting in a cow field. An ethnic-looking balcony of twisting birch branches ran along the upper part of one wall, and paintings and more personal mementoes covered the rest of the room's available wall space.

'This will be Dave,' said Don brightly as we heard a car draw up. Moments later a man in a baseball hat, leather-trimmed shirt and Timberland boots, a good degree taller than his elder brother and with an outdoor face, entered the room. His steady, countrified delivery and powerful handshake completed the fraternal contrast. Don had earlier explained to me that Dave had not left the valley like his sister and two brothers but had opted out of formal education, married a local girl and set up a business repairing automobiles further down the road.

Dave took a seat next to Don and as they both looked at me I got the sense of powerful unity, a collaborative bond out of which I was later to discover that the mountain man rather than his urbane elder brother was the definer of the family's destiny.

'So how did it all begin?' I asked. As I got out my notepadand pencil and the brothers exchanged glances to see who was going first I started to feel even more like a novice investigator embarking on his first inquiry. Watch their body language, I thought. Imagine they have just turned up at the gallery with a Van Dyck wrapped in refuse sacks, with the story that they inherited it from an aristocratic ancestor.

'I can remember my father first arriving with the picture in 1960,' Don began. For the time being the big brother was going to provide the account. 'He unloaded it from his Volkswagen bus and then hung it on our living-room wall in the most prominent place over the grand piano. It was a major event, and there was a feeling that this was now our prize possession.' He thought for a moment and then added, 'It was a great picture, one of those images you responded to as a kid – your eyes go straight to the farmer and then bounce off to the boy. We should have kept that in mind.'

He looked over to Dave, who smiled complicitly.

'We were all rather awestruck having it in the house,' Don continued. 'There were lots of parties, smoke and drink in the room, and frankly why it didn't get damaged by the baseball we used to surreptitiously play with in there, I do not know. What's more, during the early sixties the price of Rockwell's work was escalating and amazingly within six years Dad was able to turn down an offer for \$35,000 – not bad for an investment of \$900. Rockwell was aware of the offer and wrote to Dad to say that he must be crazy for turning it down, but that he adored his loyalty for doing so!'

Don went on to explain how things then started to go wrong between their parents, and I found myself being led behind the doors of a family who, had it not been for this picture, would never have had the need to divulge so much to a stranger. I was becoming party to not only his parents' lives but their children's as well. The breakdown in the relationship, he said, culminated in their decision to divorce. It was a tough and prolonged negotiation not least because the Rockwell, together with seven other pictures, ranked among the main assets for discussion and it took three years to resolve the issue. Its ending was not just a relief to their father – who had been living on his own during this time - but also the children, who were registering the stress of it all. The outcome also appeared fair: the pictures would be formally made over to the children, but during his lifetime their father was allowed to live with and enjoy the Rockwell and two of the others: a George Hughes and a Claire Weinz flower piece. Their mother was given similar custodial rights over the remaining five pictures.

So far Don was talking like someone who wished to inform rather than conceal, and I felt my guard lowering. He explained how his father bought and moved into the house in which we were sitting, then just a smallish Vermont home, which over time he extended while their mother remained in the family home, a short drive down the tree-filled slope. This allowed the children, by then adults, to make regular visits to both parents.

'On one such visit to my father I recollected being aware of some mildly out-of-keeping, mass-produced wood panelling that he had installed along one wall of the studio,' Don added, and the triviality of this recollection gave me the impression he was about to announce something. 'It incorporated a deepshelved bookcase filled with ornaments. As he was perpetually adding to his house it did not strike me as significant.'

He then returned to chronicling the family scenario: before I could get to the alleged crime scene, he was determined to finish the history.

By the 1980s, he explained, the beating heart of Arlington's artistic commune had all but ceased – most of the original *Saturday Evening Post* crowd had retired, died, or moved on, but his father's creative fervour was apparently undimmed and he worked continuously on both his house and his art, labouring by day and painting and drawing at night. Although increasingly reclusive, he had fallen for and married a local girl named Liz Ayres, a union that proved to be both sustaining and happy until she fell ill in the early 1990s. Nursing her, Don told me, had exhausted his father, and too frail to continue in the house he went into assisted living, leaving the house that we were in,

as well as its furniture, gardens, objects and pictures, devoid of their guardian.

For the children this raised the obvious practical question of what to do with the Rockwell. Conscious that a national treasure hung on the house's walls — a painting which after all belonged to the four of them — after family discussions, and with his father's compliance, Don Junior approached the nearby Rockwell Museum. This seemed both logical and practical: a perfect temporary home for so valuable a work of art where, as a loan, it could at the very least be enjoyed by the public and function in the context of other works by the great painter.

Aware that I needed to approach this story from two directions, the previous day, along icy roads in my hired car from the airport, I had driven to the remote museum, set within the Berkshire Mountains on the outskirts of Stockbridge, Massachusetts. Located in spacious shelter within woods, fields and gardens, it exuded from a distance more the air of an imposing private residence than a museum. I had been told by the curator to find lunch before I arrived because it was too far from the centre of town for such things as popping out for a bite, and it certainly felt dislocated from the throng as I entered the front doors. It may have been the weather or the time of year, but there were no other visitors in the museum's main gallery when I entered and it offered me the opportunity to take my first plunge into Rockwell's world in lavish solitude.

As I stood in the middle of the room, my eye ranging across its walls, I absorbed each of the twenty or so images in turn. I now saw where *Breaking Home Ties* had fitted in and belonged.

The ebullient characters, in guises of humour, industry, introspection and action, expressed a society on the move, so different from a utilitarian and war-weary Britain. These twentieth-century allegories were the brilliant reflection of aspirational young America: no wonder, I thought to myself, collectors susceptible to these sentiments are so powerfully drawn, spilling blood to secure the best of them.

'I'm glad you found us. If you want peace, quiet and safety, then Stockbridge is the place you want to be,' explained the lady. Linda Szekely Pero, the curator of the Norman Rockwell Collection, had emerged from the downstairs offices and had slightly surprised me as I was musing on the canvases. An impressively comprehensive scholar on the subject of her artist, Linda had grown up in New York and attended what she described as a progressive liberal arts college in Vermont before joining the museum. We had had a number of telephone discussions during which it had become clear to me that she was an important *dramatis persona* in the picture's story.

Linda led me down to the museum's airy basement library and introduced me to the assistant director, Stephanie Plunkett. It was Linda who had been most intimately involved in the Trachtes' loan, and although not in the post when it arrived in 2002 she had been closely concerned with its time at the museum. The immediate question I wanted to ask was whether the painting had struck her as in any way strange or different – a question that was inherently provocative given what it subsequently turned out to be. As we got talking I found her to be noticeably open. And yes, she did have concerns, she told me, but ones which she had nonetheless forced herself to lay to rest.

'I felt it somehow lacked something when I first saw it,' she recalled. 'I put it down to the strip lighting in the room and it also had a badly termite-eaten frame.'

I could sympathize with this claim at least. As an art dealer I have learned that although lighting is crucial to a painting's presence, its surround can be pivotal too. Many paintings, particularly old masters, lack their original frames and require new ones. These can be commissioned from workshops, or old ones can be bought from specialist dealers and auctions and then cut down or adapted to fit (we have our own in-house craftsman whose job is specifically to do this). Framing is a surprisingly challenging science, and if the colour, design, or proportions are wrong, much as with the clothes you choose to wear, a glamorous picture can be reduced to a dowdy frump. Linda's response – a questioning of the painting followed by its acquittal – was fascinatingly revealing and one that I now discovered the work had already provoked.

The first person to voice misgivings, and then explain them away, had actually been the museum's former director, David H. Wood, and Linda took me to the other end of the library to play me an old tape recording from the early 1980s. The library's archives of items relating to Rockwell were understandably comprehensive, down to musings and interviews that could be useful. So we listened to the formal tones, reminiscent of an early radio broadcast, of Wood's voice from the grave. A man who did not mince his words, he recalled seeing the picture in the late seventies, when it was on exhibition at the Bennington Museum in Vermont. Although he thought it was 'awful', crucially he did not overtly challenge its authenticity,

Thomas Gainsborough (1727–88), *Self Portrait as a Boy* Oil on paper on canvas 22.8 × 20.3 centimetres (9 × 8 inches) © Philip Mould Limited

Young Tom Gainsborough painted himself at around just twelve years of age. Even as a child his talent was prodigious, as indicated by this assured self-portrait, which probably dates from 1739, the year before he left Sudbury, Suffolk, for London.

Thomas Gainsborough (1727–88), Cornard Wood

122 × 155 centimetres (48 × 61 inches)
© National Gallery, London
The National Gallery's Comand

The National Gallery's Connard Wood, one of the most famous of Gainsborough's early works, is an undisputed masterpiece. According to the artist, it changed hands twenty times throughout his life.

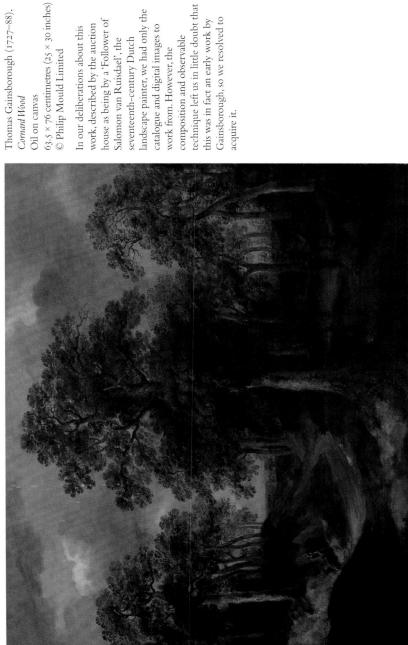

Thomas Gainsborough (1727-88), Cornard Wood

technique left us in little doubt that landscape painter, we had only the Gainsborough, so we resolved to house as being by a 'Follower of this was in fact an early work by work, described by the auction catalogue and digital images to work from. However, the In our deliberations about this composition and observable Salomon van Ruisdael', the seventeenth-century Dutch acquire it.

View from Cornard Wood © Philip Mould Limited

This viewpoint, close to where Gainsborough sat to paint the early *Cornard Wood*, takes in the distant steeple of Great Henny Church, Essex.

Oliver in Cornard Wood © Philip Mould Limited

My 11-year-old son Oliver sitting beneath an oak on the edge of Cornard Wood. The tree was notably similar to some of those portrayed by Gainsborough in both his paintings of the wood.

Don Trachte (1915–2005) after Norman Rockwell, *Breaking Home Ties* Oil on canvas, 111.8 × 111.8 centimetres (44 × 44 inches) © Norman Rockwell Museum, Mass., USA

This painting, a fake by Don Trachte Senior, hung as an original Norman Rockwell (1897–1978) in the Rockwell Museum in Stockbridge, unknown to the experts, until the original was discovered in Trachte's home in the year following his death.

Bohemia in Arlington
© Collection of the Trachte family

Dressed for the 1955 street fair in Arlington, Vermont, are, left to right: Normal Rockwell, Don Trachte, Frank Hall, Vic Donahue and George Hughes.

Don Trachte (1915–2005) after Norman Rockwell, Breaking Home Ties (detail) Oil on canvas 111.8 × 111.8 centimetres (44 × 44 inches) © Norman Rockwell Museum, Mass., USA

Norman Rockwell (1897–1978), Breaking Home Ties (detail)
111.8 × 111.8 centimetres (44 × 44 inches)
© Norman Rockwell
Museum, Mass., USA

By comparing the boy's head in the two pictures it is possible to identify the shortfalls in quality that reveal Trachte's picture to be a fake. The expression is less alert, details such as the treatment of his ear are too soft and the overall cast of the features hints at caricature.

preferring instead to ponder on whether it was a preparatory rather than a final work. He reported discussing it with none other than Rockwell's son, Jarvis, who then introduced a concept that a number of doubting Thomases satisfied themselves with thereafter: Jarvis concluded that at some point it had been over-cleaned, which had removed glazes, and that what could now be seen was underpainting rather than the finished product. This view was certainly latched onto by a visitor to the museum who had some authority on the matter, a summer student of Rockwell's in the late 1940s called Don Spaulding. When he saw it soon after its arrival at the museum in 2002 he told Linda that he had watched Rockwell working on the painting. "You should have seen it, it glowed," she recalled him saying, and it broke his heart to encounter it as it looked then."

Linda decided to pursue another line of inquiry. By way of explanation she advanced the tape to a second recording, of around the same date. This one was from a Louis Lamone, who was an assistant to Rockwell after the artist moved from Arlington to Stockbridge in 1953, which he did in order to be closer to his wife Mary, who was undergoing therapy for depression at the nearby Austen Riggs Center. Lamone had perfect recall of the picture being painted, and with compelling exactitude recollected that it needed another inch added on one side because the *Post's* printers had told him it did not fit their format; it was therefore taken off its stretcher and the necessary extension added by Rockwell. Surely, Linda had thought to herself, if I examine the picture out of its frame I should be able to detect this in some way? She duly did so, when it was hanging in the racks in temporary storage, but despite a thorough

investigation she was unable to find any anomaly.'I thought this would be the perfect way to verify it,' she told me, 'but tiresomely it revealed nothing.'

Next Linda aired some of her thoughts with Don, after which they agreed to send the painting to the Williamstown Art Conservation Center in Massachusetts, regional experts in restoration with twenty years' experience of Rockwell's paintings. They assiduously analysed it and although they could not find anything that suggested that it had been extended, they did conclude that it was entirely consistent with Rockwell's technique. They also cleaned it, which helped the colours function better.

There was one man, however, regardless of any improvements or analyses, who would never be assuaged. As an artist, more specifically a portrait painter, John Howard Sanden was a devotee of Rockwell and, of all the museums he had visited, regarded the Norman Rockwell Museum as his favourite. He loved its elegant design but also its exclusive focus, not least (I suspect) because his own subjects have a hygienic, clean-shaven, traditional look that technically owes something to Rockwell's style for expressing the myth of modern America. His sitters appear to have a good feeling about themselves, and, although un-testing as works of contemporary art, they are the sort of family portraits that comfortably slip into the middle-class interior in a way that will never scare pets or grandchildren. Rated by some as among the ten most successful portraitists in America, Sanden, with his two studios, in Connecticut and New York City, and his smoothly professional presentational skills, had become a figure who could not be easily overlooked. In

the late 1950s and the 1960s he had had the intriguing job of art director for the preacher Billy Graham and when he first saw *Breaking Home Ties* hanging at the museum he responded with a combination of artistic indignation and evangelical zeal.

'He returned a number of times,' Linda recalled, 'and frankly scared the staff, who had to ask him to stand back from the picture because of his demonstrative hand gestures.'

A master of website communication, Sanden rhetoricized online on the subject. 'What was going on here?' he asks in a posting which can still be found. 'What was a world class museum doing showing an inferior replica?' Not just content to protest in person, in the same communication he claims to have written seven letters to the museum to state his case without receiving a considered reply.

Linda and her fellow staff were irked by Sanden's protestations but nonetheless decided to accept the picture for what it was – the Rockwell that had been bought by Don Trachte from the artist, but that had been damaged in some way, quite possibly, Linda surmised, when it was exhibited in Russia and Egypt in the mid-1960s after the canvas had been rolled up – an old-fashioned technique for conveniently sending works long distances which would give today's conservators coronaries. The different climatic conditions it had suffered when travelling might also, she considered, have detrimentally affected its appearance, so that when it returned it would have required considerable restoration and conservation.

Don had got to hear of Sanden's dissatisfaction and was now regularly reading his website. Having established the family background, Don now moved the story forward for me. His pace had changed and it almost sounded like real time, as if the subsequent events were still unfurling. I had the benefit of being able to match the account from the two perspectives: that of the museum, rattled but resolved to sedately continue in their affirmation of the work's authenticity; and that of the owners, bewildered and frustrated, now wondering whether lending it had been a good idea at all, their treasure a target for art world slung mud.

The children had decided that they wanted to explore selling the painting. It had been insured for \$3.5 million but in the ascending twentieth-century market was now likely to make considerably more: every few months the major newspapers had been reporting record-breaking prices for twentieth-century masters, and the desire to ride this ascendancy was pressing upon them.

But, in addition to Sanden's regular enemy transmissions, other things were now beginning to trouble the family – strange, connected happenings which began to coalesce into a sinister implication.

In 2004 the Illustration House, New York's leading commercial gallery and auction house devoted to illustrative art, asked to borrow another picture from the family collection, *Head Tied*, a scene in a printroom by Mead Schaffer. But when Don sent them a photograph they politely declined on the basis that there appeared to be discrepancies between the Trachtes' picture and the published illustration. 'This caused us considerable concern at the time,' Don recalled, 'but we were all so busy we did not get too hung up.' The disquiet, although temporarily buried, would return.

Don Trachte Senior died in 2005, two weeks before his ninetieth birthday, and in July of that year his children held a small service of remembrance at a local church. They repaired to their father's house for a family gathering, during which one of them, by chance, found in a closet a painting by George Hughes called *Green Herons*. That would not have been strange in itself, except that it was an *exact* replica of another Hughes picture that was hanging nearby on the wall. So close were they in appearance that, to the children at least, it was impossible to tell them apart.

The confluence of Sanden's website campaign, the rejection of the Schaeffer and the Hughes in the closet was now too much to ignore and it began to pulse uneasily through the four of them. It turned to critical when Don went to New York later that year to the Illustration House – not, as it happened, for any other reason than to discuss the identification of some cartoons that had belonged to his father.

'The gallery's founder, Walt Reed, seemed a bit nervous and distracted,' Don explained. 'Then his son Roger, the gallery's president, joined him, and they said they would like to talk to me. I got the impression they had something of great importance to relate. As it turns out they did, but not in many words: "Somewhere, sometime, something has happened to *Breaking Home Ties*," Walt told me solemnly. In retrospect I now realize they were trying to let me down gently.' As both father and son were published experts on the subject of American illustration, this euphemistic detraction was as good as a fatal pronouncement, tilting Don into a torpor of pessimism.

'I came home depressed and told the others, "Folks, I think we are stuck." What made matters worse was that I had a call from Peter Rathbone, head of modern American art at Sotheby's, telling me that this would be a great time to sell and it could be slated for a spring auction. I found myself stuck in a terrible dilemma, and suggested to Peter that perhaps we should authenticate it first. "Why would we question it – it's been in your family all the time?" he replied."

Don felt himself incapable of progression. If he told Peter Rathbone everything he now knew it would scupper an auction sale, but at the same time this was prospectively a hugely valuable family asset, of apparently impeccable provenance and to the right collector – who could surely make up his own mind – the ultimate acquisition. And it was, after all, hanging on the Rockwell Museum's walls: what greater imprimatur could there be than that?

Dave now entered the conversation to explain how he had taken it upon himself to make his own investigations. The mountain man differed from his brother in more ways than the contrasting lifestyle. Dave was a pragmatist used to addressing and solving mechanical problems; he talked with the same precision as Don but with the irony of a younger brother now doing it *his* way. To me, the third of four siblings myself, it smacked of familial realism and took me closer to the conclusion that they were hapless victims of their father's contrivance.

Dave's response to the drama embodied a touch of his father's do-it-yourself outlook. Here was something that did not add up, and in order to solve it he needed to fathom the breakdown and then fix it. He was also better placed to do so

than his brother. Unlike Don, who was away working in Burlington, Dave was just down the road and could make regularly visits to the lonely, now unoccupied, house to make observations, collect thoughts and try theories. He had studied the picture and compared it with the tear-sheet cover and was under no illusion that they *appeared* different. From that starting point there had therefore to be an explanation. He began to search for clues, and now with a more informed sense of what to look for, he took each room in turn, poring over his father's mostly untouched possessions, deliberating the significance of everything he found.

His application soon bore results. Buried among copious other photographs, he found two old photographs of *Breaking Home Ties*. At first he thought them identical but as he carefully studied them it became apparent to him that they differed minutely. His eye going from one to the other, he worked out that this was no trick of light or focus but was because they were two different pictures: the one that they owned and another, fractionally closer in appearance to the tear-sheet cover. Dave rose from his chair and handed the two photographs to me with the aplomb accorded to courtroom exhibits. Even from their slightly bleached appearance I could see how the boy's expressions differed, but they were not clear enough for me to be sure exactly how. For Dave, however, this was the blatant proof he required, and he now applied himself to the hunt with even greater zeal.

Digging further into the family archives, he had then managed to locate the numbered negatives for the roll of film and with it a startling revelation: the photo of their one was taken before the other – thus going some way towards establishing that theirs could not be the same picture with repairs, damage or repainting. Animated by progress, Dave was each night on the telephone discussing every new revealed thought and fact with Don, while continuing his solitary visits to root around the house, aware that the next stages of progress could depend on him. The next advance he was able to report was that he had found in a storeroom a large roll of canvas equating to the size of their picture, together with an empty plyboard packing case of similar dimensions. And yet they agreed in their recollections, their father never painted pictures on this scale.

Don and Dave decided to keep these discoveries to themselves, and not to tell Linda Szekely Pero but instead to try calmly to develop a hypothesis on their own. Three options remained in play, which they juggled in regular phone calls each night: that there were no differences between the two pictures and their eyes were playing tricks; that the picture had been damaged in Russia or Egypt when it was on exhibition, or accidentally by their father at a later date; or, as now appeared increasingly plausible, their father had painted a replica. The discovery of the numbered negatives seemed to rule out the damage, but as it was the most attractive option, and in a last, vain attempt to prove it, in May of that year Don organized for the picture to go back to the conservators in Williamstown with the instruction that they should carefully examine and analyse the boy's face to see if there were any signs of alterations or repairs. The sombre answer came back that there were none.

Don, extremely busy at work in Burlington on a project to supply a large radar system to the military, was frustrated not to be able to collaborate in person with Dave in his forensic investigations of the family home, but he did arrange to go down for a weekend in mid-March. Dave in the meantime kept searching behind mirrors and furniture and in every other possible hideaway until he ran out of places to look. On the Thursday before they were due to meet, having found nothing further of significance, Dave decided to turn his attention to the fabric of the house itself, and in particular the walls. There was frankly nowhere else left to go. He started in the studio room and, examining the panelling that had been erected by his father in the 1970s with a mechanic's methodology, Dave tapped, pushed and squeezed anything that might not be fixed, until he discovered a noticeably loose plank. He carefully levered it back to open a crevice just wide enough to peer into with a torch. Its beam fell upon a partitioned area about 25 centimetres (10 inches) deep, in which, to his inordinate thrill, he could just make out the edges of two hanging canvases - one big, the other small.

He stopped what he was doing and rang his brother.

'I think I've found something,' he said in a voice guarded yet jubilant, 'but I'm not going any further till you come down here!'

It was the Thursday before St Patrick's Day, Dave recalled, and despite the demands of work Don decided to leave early, at noon. Sitting across from me, both brothers were now wreathed in smiles and almost talking in unison as they recounted how Don arrived with a bag of demolition tools, only to be told by Dave that he would not need them. Their father was too good a craftsman for that; all they would require were their hands and a little brain. Dave had largely figured out

how the jigsaw-like apparatus held together, and after removing ornaments and decorative wooden boxes the brothers dismantled the shelves one by one. The bottom one had a return that extended around the panelling to its right, and on removing it they revealed runners which were clearly designed to allow something to be drawn back. It could only be the adjoining panel wall. When they pushed the section, which measured 2.4 metres by 1.2 metres (8 feet by 4 feet), it gave way with ease. Almost paralysed by astonishment, like Howard Carter discovering the tomb of Tutankhamun, they saw, in previously darkened solitude, five oil paintings - the very same pictures that they thought had been distributed in the divorce settlement. In an instant they realized what had happened. In the early seventies, when their mother had moved out, but before concluding the divorce negotiations, their father must have made copies and secretly retained the originals. The authentic works, with the exception of the Hughes which they had already found (though not then realizing its significance), were the paintings they were now gazing upon.

There was no sign of the Rockwell, however. But they had only opened the outer tomb. The ultimate discovery required sliding back of the adjoining panel, which, as it turned out, was diametrically behind where *Breaking Home Ties* had used to hang before it went on loan. Rarely does a physical artistic discovery come as gratifyingly instantly as it did to the two brothers at that moment. In the art world with which I am familiar, tangible revelation normally follows a painfully uncertain process of restoration as a picture's true form and validity are gradually awakened. Not so here. With a slide of the wall a year of uncer-

tainty was put to rest, every clue explained, the spectral shadow that had haunted the siblings' peace of mind roundly exorcized. The Rockwell hung before them, together with another picture from the cache, its surface glowing almost as pristinely as if it had just left the artist's studio, the boy's face laced with authentic expectancy and anticipation – and, as Don added with a note of triumph, the canvas was conspicuously replete with its tacking edge where it had been extended for the printers. There could be no better signature of genuineness than that.

Having enjoyed the tumultuous elation of closure, Don had now turned his mind, with the collaboration of other family members, on how to break the story to the Rockwell Museum. It was something that needed to be handled carefully. There was bound to be an element of incredulity, initially at least, and if they were not properly mindful this could lead to allegations of deception and obfuscation on their part, particularly as they had been in possession, prior to the discovery, of strong circumstantial evidence that the picture may be a fake. Although the quest had ended, the aftermath was just beginning.

Stephanie Plunkett, assistant director of the museum, arrived at work on Monday morning to find a message on her answering machine. It was from Don and had been left the previous day. He sounded uptight but gave no details as to why, simply ending the call with the fateful words, 'We are coming to see you.' Stephanie and Linda met the brothers later that day, leading them to a private office where they could talk confidentially. Don began by saying, 'We've got some good news and some bad news.' Both women remember how, after this tantalizing introduction, they listened to Don's meticulously measured account

of the various stages of the family's growing concerns. As they wondered when and where his story might end, after twenty minutes he reached the finale: the painting hanging on their walls, he concluded, was a copy by his father.

Linda recalls a sense of relief surfacing through the shock she felt at the disturbing disclosure. At least, she now thought, that explains the doubts. Stephanie hot-footed it off to report what had happened to the museum's director, Laurie Norton Moffat, and plans were immediately put in place for a cohort from the museum to visit the house. The director and Stephanie, together with a conservator, Sandra Webber, their PR director, Kim Rawson, and two art handlers set off on the Tuesday, returning later that week with the now discredited *Breaking Home Ties* to make a side-by-side physical comparison. There could be no doubt: this was the real picture.

Don has no such recollection of the slow build-up to owning up to the discovery – he thought he had just walked in and told them – but this is perhaps an indication of the nervousness he was suffering, combined with accumulative memory blur caused by the amount of times he would subsequently need to relate this tale. Over the next few weeks he and his family would have to break this story hundreds of times, and among the first was to his mother, who at eighty–nine had lost none of her scepticism about her ex–husband, despite the passage of time and her subsequent remarriage. Sitting in her chair at the farmhouse down the valley, surrounded – until then unwittingly – by her husband's fakes, she listened intently and silently to the story with her hand on her mouth till the end. Her response was somewhat understandable. 'It doesn't surprise me,' she said acidly.

The museum also had some patching up and explaining to do, not least to John Howard Sanden. To this day he defines himself as the only one to have remained 'firm in the contention that the painting on exhibit for nearly three years was a fake'. The PR mechanism was effective and swift: Sanden and his wife were invited to lunch with the museum's director and received what he described as a 'very gracious and sincere apology' which he accepted with 'understanding and sympathy'. The museum's staff, having carefully considered how to handle what could be deemed a severe embarrassment in the museum world, responded with homeopathic dexterity: they held a comprehensive exhibition around the whole episode, curated by Stephanie, putting both pictures on show and telling the story of Don Trachte Senior and the Arlington art group.

Those who visited the exhibition, which was assembled in double-quick time and opened just two weeks after the discovery, were able to see the two pictures side by side, and so could have made up their own mind as to whether they would have fallen for the duplicity. Although I did not have the benefit of seeing the fake with the original, Don and Dave gave me the opportunity to examine the former, which they had held back until the end of our conversation. Although I have bought many copies of originals, only once (as far as I know) have I unwittingly bought what could be described as a contrived fake of a known artist. A minor London auction house had offered a 32-centimetre (12 inches) high self-portrait by the famous British fakerTom Keating, best known for his convincing counterfeits of the valuable nineteenth-century water-colourist Samuel Palmer. I bought it in the belief that it would

be a good painting to have in stock for the well-fed collector who wanted a witty aside to add to his collection. It was only when I picked it up from the auction house and examined the reverse of the canvas, then looked up the manufacturer's stamp, that I realized it was painted after Tom Keating's death: I had bought a fake of the faker. What intrigued me about Breaking Home Ties, however, was the scale and ambition of the sham. The picture was 112 centimetres (44 inches) square and full of technically demanding shapes, recessions and tones, added to which the work of Rockwell was as familiar to the American public as any twentieth-century artist could be. He had chosen a tough act.

Don and Dave hauled it out of a back room and unwrapped it for me in the large studio room. Although it was then late afternoon and the shadows were lengthening, the daylight lingered sufficiently to illuminate its surface. I was fascinated by the prospect of putting myself to the test. They propped the picture against the sofa, facing the main window, and I knelt before it.

At first glance it looked plausible. The paint had the lustre and finish I remembered from others at the museum. No wonder it had come back from the conservators with a clean bill of health, I thought. As a close friend and model, Trachte must have intimately observed the master down to the compounds he used and the way he applied his brush, a privilege open to very few fakers.

But there is something a conservator or restorer cannot necessarily tell, and this I suppose is where connoisseurship overtakes science. I had the grossly unfair benefit of hindsight, but the longer I scrutinized it the more I noticed shortfalls. The first was a certain shallowness. Despite the correctness of the pigments and the way they shone, the shapes and recessions appeared too glib and certain, lacking the sense of development you would expect from an artist originating a work from drawings, photographs, observations and his own memory. Once I was aware of this, the whole image appeared to soften, as if it had been carved in ice and was beginning to melt. I stood up, took a few paces back, and now noticed how the farmer's head lacked volume and that his lips failed to quite follow the contours of his jaw. I then registered faintly saggy areas of description in the bodywork of the car and, now my eye was in, the surrounding architecture too.

Most noticeable of all, however, was the emotional focal point of the picture – the boy's face. This was where Trachte had most noticeably given himself away. As humans with faces we have highly tuned receptors for registering the nuance of expression: it is a science perfected since the cradle. To precisely replicate a painted expression in a way that others will not notice, even for an artist copying his own work, let alone another hand, is a near impossibility. Comparing it with the one on the tear-sheet cover which Don had passed me, I now registered two different faces. Despite his best endeavours, and quite possibly imperceptibly to himself, Trachte's replication had inched across the boundary into caricature.

On 29 November the Trachte children and their partners were ushered into a private room next to the auction gallery on the eighth floor of Sotheby's imposing New York head-quarters on York Avenue. The auction house had organized the

ultimate showcase for the sale of so great a trophy: a catalogue dedicated solely to the picture, replete with illustrations, portrait photographs, scholarly contributions and a full account of its history, had been distributed to collectors worldwide; the Sotheby's publicity machine had been carpet-bombing the press with the story of the painting's dramatic resurgence, and now its availability to the highest bidder; favoured or likely clients had been given the opportunity to see it before the view days. The family had agreed a pre-sale estimate in excess of their insurance valuation of \$4-\$6 million, which even in its implicit optimism (in relation to the earlier valuation) could prove conservative in the prevailing market conditions. The previous auction record for a Rockwell was \$9.2 million, at Sotheby's in May of that year for Homecoming Marine, another arrestingly commercial composition, and there were those in the swim who believed this record could be broken.

The Trachte clan gathered on chairs around a video screen in a side room near the auction and were able to watch the family's financial destiny unfold in virtual reality as their father's beloved family asset appeared on the rostrum and the bidding began. The auctioneer, Dara Mitchell, opened at just below the lower estimate and the Trachtes sat adhered to their chairs as the bidding sedately climbed. When it had reached \$10 million they realized the roof had been lifted and anything was now possible. They kept on willing the bids to increase, and their exhortations worked. Together with auction commission, *Breaking Home Ties* exceeded all records for the artist by making just over \$15 million — a price for the artist that as I write has yet to be broken. Although at the time there was some

speculation that Stephen Spielberg was in the running, the buyer to this day remains anonymous.

The night of our interview Don suggested we go for dinner at a special place he knew, a restaurant high in the mountains over Arlington. There, he said, we would be joined by his partner Michelle, whom he had described more than once as having been an important sounding block and companion during the final months of the revelation. As Don and I sat in the bar awaiting her, a local band was setting up behind us and the proprietor's 6- or 7-year-old daughter was perched on the carpet counting out a pudding bowl full of dimes, sprightly calling out her tally as she approached 100. I chose not to ask Don what he and his three siblings had done with their proceeds of the sale - it felt too crassly tabloid (although I gather Dave did go out and buy a new digger) - but I did want to know what he thought his father had been up to, and why he had not told his children of the secret before he died. To me it was obvious that he had embarked on a fraudulent act in the early 1970s when the marriage settlement was being discussed. The fact that, after three years' negotiation, he ended up as the lifetime keeper of the main picture was not something he could have forecast. Once he was committed to his plan, particularly after friends, family and visitors had become familiar with the fakes, it seemed to me that he simply could not risk exposing any of them as not being the real thing. Besides, who knows, perhaps privately he relished the fact that his artistry could be every bit as good as his nationally successful contemporary, for chippiness is often one of the motives that drive a faker.

'As we grew up,' Don recalled, 'he became increasingly reclusive. His work was off-limits to us and we became distanced from him as time went on. Every time we speak about him now we try to work out what he was up to. And then there were the clues — not just the ones we found before, but also afterwards.'

Don produced a piece of folded yellow paper that he had found among other documents in his father's safe after his death. It was a diagrammatic plan which consisted of seven rectangular shapes correlating exactly with the size and position of each picture hidden behind the panelling. There were no words or explanations, just this simple map-like drawing. When he first went through his father's possessions Don had entirely overlooked it, but since the discovery, and on revisiting the papers, its relevance had hit him like a lighthouse beacon. The fact that his father had locked the document in a safe he also regarded as highly significant.

'So it seems he was trying to lead us to something,' Don said. 'But only after his death,' I replied.

'That's true - though we got there in the end.'

'But what is your considered view as to why he did it?' I asked, wanting to hear it from the eldest son in plain words.

'I have sometimes thought that perhaps he painted the pictures for security, in case they were stolen. The thieves would then end up with worthless copies,' Don answered.

'But it wouldn't have prevented him telling you,' I pointed out gently.

'Yes, but perhaps he just went to sleep at the wheel. He crossed over into another time zone. It was just something he forgot to tell us.'

Michelle arrived and we went through into the restaurant. A sophisticated, elegant woman in her fifties who had trained in psychology, she added a thoughtful under-layer to the evening's conversation. She had been Don's partner for four years and from what he had told me, and the proud way he presented her, was a pivotally supportive element in his life. We placed our orders and with Don's guidance I chose a bottle of Californian Merlot. While we waited for the wine Don briefly excused himself to go to the bathroom, so that Michelle and I had a few minutes to chat alone. It was a useful interlude: the two brothers' accounts, combined with Linda's recollections of the previous day, were still thrumming in my mind, and as I'd had no discussions with anybody except the protagonists I felt in need of some sideline perspective. Not that I didn't genuinely believe the story of the discovery as it had been told to me. It had the stamp of authenticity, but knowing how people in the art world sometimes respond more to what is documented on paper than to what is on the canvas, I could see how one viewpoint had eclipsed the other. Don and Dave's punctilious account, charged with honesty, certainly felt dependable. The only thing that was missing was some objectivity about Don Senior himself, in light of Don's evident veneration of his father and his reluctance to attribute any base motives to him. It all now linked in with the house's shrinelike interior, the untouched surrounding gardens and, as Don had begun to tell me in the car on our way to the restaurant, his desire to set up a museum around the story of the discovery and of the Arlington Art Group. Why couldn't he see his father for the faker he was?

Michelle began by recalling the nightly telephone conversations between the brothers, and the escalating pitch of intrigue as hypothesis began to be fleshed out with real evidence. I then edged her round to the subject of the posthumous culprit.

'But what about Don Senior?' I asked. 'What type of man was he?'

She answered the question, as I hoped she would, with an observation about his son.

'There's something very strong going on with Don Junior's attitude to his father,' she was saying as he reappeared, 'and it seems that for the time being he can't get beyond it.'

This was the confirmation I was seeking: Don could not propose the straightforward theory that his father was a selfserving faker. He was blocked by filial piety - and it was strikingly similar to the unquestioning reverence that he, and many others, had shown towards the fake Rockwell. Parentage and provenance share similar powers of supremacy. I have often observed how its story, a tumultuous price, or the esteem attaching to a former owner can dictate the perception of a picture's merits, and indeed auctioneers and dealers sometimes rely upon these. Although a painting's provenance is no more than a historical given which can be added to or subtracted from as facts emerge, to penetrate this, or 'get beyond it' - as Michelle observed about Don's perceptions of his late father can prove an insurmountable task, even though there may be every reason to do so. Don's devotion to his father was as constraining as the most air-tight provenance.

Yet this mortal trait can have its upside, I reflected, as Don drove me back down the steep mountain road to my hotel and,

with my encouragement, continued to sketch out ideas for Arlington's first art museum – an institution for the public good born out of a son's unquestioning love for his father.

Provenance can unlock a picture's importance just as easily as a false history can misrepresent it. It has happened thousands of times, and to me most memorably some years ago when I informally partnered up with a very significant man.

There are certain people in the commercial art world whose influence and financial clout are prodigious but whose role, because they do not have a visible presence in the form of a ground-floor gallery or do not attend art fairs or stage exhibitions, remains broadly inconspicuous. Dr Alfred Bader is one such figure. This most unusual man and his wife have financed a number of highly important acquisitions by myself and by others. Bader is a figure of such curious and impressive background that his story needs to be told in a voice other than his own, not least because the account of his trajectory from poverty to plutocrat, together with the epic tale of the love affair between Alfred and his wife Isabel, help throw light on the irrepressible tenacity and motivations that have impacted on the world of old masters.

I first met Alfred in 2000 when he wandered into my then upstairs Dover Street Gallery. At first I had no idea who he was. A man in his late seventies, he had his wife in tow, who followed him up the stairs with polite, tight-lipped compliancy in her no-nonsense woollen coat. The couple were met at the door by my office manager, Lottie Tate, who ushered them into my office. His appearance did little to persuade me that this was

a man here on business. He wore an undistinguished grey raincoat and his largish frame, balding grey head and strong glasses put me in mind more of a retired academic than a business magnate. He also carried a picture under his arm. We have quite a few visitors of a certain age who call by on the off-chance of discussing a picture, and as long as there is not pressing business to attend to we do our best to help them with their queries, which are normally to do with the identification of a portrait. But, when the man told me his name and I recognized a German-American accent, pieces began to fall into place. Moments later, as he continued to explain that he was both a dealer and a collector, reeling off a list of high-profile colleagues with whom he worked, the full realization of who had walked into my gallery hit me. Now, as I recall closing my office door and beckoning them to sit, I am acutely aware that the sudden change in my body language must have suggested an uncouth eagerness.

This art-world angel (to use a theatre term for a backer), collector, dealer and notable philanthropist, was born in Vienna in 1924. His mother Elisabeth was the daughter of Count Johann Nepomuk Serenyi of Hungary, a Catholic aristocrat, one of whose family's castles, set in majestic Moravian countryside and bedecked with frescos and family portraits, is today a museum. Alfred's father, a Jew, was the son of Moritz Ritter von Bader, a brilliant civil engineer who aided De Lesseps in the building of the Suez Canal and was later knighted by Emperor Franz Josef I of Austria. Because he died two weeks after he was born Alfred never knew his father, whom he describes as a charming but shiftless gambler. As a

boy he was told that his father had committed suicide but later worked out that he was more likely to have been murdered.

His death left his wife and two children destitute, added to which inflation was raging in Vienna at the time. Elisabeth had no choice but to allow her son to be adopted by her late husband's sister Gisela, a wealthy and childless widow who raised him a Jew, while his sister remained with his mother to be brought up a strict Catholic. Alfred fully adopted his new mother and his affinity with Judaism became increasingly important. Every Friday they lit candles, they never ate pork and as he went off to sleep he would recite the Shema (an affirmation of Jewish faith). This religious identification became even more pronounced when, on the rare occasions he saw his real mother, she would make the sign of the cross on his forehead and warn him, 'Anyone who could be a Catholic but chooses not to is sure to go to hell.' His problems were compounded when she remarried a Nazi, according to Alfred a brute of a man who tried to rape his sister and was briefly imprisoned for it.

In the 1930s life for Alfred and his adopted mother became increasingly terrifying. Vienna was awash with anti-Semitic propaganda, hideous pictures and caricatures were pasted up, fascist rallies and purges struck at all things Jewish, and the synagogues were attacked. Hatred on the streets contrasted with the unconditional love Alfred received at home. Gisela was partly assisted by a fat, jolly governess and factotum called Hilda and together they saturated Alfred with affection, butter and cakes, giving him a pot belly which he never lost.

New anti-Jewish laws obliged Alfred to leave school at the age of fourteen, but already the art dealer in him was germinating, for whenever he had the money he would buy stamps, and on one occasion an old master drawing.

Material comfort did not last long. Gisela faced financial ruin after a series of disastrous investments, the *coup de grâce* coming when she followed advice to put her remaining money into mortgages on Viennese coffee houses which then failed in the depression. They were forced to partition off their house, sleep in the same room and do without a bathroom. The political situation reached breaking point in March 1938, when Hitler marched into Vienna to be met by citizens with tears of elation in their eyes.

The opportunity for Alfred to cut and run came in the form of the Kindertransport, a series of trains that allowed Jewish children to escape mainland Europe for Britain. Ten thousand visas were issued and the 14-year-old Alfred took a place on the first train from Vienna. On the cold morning of 10 December Gisela, Hilda and Alfred's real mother tearfully saw him off at the station. He had prepared for the trip by swapping, with a local dealer, some of his stamps for the ones that would be most saleable in Britain, secreting them in his suitcase in the hope that the Germans would not confiscate them. Gisela, who some years earlier had been given a \$1 bill by a friend, now slipped it into his pocket.

Unknown to Alfred, he would never see again the three women who had come to bid him farewell. Gisela died in Theresienstadt, the Nazi concentration camp near Prague, in 1942, Elisabeth died of a stroke in 1948 and Hilda was felled by cancer during the war.

Alfred worked hard to overcome adversity in the alien world of England. He was given lodgings in a small room in a house in Hove with once-removed friends of his aunt and attended the local school. Soon he showed signs of academic distinction and a particular enjoyment of chemistry. And meanwhile his dealing skills were sharpening: he started trading in stamps, becoming quite an expert at buying them in the Lanes, an area of Brighton then full of dealers, and selling them to his school mates. This remained his only source of pocket money for a couple of years until, to his great shock, he was summoned to a hearing in May 1940 for contravening visa regulations by earning money. A Brighton stamp dealer called Spowart had reported him to the police, describing him as a national threat.

Before Alfred could attend court, however, matters of greater consequence supervened. Churchill, alarmed by the threat of fifth columnists after the invasion of the Netherlands, Belgium and France, had ordered, 'Collar the lot.' Just turned sixteen, and ten minutes after he had summoned enough courage to ask a girl for his first date, Alfred was detained by two detectives, who drove him home to collect some clothes and a toothbrush. At first he thought his arrest related to his stamp dealing, but Churchill's order had been to arrest every refugee between the ages of sixteen and sixty-five. Two months later he found himself at Fort Lennox, a forbidding internment camp on the Ile aux Noix in Quebec, Canada. He had also been parted from his suitcase.

Even though internees were imprisoned behind a barbedwire fence and subjected to a six-day week of tough labour, life at the camp improved as a result of a growing awareness that these people, all Jews, were not dangerous enemy agents. Alfred now looks back upon his time there with considerable gratitude and fondness for the friends he made and, above all, the education he received. Young people were allowed time off from their chores to study in a camp school run by another internee, an able engineer from Berlin who used textbooks supplied by the International Student Service.

Alfred absorbed everything that was laid before him. In November 1941 the internees were freed and Alfred continued his education by gaining a place at Queen's University in Kingston, Ontario, followed by a move to America to take up a fellowship in organic chemistry at Harvard. Educational accolades were heaped upon him. By now a formidably competent chemist, he started work in Milwaukee for the Pittsburgh Plate Glass Company in chemical research until, in 1951, he cofounded Aldrich (later Sigma-Aldrich), which became the world's largest supplier of research chemicals. Forty years on, with the inordinate fortune he had accrued, he turned his attention back to a more personal form of fulfilment. By then stamps felt limiting to him and were replaced by the larger, one-off attractions of oils on canvas or panel. In 1992 he left Sigma-Aldrich, took on an assistant and opened an apartment gallery in downtown Milwaukee's Astor Hotel, a base from where he could both sell lesser value pictures on his own account and collaborate as a backer – as befitted his more ambitious tendencies – to a number of international dealers handling major works of art.

That was the man now sitting in the chair opposite me. He had accepted a cup of tea and had begun removing the shabby,

reused brown paper from the picture he had been holding. But no sketch of Alfred Bader would be complete without the inclusion of the lady sitting beside him. Isabel had begun to intervene in the operation, helping carefully fold the wrapping paper and unknot the string for use later in the week, expressing with some piquancy how important such savings were. This was part of a powerful joint creed – justified on the basis that the more they could save the more they could give away – with which I was to become familiar, occasionally to my exasperation but ultimately with fondness. It is an ethos which pervades their life.

It was while sailing from Quebec to Liverpool on the SS Franconia in July 1949 that the 25-year-old Alfred Bader met Isabel Overton, who was two years younger. A highly attractive woman with an elegant nose and fine legs beloved by her husband, she has in early photographs the alluringly natural, expressive face and evident intelligence (with a look of Meryl Streep) which drew him so strongly towards her on that voyage. Photographs of Alfred at that time – the young, notably handsome chemist with something of the Hungarian aristocrat about his looks – give the impression of a man bristling with the self-confidence born of recognition for his achievements. He was ready for marriage, they fell for each other instantly and he proposed within nine days.

Alfred was increasingly bound up in his faith (the following year he became a Jewish Sunday school teacher in Milwaukee) and religious devotion featured strongly in Isabel's life too. However, she was the second daughter of devoutly Christian parents from Ontario, her father serving as a lay preacher

(although for a short while he had been a Jehovah's Witness), and given her earnest attachment to Christianity few would have thought of pairing her with a committed Jew from Vienna. And even though Alfred was experiencing a curious pull away from the Semitic roots which he had embraced since childhood, as if in love he was seeking a greater affinity with his mother's faith, there remained a religious incompatibility that struck Isabel as irreconcilable. After a romance of just a few months which nevertheless saw the exchange of eighty-one love letters, she wrote saying that for this reason marriage could not work. Despite the grief it brought him, Alfred ceased to contact her after his last two letters to her remained unanswered. Isabel settled in England to pursue a career as a teacher at Bexhill-on-Sea in Sussex.

Two years later Alfred married Danny who, although the daughter of a Protestant pharmacist from Aberdeen, South Dakota, had accommodatingly converted to Judaism. They would stay together for thirty years and have two children, but after twenty-three years of marriage Alfred began to suffer recurring nightmares in which the gaunt figure of Isabel's father kept asking him why he was not with her instead. It impelled him to find her address, which he did by contacting her brother through the alumni society of Queen's University, where he had been a student, and much to his surprise he discovered that she was still a teacher in Bexhill, and still unmarried. He decided to fly over to see her. Isabel's father, after hearing that Alfred was returning, died that same week.

The woman Alfred found was the same woman he had parted from. In the intervening years she had never cared for

another man, harbouring a hope that he would return to her. They had an emotional reunion, although at first she told him to go away, saying that he was happily married and he should leave her alone. But just as Isabel is known for her moral rectitude, so Alfred Bader is known for his powers of negotiation, and six (platonic) years later, in 1981, destiny prevailed. Danny, aware that she could not steer her husband away from the object of his fulfilment, asked for a divorce: six months after it was granted he and Isabel were married. Alfred was fifty-seven and Isabel fifty-five. Since then they are rarely encountered apart.

Alfred asked me to sell the picture that they had unwrapped for me that day. It was a drawing of the poet T. S. Eliot smoking a pipe and I was able to add some research and an attribution, which meant that we were able to elevate its value by $\pounds 2,000-\pounds 3,000$, a profit which we duly split between us. But perhaps the most memorable part of the transaction was the punctilious way Alfred then worked out every cost down to the last few pence, the framing and all other incidentals, as well as the interest payable. I didn't know it then, perhaps he didn't, but it turned out to be a test, and one to which he has subsequently referred. I passed through an initiatory trial of trust and competence which led to an enduring commercial friendship.

Two years later I watched, from the back of the saleroom, the same man who can spend half an hour trying to work out how to save £15, and who walks around with lengths of used string in his pocket, bid £35 million for a Rubens at Sotheby's, Massacre of the Innocents. I came up to him after the sale to commiserate after he failed to buy the painting – it went for

£45 million and today hangs in the Art Gallery of Ontario, Toronto—and used the opportunity to relay some news on the first major picture we had bought together. Having been prepared to spend so large a sum of money, only to be roundly beaten by the opposition, he was in that deflated and distracted post-auction mood I know so well from my own experience. Our picture, however, although by no means of similar stature, was beginning to look like a success story and I was aware that its fast-emerging commercial prospects could only act as a tonic to his wounded spirits.

The painting, which we had bought the previous year at Phillips in Bond Street and which had launched our collaboration, was a fully catalogued portrait by Sir Anthony Van Dyck of Lady Mary Villiers, daughter of the ill-fated Duke of Buckingham. After Buckingham's assassination in 1628 Charles I effectively adopted his children and brought them up at court as his own. This portrait of Mary appeared to have been painted shortly before her marriage to the Earl of Pembroke in 1635, when she would have been flitting around the royal palaces as a relatively carefree 14- or 15-year-old. She was dressed in an arresting golden-yellow gown, but what so attracted me was how the painting demonstrated Van Dyck's skill in imbuing a portrait with movement and atmosphere. It was as if Mary had glided through the picture space just long enough to be painted, her head turned to the artist with an arresting look of coquettish nobility.

When I first saw it the picture was extremely dirty and overpainted, but underneath it was evidently in good shape. Alfred agreed that from the catalogue illustration it appeared to be an interesting and important work, then proceeded assiduously to cross-question my rationale for wanting it — or, to be more precise, for his paying for it. He may have begun to trust me, but he also needed my argument and conviction. After a number of incisive telephone calls between us and his own visit to the auction preview, he agreed with me that, although it was nothing like as elaborate or ambitious as some of Van Dyck's more monumental paintings, it was definitely something of consequence and charm: put with art dealer's bluntness, it was an authentic and saleable work by the biggest British name of the seventeenth century. To me it also had the look of something potentially more exciting, but at that stage I could not put my finger on precisely what that was.

The problem was that there was no early provenance to suggest who had first commissioned or owned it, and although it was thought a generation later to have been in the Legge family, cousins of the sitter, there was nothing to connect it to either Mary or the King. This would have considerably elevated its status, particularly for a museum buyer, so it was an aspect I promised Alfred I would work on. A painting of Lady Mary Villiers described as 'before she was married' was in fact recorded in the collection of Charles I himself, far and away Van Dyck's most significant patron and a considerable art connoisseur in his own right. It was listed before the King's execution in 1649 as hanging in the Gallery at St James's Palace, together with others from his abundant collection of artistic treasures, including a painting of Mary's two young brothers, also by Van Dyck. Following the King's death his whole collection was dispersed by Cromwell to pay off debts and, although

a number of the better works ended up in collections in mainland Europe, after the Restoration of the monarchy in 1660 strenuous attempts were made to regain as many of the lost pictures as possible, as well as to add to the collection and fill gaps. In the process a picture by Van Dyck of Lady Mary Villiers – noticeably older-looking than in the portrait in question – was added, first officially recorded in the reign of James II, towards the end of the seventeenth century. Sir Oliver Millar, an expert on Van Dyck who became Surveyor of the Queen's Pictures in 1972 and later Director of the Royal Collection, had implied in his cataloguing of the painting in 1963 that this was likely to have been the same picture as had been hanging there originally, thus (quite possibly unintentionally on his part) hindering the claim of any other portrait of the sitter by Van Dyck to have the same lustrous provenance.

The picture was estimated at £150,000-£200,000 and after a skirmish with a pair of American-based dealers we ended up buying it for just under £400,000. Alfred did the bidding, and having bought it he passed it over to me and I sent it to be restored by Katherine Ara, a highly regarded restorer I had used before for trophy pictures. As is the normal procedure, she carefully inspected it in studio conditions, carried out tests and firmly suggested that after cleaning, and before she started retouching, it should be delined and then relined. Relining is a common procedure by which the original canvas, which naturally degrades or loses its tension, is re-supported by affixing it to a new canvas with adhesive. This process is often essential in order to resuscitate a painting's original surface and to prevent flaking or paint loss. Relining can happen a number

of times throughout an old picture's life, and each time the reliner will peel off the replacement support canvas before applying a new one. This makes it possible to inspect the reverse of the *original* canvas and see it as it was when it left the artist's studio. Although often obscured with glue and paste, this otherwise hidden area can sometimes reveal crucial inscriptions relating to the painting's authorship, identity or history.

I was in the South of France on holiday, somewhere between my laptop and the swimming pool, when I received a telephone call from Katherine. I'd spent an unsatisfactory week trying to resist the demands of the office, which was thrumming with administrative trivia that I had felt unable to delegate. The sun was in its full glory but I was unable to wean myself off the routine and feeling short-changed by life's pressures. Normally controlled and academic in her response to pictures, Katherine betrayed her exhilaration with a bright skip in her voice as she told me of the latest development. She had just put the phone down after talking to Tim Watson, one of Britain's leading reliners, who had been entrusted with the Van Dyck.

Watson was in a state of some excitement, and for good reason. On the reverse of the picture's original canvas he had discovered the royal cipher, an ink brand stamped by the royal archivist during the reign of Charles I on pictures that had been in the Royal Collection. What made him doubly pleased was that he was a member of the Sealed Knot, a group of enthusiasts who don English Civil War uniforms and weaponry at the weekend and relive seventeenth-century conflicts, and this was just the sort of thing that got him going.

For different reasons it had the same effect on me. I went to the pool and announced to the soporific gathering that we had just struck upon the most exciting and conclusive proof of the ultimate English provenance. The sunbathers barely broke off from their books, but the revelation allowed me to forget the office, enter my imagination and start the holiday. That evening I phoned Alfred in Milwaukee and he responded with jubilance of a different kind. 'That means we shall be able to sell it more quickly then,' he said, before going on to discuss the next stages, restoration and framing, and the implications of dollar interest rates upon the investment.

When Lady Mary arrived back a few months after I had returned refreshed from my break in France it was as if she had enjoyed some of the same: rejuvenated, she looked more poised and royal than ever. The relining and restoration had been highly beneficial and the paint surface, which also had been gently cleaned, with minor abrasions rectified, was now radiant. The same day it arrived I had it professionally photographed to send to Sir Oliver Millar, together with a photograph of the royal cipher. Millar was the obvious man to show it to as both the then leading expert on British-period Van Dyck (a role now amply filled by Dr Malcolm Rogers) and the former Director of the Royal Collection. He telephoned me a week later to say he would be able to call in before lunch the following Friday and that he was looking forward to seeing the picture. It was a pleasing prospect for me too: I had something new to add to the history of the Royal Collection as well as to the repertoire of his favourite artist and I looked forward to receiving his approval.

The portrait was sitting on the easel in my office when Millar walked in with his wife Delia (who would often accompany him on his art-history jaunts), and Lady Mary looked more ready than ever to receive an audience. Although in his late seventies, he retained the discreet look and manner of a period courtier himself. Tall, fine-looking, inordinately well educated in art and history, devoutly Christian, and altogether quite scary to certain dealers and auctioneers, he was beloved by the Queen, who had elevated him after forty years' service to Knight Grand Cross of the RoyalVictorian Order, the most distinguished order of chivalry for those who have served the monarch with distinction.

I had done my best to prepare both the picture and the room for the occasion. Lady Mary had been reframed in ebonized black, in contrast with the tawdry nineteenth-century gilt frame we bought her in; we had drawn down the blinds and dimmed the gallery beams to light up her orange dress as if by candles – the most atmospheric lighting for paintings of this period. What had also became apparent in this gentle lighting was that her facial expression was more whimsical; subtle cleaning of the flesh tones and slight strengthening of abraded glazes to the hair had returned volume and character to her head. In both artistic and art-historical terms she was now fully functioning.

In a way I saw this meeting as little more than a formality: a picture of this subject was recorded in the Royal Collection, the stamp conclusively proved that it had been there, there had been no others recorded, and the one Millar had published – before this was discovered – had no such brand and did not

evoke a woman 'before she was married' anything like as much as this portrait. All it required was for Millar to revisit the latest evidence with an open mind.

'An appealing picture,' he said in his low, courtly voice, 'and noticeably informal.' I hesitated before responding, picking up a hint of reticence which made me edgy.

'The brand certainly *looks* right,' he added after surveying the photographs I had placed next to the portrait.

'So at least now we have a picture to match the description?'
I ventured.

He continued to ponder, saying little, then after a minute or so turned to his wife and said, 'Not the sort of painting that is likely to have hung in the long gallery, though. Not grand or substantial enough.'

I could hardly countenance what I was hearing. All it required was for him to say that he just might have to reconsider this as the picture referred to in the inventory, but the longer he ruminated the less it appeared to be forthcoming.

'Are you saying this was not in the Royal Collection, then?' I asked, my exasperation surely evident.

'No, that it was probably in some closet or bedroom, and somehow missed being listed.'

'But it also much more fits the description of someone *before* their marriage, rather than the later one in the Royal Collection,' I tried to argue, but it sounded more like a whine.

He didn't react much to this and returned to examining the picture surface.

Meetings with Millar never lasted that long, and after this one I didn't feel like further confronting him on his own turf: it would only have left me bruised by an avalanche of facts and references to which I could not have responded without flee-ing to my library.

When my visitors had left I went straight to my library and took down from the shelf the fully transcribed list of pictures hanging in the Royal Gallery at St James's Palace during the reign of Charles I. I could not rule out what Millar had just proposed, but what had knocked me was the certainty with which he had concluded it, to the implicit exclusion of any other possibility.

Although measurements were not given, the gallery was full of paintings of different sizes and orders of magnitude: there were indeed a good number of monumental old masters but also lesser works, among them such intimate asides as a still life of a book and a painting of a church interior. While it may not have been able theatrically to compete on the same level as a lot of the grandees, Lady Mary could have certainly held her own, possibly hanging quite high, and within sight of Van Dyck's portrait of her young brothers.

I am left with no other conclusion but that for Millar to have revised his already published inference was too great a departure for him. He later reaffirmed his position in the *Van Dyck Catalogue Raisonné*, published in 2004, which he co-edited. Here he failed to mention under the entry for our portrait, despite the unequivocal evidence of the royal brand, that there was a reference to a painting of this subject in the St James's Palace Gallery during Charles I's reign. Instead he cited the possibility under the catalogue entry for the one hanging in the Royal Collection (without a brand that has been found) which

he had originally favoured as the candidate. This was not to be the only time I discovered that this doyen of seventeenthcentury British art could not cross the psychic hurdle of rectifying an earlier pronouncement, and I have encountered other such authorities too. His initial (suggested) provenance remained immutable - for me it recalled what the family history had done to the Trachte 'Rockwell' - rendering the emergence of alternative possibilities awkwardly invalid. This is not to say that Millar, who died in 2007, was not an outstanding scholar, for he certainly was; but it is an example of how even the most distinguished academic expert is emotionally susceptible to what they perceive - wrongly in my view - as the cement of their scholarly reputation given that they have already expressed a published view. The episode also offers a glimpse of the challenges, touched on in my introduction, in rehabilitating a discovery in an academic art world and market that is forever evolving.

My own mind, Alfred's and those of many others, including a senior member of the Royal Collection staff, remained firmly attuned to the notion that ours was the picture listed, and although art-historically frustrating, commercially Millar's reticence made little difference. The cipher had waved a magic wand over the portrait's status, and a year and a half later we were able to sell it to the Timken Museum of Art in San Diego for close to £1 million in a private deal through an auction house. After this Alfred and I became more of a team than ever, and I have been fantasizing about royal ciphers concealed behind prospective purchases ever since.

* * *

Provenance can also *lead* the hunter to the quarry. It has done so on many occasions when a work of art that was known to have existed is traced via the trunk or branches of a family tree to a living descendant. As a last resort, when we have been requisitioned to find a picture and have exhausted the commercial and exhibition records, we have employed this method ourselves – but it can feel embarrassingly like cold calling to ask an 'unknown' if they have been fortunate enough to have inherited a treasure. There exists one man, however, who has excelled in the use of this style of genealogical research to track down the lost portraits of one artist in particular, and he has done so with tenacity and skill.

Christopher Wentworth-Stanley looks, in his mid-forties, just like the sort of character that Graham Greene would have stolen for a novel. He would make a most convincing post-war Foreign Office man: intelligent, self-effacing and manifestly English, he is as intolerant of his culturally dumbed-down homeland as he is attached to his adopted city of Vienna. After arriving in Austria on a school-exchange trip at the age of sixteen, he never returned to live in Britain, later installing himself as a portrait painter in Vienna, a society still susceptible to the touch of the grand manner that his swagger brush was able to offer the descendants of the Austro-Hungarian Empire. In between his art-historical activities this rarefied ex-patriot is now normally to be found in one of two atmospherically contrasting haunts: the Austrian Jockey Club, a bastion of the ancien régime, located in the Ringstrassenpalais in the heart of the city; or the Café Hawelka, by far Vienna's most authentic bohemian refuge, whose idiosyncratic continuity has been

assured by the proprietor and his late wife who have run it since shortly after the war, a time when Leopold Hawelka was obliged to wheel his wife's pram out of the bombed-out city to the local forests to gather the café's firewood.

I was in Austria for a wedding with my wife and had arranged to meet Christopher at the café on a burning-hot summer's day, although sunlight was scarcely able to penetrate the tobacco-stained recesses where I found him seated at his regular table, subtly designated by one of his own drawings of the Hawelka's interior above his head. Even at a distance there was no mistaking his British provenance: with his noticeable height, receding hair, skilfully cut tweed jacket (he had managed to find and instruct a Viennese tailor to cut his cloth in the English style) and polished London-made brogues, his bodily presence marked him out as eloquently as the uproarious laughter and loud Etonian drawl with which he greeted us.

Seeing Christopher again instantly brought back the first time I encountered him, at a London drinks party when we were in our twenties. On that occasion, still wearing his tails from a wedding, he had been at full throttle anecdotally and plied me with his ardour for a portrait painter who had established his reputation in Vienna in the early years of the twentieth century, Philip de László. Christopher's regard for his works was still emblazoned on him as we sat together that morning, and it was heightened by the fact that over the past four years, in collaboration with the artist's grand daughter-in-law, Sandra de László, and a team of assistants, he had helped create an impressive online *catalogue raisonné* of de László's work,

in the process perfecting a technique for tracking his lost portraits as effectively as the most astute private investigator.

Between 1899 and 1914, when de László primarily worked in Vienna, hundreds of men, women and children sat to this artist whose fluid, effervescent style – at first glance reminiscent of the great society painter John Singer Sargent – elevated them to beau monde. He later moved to London to provide the same service and many English collections from royalty downwards contain his works (he even painted the present Queen as a girl, a picture the Royal Collection has on display in Clarence House, the former Queen Mother's house). I myself have handled a number and was once shown one on *The Antiques Roadshow* which we were able to establish was a forgery on the basis of its misspelled signature, much to the gloom of the owner.

When it came to preparing the catalogue the co-compilers quickly realized that many of the Viennese and European portraits were now lost from view, locked away in private collections or obscure museums where the radar of art history had not yet reached. Added to this, unlike the British, many Austro-Hungarian descendants tended to view their portraits not so much as art as private family documents; art historians who wanted a glimpse of other people's grandparents therefore tended to be seen as nosy parkers, and letters and approaches remained unanswered. Christopher's immaculate manners, social confidence, fluent German and artistic credentials – combined with skills he developed for arcane genealogy and record research – largely rectified this. He would track down the descendants, convince them of his integrity and

seriousness, make a visit and then fully catalogue the picture, sometimes resuscitating long-forgotten facts which were also a surprise to the owner. Astonishingly he has managed to summon back to life close to a hundred such lost images over the past few years.

De László was not the reason I had come to see him that morning, however. I had heard a charming story of how he had used this technique to track down a major painting by a Russian count who was hiding in the city.

'Oh, that thing!' said Christopher when I told him I wanted to include it in my book. Where do you want me to start?' He called to the waiter for coffee and took up the story at characteristic high voltage.

It was the art patron and banker Jacob Rothschild who triggered the chase. Christopher had met Lord Rothschild at a house party in a grand schloss in southern Germany and, during a conversation that centred on a swimming-pool house Rothschild wanted to build at his villa in Corfu, he asked Christopher whether he knew anything about classical architecture. So in awe was Christopher of the great man that he could not get out the word 'yes' - even though his knowledge of architecture. is spectacularly good - and this missed opportunity had gnawed at him thereafter. Having met Jacob Rothschild myself, and once tried unsuccessfully to negotiate with him over a picture, I could entirely understand the near-catatonic effect that he might have induced in Christopher. Rothschild exudes patricianism, partly by his looming aristocratic presence (captured in oils at the National Portrait Gallery by Lucien Freud) but also the family name, which headily summons the two

centuries of financial and artistic elitism that he continues to embody. The British branch of the dynasty came to prominence after the Battle of Waterloo and in a more sustained way than probably any other European family has retained its powerful influence in finance, politics and the arts. Jacob Rothschild himself has held a string of high-profile artistic appointments, including chairmanship of the National Gallery, and is a man that someone in his world would not wish to disappoint.

A year later, as chance would have it, Rothschild telephoned Christopher to ask whether he might be able to track down a full-length portrait of Count Kirill Razumovsky, a towering figure from eighteenth-century Russia who held great political sway at court and was also a European collector and patron of prominence. So handsome, witty and charming was Razumovsky that Catherine the Great observed that the most beautiful women at court squabbled over him. Rothschild wanted to exhibit the painting of the eighteenth-century beau in conjunction with a Sèvres dessert service commissioned by the Count and which he had recently acquired for Waddesdon, the Rothschild family home in Buckinghamshire, now administered by the National Trust. He knew that the portrait, painted by the exquisitely smooth neo-classical Roman portraitist Pompeo Batoni, had been exhibited close to half a century earlier in Rome – but he had been unable to progress his search further than that. Razumovsky's son Prince Andrey had been ambassador in Vienna and some of the family had settled in Austria, so Rothschild wondered whether the portrait had remained there too. Christopher did not wish to make the same mistake this time around and impetuously answered, 'Of course, Jacob.'

Having put down the telephone, he realized he did not know where to go. This was no early-twentieth-century Viennese nobleman by a society portraitist he was seeking but something altogether earlier, more valuable and more exotic. Batoni's portraits are highly sought after and frequently fetch well over £,100,000 at auction; his best works, should they come on the market, would make millions. Daunted but nonetheless determined, the portrait hunter turned therefore to his tried-and-tested technique of first considering the most likely scene of the crime. Sleuthing a lost portrait from scratch can be depressingly difficult. My business has sometimes felt like a failed missing persons bureau when descendants ask, indeed on a few occasions plead, for my help in finding their lost ancestors. Having exhausted all the normal art-historical literature, photo libraries and archives, and checked auctions and public exhibitions, you can do little except offer them a cup of tea and ensure them that you will do your best. Beyond advertising the image (should there be one) throughout the appropriate press in the same way one might look for a lost cat, luck is about all you can depend upon.

Christopher did, however, recall meeting in Vienna a man who happened to bear the same name as the sitter, a journalist who worked for the German newspaper the *Frankfurter Allgemeine Zeitung*. The chance of his being even distantly related to the ambassador prince (who had no legitimate descendants) struck him as remote, not least on the basis of his distinctly unprincely appearance. In a city known for its elegant formality Andreas Razumovsky, Christopher recalled, looked noticeably down at heel, with the wiry beard, unkempt hair and bottle-

glass spectacles of the unworldly intellectual. He needed somewhere to start, though, and so went to his library, not this time to the Almanach de Gotha or some rarefied genealogy but to another work, which had in the past proved a valuable resource: the local phone book. Running through the first few R's he did find a man of that name living in an apartment block in a rundown part of the third district, which Christopher described delicately as 'rather too close to the Gürtel', Vienna's outer ring road. Despite its proximity to the Belvedere and Lanckoroński Palaces, with their fabulous art collections, the nearby railway station had been targeted by air strikes during the SecondWorld War, leaving the palaces and surrounding buildings in ruins and sixty years on the neighbourhood had yet to recover. It felt to Christopher like the sort of place that the journalist might live and so telephoned him. By now confidently adept at this type of near-cold call as a result of his art-historical researches into the lost portraits of de László, after initial convivial chatter he artfully moved the conversation round to the subject of Mr Razumovsky's family pedigree. To Christopher's confoundment Mr Razumovsky revealed that Count Kirill was not only his relation but a direct ancestor. This was more than he had dared hope for, and he went eagerly on to describe the portrait he was looking for in the hope that Razumovsky might have known of its existence or, better still, have seen it.

'Do you have any idea where it might be?' he asked.

'Of course,' Razumovsky replied, failing to appreciate the impact of what he was about to announce.'The problem is that it is too big for my apartment. Come and see it if you want, it's hanging on the stairs.'

Christopher hurried over to encounter Count Kirill in the stairwell of the dingy building, as he had been promised. This highly important trophy among the artist's full-length portraiture, arguably his most ornate image of aristocracy and one of his highly desirable Russian subjects, was hanging ignominiously in a communal area of the apartment block, vulnerable to theft – although its sheer size would have daunted all but the most determined burglar – and all manner of possible damage. Razumovsky had little concern for its importance or value, viewing it as a slightly cumbersome piece of family furniture.

Christopher telephoned Rothschild, the loan was arranged, and the painting set off for England, where it remained for two years at Waddesdon.

Quite what happened to it after it ceased to be exhibited in 1999 I do not know, but it was a painting now firmly implanted in art-historical consciousness, as well as that of a group of Russians whose fortunes were to dizzily escalate over the next eight years. Razumovsky died and later his family decided to sell the picture. Two months before I finished writing this book I watched it fall under the hammer in a specialist Russian sale at Sotheby's for just under £1.3 million: a quaint example of how a man's lucky but bold approach to the logic of provenance both unearthed a valuable treasure and won him the regard of an art-world titan.

THE SCHOLAR

In an old house in Amsterdam lives a professor who wields daunting power in the highest echelons of the art world. His name is Ernst van de Wetering and he has come to be an arbiter of life or death for the works of Rembrandt van Rijn. Given that Rembrandt is arguably the most famous artist who ever lived, this allows the professor's deliberations prodigious consequence. If he gives your seventeenth-century panel painting the 'up' sign it could be valued at, say, £15 million. Should he give it the 'down' sign, perhaps as little as a few thousand pounds. Considering that to 99.9 per cent of the population both works would look the same, it is easy to see why to many the status of this man is somewhat akin to that of a medieval alchemist – a superhuman who can transform base metal to gold or, to put it more prosaically, a piece of antique decoration into a compelling cultural artefact.

In 2003 something greatly heightened my curiosity about Ernst van de Wetering. He had been sharply thrust into the media's glare when a previously overlooked Rembrandt fake, of negligible value, was unmasked as an original to be offered at auction. Asking around I began to piece together one of those absorbing tales of detection and commitment that so often make art-world discoveries more compelling than the ripest fiction, and from which the professor and his team began to emerge with audacious triumph. I have to admit to a personal fascination. The skills he demonstrated go to the core of what I and many others aspire to do for a living; the difference was that here was an establishment intellectual prepared to take daring risks not for any commercial gain but in the exclusive pursuit of truth.

The name of the picture's owner was gifted to me. It came from a lucky meeting with a French small-time dealer in old masters at the opening night of a contemporary art exhibition in Bond Street. It was one of the many modern shows thrown by Thomas Williams, an old-master dealer with an artist's background and a flare for promoting new talent to balance a business specializing in the long dead. Having noticed the Frenchman at auctions and other events over the past twenty years, I had marked him as a man well tapped into his native art scene, from where, it was rumoured, the picture had recently emanated. His calling card was a richly patterned Scottish tweed suit, cut rather more huggingly than Savile Row would countenance, and I spotted it from across the room. Perhaps he had confused the Pimms for lemonade but, by the time I made my way over to him through the noticeably glamorous multitude that evening, he was drunk. A slice of lemon had tumbled from his glass and lodged itself between

his shirt buttons, an observation for which he thanked me before becoming pipingly emotional on the subject of the Rembrandt which had filled the art press the previous week. He was intoxicatingly keen to unburden himself. The owner, he told me, had been a dealer in *broccante* (bric-à-brac) named Paul Page. He had known the man in the sixties and had even bought some items from him: he also clearly recalled the picture hanging on his wall. If *only* he had acquired it when he had the opportunity to do so, he morosely exhaled, his life would have taken a different course. As all ownership details had been held back from the press this nugget was progress, but I was not keen to play receptacle to either the teetering contents of his glass or his mounting melancholy and chose to call it a night.

Paul Page had bought the painting in a Paris auction in the 1960s, this part of the sale provenance was known, but what I later gathered from others was that he did so with the not uncommon dealer's hope that it might be genuine, that beneath what looked like later additions of jewellery and ornamentation lay an authentic Rembrandt, struggling to free itself from its incarceration by paint. Having secured the work, Page decided to play part liberator too. It was, and still is, a common enough practice for dealers at the lower end of the market to avoid costs by restoring paintings themselves, sometimes with disastrous results in the case of sensitive old masters. As I admit in my introduction, I once judiciously tried it myself, in the full knowledge that an enthusiastic amateur wielding solvents and blades is about as reassuring as a beautician with a blowtorch. To be fair to Page, however, a previous owner had already

begun the process, as evinced by a surviving photograph from the thirties which showed that the subject had originally sported a faintly farcical red bonnet. Page perilously continued the process by removing yet more detail with a scalpel – namely a pair of gaudy earrings, together with hair and moustache extensions.

Despite some very strange passages in the face, including a solid-looking fish eye, and an unlikely costume, Page's further trimming went some way towards improving its appearance so much so that he felt ready to requisition the support of an academic authority. In Paris at the time there was one obvious figure who, although not a Rembrandt painting expert, carried a reputation for exacting connoisseurship: Frederik Lugt. In my gallery we have a number of his volumes on the history of collections and these have proved an invaluable research resource. Frits Lugt, as he was known, was more than just a punctilious amasser of invaluable information, however, and it is easy to see why Page would have sought him out in the sixties, for at the end of the previous decade he had helped found the Institut Néerlandais, a bastion of Netherlandish culture in France with the express aim of promoting Dutch literature and the arts to the French public. It also became the home of the Fondation Custodia, a choice collection of paintings, prints and books meticulously collected by Lugt and his wife

In what circumstances Lugt first viewed the picture is unknown to me, but his response, I discovered, was guardedly encouraging. He did not rule out the possibility that it was by the great master. But, whatever view he might personally have held, he did not have the authority to elevate it, particularly given its compromised state.

In the 1980s, Page and Lugt having died, Page's daughter (whose first name I have not found; had I continued with my inebriated companion I might have done so), mindful that it was still unfinished business, decided to try to progress the painting's destiny herself by seeking the opinion of one Maria van Berghe, the then incumbent director of the Institut Néerlandais. Van Berghe duly sent an image to Josua Bruyn in Amsterdam, who in the 1980s was one of the most prominent Rembrandt scholars. The response was not heartening. The anointed expert pronounced it a 'charming fake'.

Still undeterred, a decade and a half later Page's daughter arranged to show it to the new gatekeeper of Rembrandt's work, Ernst van de Wetering. What happened next, with the professor's blessing, was the boldest feat of detection and restoration I had ever heard sanctioned by an eminent academic, and the desire to find out more grew irresistibly when I heard that the professor, together with his favoured restorer, Martin Bijl, had continued to perform these magical operations in their home city of Amsterdam. I was therefore uplifted when, after a couple of failed emails, the academic colossus finally agreed that he would be happy to grant me an audience and told me that Bijl would also see me the following day. As luck would have it, one of their latest 'upgrades' although somewhat more modest in physical transformation - was on display at the TEFAF antiques fair in Maastricht, so I decided to visit this and then take the two-hour train journey to Amsterdam.

Maastricht is to the newly cleaned, researched and represented old master what Cannes is to the latest film, and for nine days in March this ancient Roman city becomes a Mecca for the art and antiques trade, whose members present the finest objects they have acquired in the previous year; of late it has expanded to include more recent and even contemporary works. The fair is located not in the centre of the picturesque medieval market town but among a jumble of modernist buildings in a vast exhibition centre that has forfeited architectural distinction for functionality. Unlike other art and antique venues, such as Grosvenor House in London or the Armory in New York, its purpose-built efficiency allows exhibitors the freedom of theatre designers to express any concept or fantasy best suited to their wares. Some choose painstakingly to reconstruct the interiors of their gallery showrooms back in London, New York or Paris; others reinvent themselves, go sparsely modernist, or unleash their dreams by cladding their stands in original panelling from French chateaux. Everywhere there are treasures exquisitely lit and labelled, vetted by a crack team of academics, dealers and restorers whose job it is to uphold the reputation of the event and ensure that only the finest and the best can be set before the fair's visitors.

And well they might. For migrating to this feast of annual splendour are some of the world's biggest art buyers and most distinguished eminences: museum directors with their favoured patrons, major collectors both young and old, established and new art historians, journalists and writers, as well as a preponderance of dealers. It is the art world's equivalent of the mayfly

hatch, when trout unanimously break the surface, and it is there that the annual fortunes of many dealers are decided. As the profit made by the fair organizers is fed back into its running, the event becomes yet more ambitious and marketed each year. To add a flourish for old timers who have been visiting since its inception in the mid-1970s, in 2008 the interior was decorated with 175,000 anemones, representing 70 per cent of the world's entire cultivated production of the species for the first half of March. The imprint of its enlightened new chairman Ben Janssens, himself a dealer in oriental works of art, was also evident in a row of mini-stands next to the main restaurant, a new concept for less established dealers of quality who might one day make it into the grand pantheon itself. The city does its best to accommodate the annual event too. The morning I arrived, two days after it had opened, the organizers proudly reported that 10,000 people had attended their private view, that every hotel and restaurant had been reserved or filled, and that 136 private jets had already flown into the airport (including a private Boeing 707).

Manoeuvring my way through the blooms and past some of the 227 exhibitors, a number of whom were friends and colleagues, I finally found the Rembrandt. The proprietor of the stand, Will Noortman, was a youth by art-world standards, a fresh-faced, 26-year-old, Dutch Old Etonian with swept-back black hair and sporting a slightly burdened look on his fourth day of incoming crowds. His father Robert had been a remarkable powerhouse within the art world, determined, driven and inordinately successful, with a particular flair for early Dutch art, but he had died a year earlier, barely months after selling his

gallery and stock as a going concern to Sotheby's for what amounted to over \$80 million of shares and capital. I found Will seated at a large table in the middle of his capacious stand, behind him, cordoned off with ropes, an 18-centimetre (7 inches) high Rembrandt self-portrait around which visitors were constantly collecting.

I recalled too well that mid-fair feeling as I sat down with him that morning. Although my experiences derive from the art fairs of London and Palm Beach, the endurance course was similar, and I freely admit to not being good at it: the constant requirement to remain vigilant for the transformative big buyer (particularly the one who appeared on the first day seemingly ready to commit but has yet to return); the need to ration energy but be charming to all; the necessity to listen and be educated as well as to educate; and the growing awareness of the weight of your human frame as you stand in preparedness (I now increasingly sit) three days into a fair that continues for God knows how long more, fresh air and daylight dwindling into distant memory. Sometimes the pressure of such confinement grows unbearable and by the last day I have known experienced dealers to flip. At Palm Beach one year I and some of my colleagues developed an unhealthy fascination with the face-lift culture. It seemed that every wealthy female visitor over a certain age had been attended to by one of two surgeons who based his designs on either Michael Jackson or the Bride of Wildenstein: spotting the cosmetic master became a competition of some connoisseurship.

Will's stamina buoyantly revived when I asked him about his star attraction.

'This has been the picture's first Maastricht since it was rerestored,' he explained, looking back at the painting. 'We sold it to a collector and then, following the recent remarkable transformation, we are reoffering it for the present owner.'

Behind his public-school vowels I could not detect the faintest Dutch accent, and his manner was direct, open and engaging. I could not help feeling that William could one day go some way towards filling his father's shoes, or at least fashioning a distinguished pair for himself.

Rembrandt's eighty or so recorded self-portraits have always been particularly prized by collectors. Not only did the artist have haunting and, as a young man, romantic looks, but he used his face and body to express his constant explorations into technique and characterization. As Professor van de Wetering had proved, Rembrandt held them in stock for clients who wanted both the subject itself – the celebrated artist – and an intrinsic work of genius. Three hundred and fifty years later the market has remained as strong as ever.

The transformations to which William was referring were those to the hat and the hand. The diminutive portrait's recent history had restarted in 1997, when it was with a Parisian dealer and considered to be either a copy or the work of a follower. In that year Van de Wetering and his team conclusively declared it a genuine Rembrandt, a significant new addition to the artist's oeuvre and his smallest self-portrait. However, as the professor pondered it more over the following months while working on a major new study of the artist's self-portraits, he became convinced that something was not right, that there were anomalies to its appearance, which he managed to narrow

down to the artist's hat and hand. As befitted his proactive style he requested (via Robert Noortman, who was then handling it) that the owner allow them to do additional research, and, after intense scientific and art-historical analysis, he further suggested that these additions could be removed. The obvious man to do it was the RRP's expert restorer, Martin Bijl. The picture's owner acceded to the request. Bijl's solvents and scalpels got to work and revealed the shadowy remnants of Rembrandt's original hand beneath its prosthetic predecessor. The same was done to the hat, which had been fashionably 'updated', probably by the same artist at around the same time, and it was duly returned to its less voguish original appearance. Thus the Maastricht public were now invited to pay tribute to two exciting arrivals: the artist's newly revealed hand and his original hat - or, to quote the gallery literature, 'the painting ... as Rembrandt created it'. As I left his stand William accurately touched on the magnetism that such an object exerts on the inordinately wealthy: an original Rembrandt self-portrait, he commented with a smile, has ultimate sex appeal.

Although American museums sometimes deaccession pictures and discoveries are occasionally made, in 2003 Sotheby's worked out that only three Rembrandt self-portraits remained in private hands. This one was on sale for 18 million euros. The twenty-first-century art market had also been a commercially bountiful one for this artist, partly underpinned by high auction prices but also by dealers such as Alfred Bader and Otto Naumann. Also it often takes one man to boost a market, as had been proved by a 45-year-old Wall Street financier named Tom Kaplan who in the previous few years had

astonishingly managed to acquire at least eight original Rembrandts – an almost impossible accomplishment of collecting prowess given the scarcity of available works. The market for authentic Rembrandts was stronger than it had ever been, and to be able to offer at Maastricht a 'new' self-portrait courtesy of Professor van de Wetering and his committee was something of a coup.

I had arranged to meet the great man at the Rembrandt House, a priceless remnant of old Amsterdam which has the distinction not only of having been the home where for nineteen years the artist lived and worked, but also, by one of those historical flukes following his unavoidable bankruptcy in midcareer (during a liquidity crunch), of having had all its original furnishings and chattels documented in minute detail. Using the lists as a guide, the Dutch have faithfully reconstructed the interior with seventeenth-century furniture, objects and paintings (some of which hung there originally) with the same historical care and reverence employed at Anne Frank's hidden apartment a few streets away. I arrived early for my appointment and spent an hour looking through the menagerie of pictures, plaster casts, sculptures and artefacts from the kitchen upwards, many in the same position as they had occupied in Rembrandt's day because the inventories had identified items by location too. Rembrandt was an art dealer as well as a painter, and the large building was not merely a home to live and paint in but a place in which to entertain and do business, for he sold not just his own paintings and prints, but also works by pupils, assistants and other artists whose work he admired. For a period he had a thriving business supplying and producing art for the connoisseurs of Holland, employing a coterie of helpers to replicate, copy and adapt; and despite the dislocations of time and history, and the dead hand of the health and safety regulations that all museums must observe, the faint hum of seventeenth-century industry can still be imagined.

On the ground floor I took a moment to survey the bookshop, heaving with publications on Amsterdam's artistic legend. Ernst van de Wetering's name featured almost as ubiquitously as Rembrandt's. The sight of all this scholarship and the thought of the scantness of the research I had undertaken in London made me feel a little uneasy. How, I began to wonder, would I fare in conversation with so formidable a man about an artist who was far from my specialist subject? The princes of art history can be intolerant of ignorance, particularly when it is a result of not having read their own publications. I fully remember one to whom I showed a picture while at university, who told me to bugger off and read the second chapter of his book before he resumed the conversation. I am still smarting from the redress twenty-five years on. That formidable scholar, the late Sir Oliver Millar, whom we have already met in earlier chapters, had a courtly demeanour that could also be graciously withering, and as a younger dealer I would sometimes use his encyclopedic knowledge of British houses, collections and their ancestries to avoid direct discussion of the attribution in question, particularly if the picture was in poor condition, which he had a tendency to respond to as artistic shortfall. His forte was to swamp our discussion with a torrent of comparable examples 'of which of course you will be aware, Mr Mould'.

I knew that Ernst van de Wetering had been involved with Rembrandt for forty years since the Dutch Government's decision in 1968 to support a committee of establishment art historians under the name of the Rembrandt Research Project. The idea was proposed by two art historians, Professor Josua Bruyn (the same man whose opinion had been sought by Page's daughter) and Bob Haak, director of the Amsterdam Historical Museum. This was strikingly innovative, and the first time an authentication committee had been established for a deceased painter. In fact its establishment was deemed essential, for an implausible number of paintings were knocking around that were said to be by the nation's greatest cultural luminary, largely because there had been (and still is) a tendency to mistake for authentic original works by talented assistants and followers who deliberately aped their master's techniques and style. The Van Gogh Museum, following the RRP's example, has since taken a similar approach to its artist, and it is a style of comprehensive art-historical analysis which could greatly benefit a number of other internationally renowned painters whose works are often subject to such mistakes: I would personally like to see more inclusive forums for some of Britain's leading painters, notably Gainsborough and Constable, but the requirements of this approach are not without problems, as the RRP itself discovered in the early days.

In 1905, when the first serious Rembrandt catalogue was attempted, there were believed to be close to six hundred original Rembrandts in the world (this has now been reduced to about 330) and although by the time the committee began this

number had been whittled down, there was still a lot of confusion between the ducks and the swans. Ernst van de Wetering was present from the outset, although his initial attachment to the great endeavour was largely a fluke. Reading his CV, you would hardly describe him as the classic art historian the RRP's founders would have had in mind for the job. The son of a Dutch technical designer and a German mother, he trained as an artist at the Hague Royal Academy and then taught art at a secondary school, but at the age of twenty-three he decided to throw it in and travel through Italy, Egypt and Greece. In Greece he bought and journeyed around on a donkey to complete what, in his idiosyncratic way, he perceived as the authentic native experience. There this explorative bohemian met up with two German intellectuals who so fired him with academic enthusiasm that after another spell of teaching he decided to go to Amsterdam University to study philosophy, only to find he lacked the necessary classical qualifications, and much to his chagrin he was obliged to pursue art history instead. A noticeably accomplished artist, before he finished his bachelor's degree he spent six months in Brooklyn, New York, where he carved his own panel supports for his paintings and ground his own colours in monk-like, focused seclusion - a taste of the compulsive investigations he was later to apply to Rembrandt

At the age of twenty-nine Van de Wetering was invited to temporarily assist the fledgling RRP by its then chairman, Josua Bruyn. His job, that of a student assistant, was fairly menial to start with and involved planning research trips for the committee and assembling the necessary documentation;

it was not well paid and he was obliged to supplement his income with another of his gifts, the ability to play the flute, clarinet and piccolo, which he did in the evenings for professional orchestras. It was not long, however, before his visual talents were noticed by the professors of the RRP. This partly came about because one of the committee fell ill and someone was required to fill his place; the young administrator was therefore temporarily requisitioned. Able now to contribute more conspicuously, he was quickly perceived by his elders as having a peculiarly powerful eye born of an artist's practical insight. They wanted him to stay in Amsterdam, so a formal position was crafted for him within the city's Central Research Laboratory for Objects of Art and Science, where he would work for almost two decades. It was a fortuitous placement for all concerned. With Van de Wetering embedded with some of the brightest art restorers and scientists, not only did the RRP now have a sound technical underpinning for its investigations, but the hippy turned art historian could begin to foment his own potent blend of eclectic connoisseurship.

The appointment brought another benefit in that his growing experience equipped Van de Wetering with the moral courage to go further in seeking out answers than many art historians had felt comfortable enough to do before. During this period he gradually raised his profile as an internationally regarded expert, lecturer and adviser in both the theory and ethics of conservation and restoration, for six years coordinating a working group in the field for the International Council of Museums. This new brand of academic study, in which he

became a leader, partly focused on the controversial principles of how far it was acceptable to go in returning an artefact to its original appearance. In pursuing itVan de Wetering acquired the acknowledged authority which he was later daringly to wield as the RRP's chairman.

The committee's members had set about their work with the zeal of the Spanish Inquisition, travelling in pairs, traversing the world to cross-question every claimant, and developed a tendency to come to conclusions by group consensus using old-fashioned techniques of subjective connoisseurship. In other words, they established a concept of what a Rembrandt should look like and individual paintings were branded either 'right' or 'wrong', or occasionally accorded a 'don't know'. Howls of grief and shock were heard in some of the greatest stately homes and museums alike as news came through that the hallowed Rembrandt had been given the thumbs down. It even happened at Buckingham Palace, where the Queen was told that her esteemed Rembrandt Bust of a Young Man in a Turban was instead by his apprentice, Isaac de Joudreville. The process was cold blooded and in some instances unduly restrictive but nonetheless helped give the committee a ruthless authority. By 1989, and working chronologically, they had published three volumes, with considerably more to come, but, although integral to the project from its inception, Van de Wetering was beginning to feel unhappy. He had spent eighteen years attached to the laboratory, analysing the techniques, considering the functions of sketches, immersing himself in the theories of art of Rembrandt's time, as well as studio practices and fashions in art, and realized that a different approach was

required that involved a more inclusive style of deliberation. He saw paintings as a 'process' and attribution as crucially dependent upon a group of supportive arguments from various academic disciplines.

With youth on his side (the old guard were by now becoming aged) and a formidable group of collaborators from a diversely picturesque set of disciplines, among them the fashion historian Marieke de Winkel, the restorer Martin Bijl, the scientist Karin Groen and the dendrochronologist Peter Klein, as well as experts in archival research, handwriting, etching and drawing, in 1993 Van de Wetering, with his rarefied brigade beside him, raised his standard as the new chairman of the Rembrandt Research Project. 'Connoisseurship,' he announced in the Burlington Magazine, a leading academic publication dedicated to art, 'will be deployed with the greatest possible reserve and only when all other arguments have been exhausted.'The art world sat up and listened. He is not without his critics, including respected art historians who have challenged his approach, but, following the publication in 2007 of the RRP's fourth volume, very many continue to believe that Van de Wetering's committee and its dramatic advances - not least brave revisions of some of the previous committee's pronouncements - have gone further than anyone else in rationalizing and codifying the art and science of attribution. In the case of the Page self-portrait the RRP's joint disciplines and expertise had elevated a misshapen duck to a serene swan of the art world.

It was late afternoon when I arrived at the Rembrandt House Museum, where the receptionist told me that the

professor would meet me up on the third floor. As I exited the lift a group of what I assumed were Rembrandt-owning hopefuls of Middle Eastern appearance were being shown out. I saw that I was now at a centre of the living process, the place where Rembrandt's legacy must so often have been considered, adjudicated and discussed. A Dutchman who had been hosting the group then turned to me. He had a plump, Falstaffian appearance with white, curly hair and round glasses, but what gave his face distinction was the classically shaped mouth, which I immediately recognized from the dust jackets. Professor van de Wetering welcomed me with a hurried smile, offered me his hand, and then briskly led me off into a large general office, filled with desks, screens and books, which contrasted starkly with the historical interior of the museum – with one notable exception: somewhat incongruously propped on the floor were two Rembrandtesque paintings on low easels. The professor explained that one belonged to the Tel Aviv collectors who had just left, the other to a Miami collector, and then went straight to the point.

'I thought I might show you the sort of thing I'm frequently obliged to consider. Two paintings of similar subjects that show the workings of his studio assistants – "satellite paintings", we call them – variants of the master's originals, which he encouraged.' His ability to express complexity with clarity in a language not native to him was impressive. Throwing a look around the museum's nerve centre, he was clearly concerned that our discussions would disturb the staff, so before we got into any deeper deliberations he suggested that we go next door, where we could talk more freely.

This, it turned out, was the building next door, 'Rembrandt Corner', the house where Rembrandt first lived when he came to Amsterdam. It was also a bar and Van de Wetering admitted he would like to conduct our interview in relaxed circumstances and could do with a drink. We found a corner table overlooking a canal, above us, cravenly leering like an ageing fairground prop, a waxwork figure of Rembrandt. Ernst, as I was now asked to call him, speedily ordered beer and a plate of meatballs dipped in breadcrumbs, which were set down next to the weighty volumes he had brought down from the museum. Thus installed and ready to talk, he visibly relaxed. Within minutes this curious amalgam of artist, academic and, as I was to discover, disarmingly potent romantic became human. I was not there to see him with a picture to prove, my normal reason for visiting such pedagogues, but in a sense almost the reverse - for him to explain to me how he saw, how he understood, and how he had achieved the insights that have brought him and his committee their extraordinary status. It was a refreshingly novel dynamic that allowed me to play an ingenuous member of the informed public and he the vendor.

Unless they are challenged introverts, art historians generally learn to converse with a wider public, not least because of the need to persuade their publishers, fellow scholars and students about their product. Van de Wetering, it rapidly became clear, had elevated this power of communication to an altogether higher level. As he sipped his drink and nibbled on his snack he lured me into his subject with charisma and conviction that went well beyond the normal. He began by talking of Rembrandt the prodigy, the most intelligent and adventurous

artist in Holland, an artistic giant, unintimidated by history and thrillingly discovered in his native town of Leiden by young intellectuals knowledgeable about the arts, who identified in him the promise to 'surpass the achievements of antiquity'. It set the scene like the introduction to a great historical novel, yet all the professor was doing, in a greatly simplified form, was alluding to sixteenth– and seventeenth–century artist writers such as Karel van Mander and Samuel van Hoogstraten, in whose works he was immersed. By knowing about Rembrandt's times, the society in which he worked and the patrons who fed him, he explained, his art becomes more comprehensible, individual works more attributable.

'He reinvented painting,' Ernst continued, now in his evangelical stride. 'Rembrandt took every aspect and scrutinized it: space, light, drapery, human proportions, attitudes, composition, reflection of light. One of his great miracles was his use of paint, how he used it to imbue the painting with life; the play with chance gets stronger and stronger; it is a process that brings him closer to nature, and in a way the painting paints itself!' He had moved his drink and opened the book before him, gesturing to the thick, complex layers of paint applied with abstract wildness in a late composition. I loved the way he was now using an Amsterdam bar table from which to deliver meaty artistic concepts, evoking the passionate outbursts one might have heard in the artists' dives of Paris or Berlin in the early years of the last century. Rarely had I heard someone talk about seventeenth-century painting in such startlingly fresh, modernist terms or, for that matter, with such artistic confidence when he moved to the artist's play with reality.

He had turned the pages to an early self-portrait which I immediately recognized as the restored Page portrait. His insights now became more conspiratorial, like some senior figure from a secret society inaugurating me as one of the brotherhood.

'Notice how the light from the nose and cheekbone reflect into the eye socket,' he said. 'It can be described as a *traffic* of light, an example of Rembrandt's utter sophistication. The normal beholder does not question the means of illusion. If the illusion is successful by definition you do not see its means – but it's the means that creates the effect. By examining his art in this way, it gives us a greater vocabulary – and with that comes articulation, and the power of argument.'

It was masterful advocacy, born of indefatigable observation and reflection, the sort of incisive seeing and deconstructing that can lie at the heart of devastating connoisseurship. He had also mastered a style of conveying his subject's genius in that electrifying way with which I have seen great teachers win over and inspire their students for life.

Eventually, at my insistence, we moved the subject from Rembrandt to Van de Wetering and he talked about his artistic youth, his early desire to be a philosopher, and his love of Goethe and the German Romantics. We also discussed his home life and how he had divorced, then remarried, only to marry his first wife again in later life. The couple now lived on separate floors of their tall Amsterdam house. Such was Ernst's candour that I felt confident enough to broach the topic that particularly fascinated me: how he squared his life's work with the huge financial consequences of his deliberations. This

allowed me to go on to raise the subject of the Page portrait. In so doing I hit a nerve. His expression tightened.

'Money gets in the way of your perception of art. If you want to buy a sonata by Schubert you can do so for ten euros and with it a whole collection of others by him. A Shakespeare sonnet costs you nil. Great art should be everybody's, but the problem is that concepts of rarity and originality can block perception. The eye is disturbed by the aura of authenticity when looking at the original. This is why I greatly support the idea of popular reproductions as they remove you from this.'

'But how,' I asked trepidaciously, 'do you square all this with your power? Whether you like it or not, your pronouncements can have the effect of turning water into wine – or the reverse. Does it not daunt or compromise you?'

'I have tried to follow the cues of the Romantic movement,' he replied. 'To live life honestly, to trust my own emotions and get closer to the truth. This is what carries me, and I never involve myself with the money. Value makes me sick. I hate TEFAF and the art market – in fact I actively seek naivety.'

I couldn't recall how much I had told him about my own art dealing but considered it prudent to keep the subject out of our discussion. The way he was talking I was even beginning to question it myself.

'We all have the right to be naive,' he went on.'It gives us the freedom to get back to art and its purpose. Once I was charged for driving off a motorway along the hard shoulder towards the exit. I do not drive much and did so innocently because I was in a traffic jam and thought it would bring relief to the other drivers. A truck driver then blocked my way until a policeman

came along and fined me. I contested it in court, pointing out that all I was doing was trying to help. And yet they took me for a hard-shoulder bandit! The judge put it to me that I was behaving naively. "But it is your job, sir, to protect my naivety!" I replied. Neither now, nor then, do I feel guilty for my action because I was assisting others.'

Ernst smiled as he ended the story and I got the impression I was not the first to hear it. Taking another sip of his beer, he looked out of the window to the canal opposite and ruminated for a moment before turning to me with a look of sober reflection.

'Truth is of the utmost importance to me. This is what drives me. Until I was fifty I was afraid about telling people my secret.'

'Your secret?' I asked, wondering whether I had missed something in our earlier conversation or overlooked some crucial fact in my background researches.

'Yes, that for forty years of my life I thought that my father had been a Nazi.'

'A Nazi?' I replied, playing down my surprise. 'But I thought your father was a Dutchman.' Our encounter was moving into a realm I could never have anticipated. With Anne Frank's house close by it was easy to understand the enormity of Ernst's revelation. Even today the occasional German tourist returns to his car to find it scratched by Dutchmen with long and painful memories of the Nazi occupation of their homeland.

'He joined the NSB, the Dutch National Socialist movement,' Ernst continued unabashed. 'He was one of the many who were impressed by Hitler's rebuilding of Germany but also, like other Dutchmen, he believed it would prevent the Netherlands from becoming a part of the German Reich. In 1944 my German mother fled Holland to avoid reprisals but father stayed behind, following us to Germany in 1945. He was then arrested as a Nazi suspect by the British while sketching the little harbour of our village – they assumed he was a spy. After four years in various prison camps he was finally freed, which allowed us to return home. But during the forty years of my life between 1948 and 1998 I concealed the painful secret that he had been a member of that party. It automatically stigmatized him, all of us, as devils! It was a huge relief when I decided to tell people – it allowed me not to be afraid of anything any more. It is how I seek to lead my life.

'As it happens, however, some of my fears were unfounded. I later got access to the files and it turned out that he had never harmed anybody, nor had he been found guilty of any treason or collaboration. It was his membership of that party – and the fact that he been allowed to keep his radio – which deeply irritated the tribunal!'

By this time I was feeling that there was no subject I could not broach. I had also noticed that two and a half hours had passed and I had still not properly addressed the subject of the Page self-portrait. Now, as I began, he was totally prepared for my questions and in his response was a flicker of pride too.

'As you know, it had been turned down as a "charming fake" by my predecessor, Josua Bruyn,' he told me. 'It was 1995 and this time round I insisted to the owners that if we were going to relook at it we needed the full scientific team in place – the dendrochronologist, X-ray man, the paint sampler. When they

first showed it to me I remember thinking next that it looked like a Rembrandt – and then it didn't, because although the right eye, the chin, the nose, the contours were convincing, the rest was not. After two days of intensive analysis I was satisfied that it was a work produced during Rembrandt's lifetime and that the signature looked authentic.'

At this stage his research into Rembrandt's studio practices proved invaluable. His ingeniously convincing hypothesis (which he was later to write up) that these self-portraits were stock items in Rembrandt's art-dealing operation explained a course of events by which a genuine self-portrait could have turned into the work of a follower within his own lifetime. Under instruction or supervision from Rembrandt himself, his pupils could have either 'updated' the features to reflect the maturer man or converted them into a *tronie*, a fun-looking character head with more decorative or commercial appeal, in this case an exotic Russian. Rembrandt had an art business to run, and a little upgrading of his own work here and there made sense for a shopkeeper wishing to stay abreast of the whims of his fashionable clientele.

'As the additions had already been partly removed, this also added to our thinking, particularly as we had on file the photograph from the 1930s showing how it was,' Ernst continued. 'Under normal circumstances we would never advocate undoing part of a painting's history but there was a valid ethical argument in this case as radical interventions — in the form of previous paint removals — had already taken place, leaving it looking like a hybrid caricature. I told the owner not to sell the painting but to find a partner who would go through the

process of restoration and investigation. As we wanted the scholarly benefit of it I offered to supervise it. Martin Bijl, who ended up undertaking the restoration, was the perfect man for the job – he has guts and sensitivity and a great love and understanding of Rembrandt.'

I had arranged to see Bijl the following day and before we ended our conversation I asked Ernst about his own art. During the meeting it had struck me as potentially revealing to test how Rembrandt's appointed man on earth would handle a brush himself. He proceeded to describe a convoluted composition he was working on of himself watching his father painting in the German village in which they had lived before returning to Amsterdam - and where he had been with the family for only one week before his arrest by the British. In fact he had the watercolour that his father had painted hanging at his home and it poignantly evoked this time when the young Ernst followed his father around, watching him paint. At my request he did a rapid sketch of the composition he was working on, including the eye-lines of himself observing his father. As he prepared to leave I could not help but consider the significance of this and felt sufficiently emboldened to hazard an interpretation of his own artistic 'process', for it had struck me as headily poignant that he was seeking to memorialize his father in this way.

'A documented image of you witnessing the fact that your father was the painter of the picture,' I said. 'Given that your life's work has been about getting to the truth of authorship and attribution, your picture is unusually revealing, is it not?'

He was now standing up to go. 'You could say that, I suppose,' he replied with a whimsical smile, leaving me with an ambiguous sense of only half hitting the mark. Donning his coat and placing the heavy tomes under his arm, the great professor disappeared into the night.

Some months later he sent me an image of the painting he had by then completed.

I had never had the opportunity to interview Paul Page's daughter but, after she showed the painting to Ernst in 1995, there followed what can only be described as inertia, for nothing was progressed for five years. Then, one morning in 2000, Nicolas Joly, head of Sotheby's Old Master Paintings department in Paris, was asked to come down from his office in Rue du Faubourg Saint-Honoré to meet a lady who had brought in a picture. He recalls that it was luck that he happened to be there as she had made no appointment and he was often out. But, when she removed it from its unpromising white plastic bag, Joly, very used to assessing all manner of pictures in his job as the auction house's representative, reacted instantly: here was something exciting and to be taken very seriously. He arranged for it to be sent to their London office, where it was next seen by George Gordon, a senior figure at the auction house and an expert in seventeenth-century Dutch art. He recalls that two of his colleagues, Alex Bell and Arabella Chandos, were present at the first encounter.

'I remember thinking, this looks like nothing on earth,' George said. 'It was an absolute mess. Looking at it more carefully, however, I began to notice passages of quality, so I placed

a piece of cardboard to cover the problematic upper portions of the face and could see that the lower levels looked real.' At this point he had no idea that Van de Wetering had expressed an interest in the picture's destiny and was relying entirely upon his subjective response.

'We then sent it to Amsterdam and much to my surprise Ernst van de Wetering told me he had been expecting the picture to return. I had no idea he had seen it!'

Sotheby's thus became the avuncular partner in the owner's ambitions to restore and conserve the picture and the painting made its way to Martin Bijl – arguably the Netherlands' most celebrated conservator of old masters, himself a member of the Rembrandt Research Project and one of the few people in the world sufficiently versed in the artist to perform the restoration equivalent of open-heart surgery.

Bijl lives on the outskirts of Alkmaar, known as the cheese town of the Netherlands, in a large house and studio camouflaged from the outside to look more like a garage than a dwelling, with the further security precaution of having no address. I was momentarily fazed when, having arrived at the railway station, I saw an athletic-looking man in his early fifties with Caravaggesque good looks, a thick head of white curls and heavy, black-framed designer glasses draw up in a brand-new Range Rover. On reflection I had pictured this renowned painstaking restorer as a boffin rather than a man of magazine-model gloss, but, as I was to find out, he was another of these maverick figures whose trajectory into the rarefied world of Rembrandt detection could hardly have been foretold.

Bijl's father was a professional soldier and had also worked for one of the country's leading professional football clubs. Despite his young son's manifest interest in drawing and making and repairing models, he distrusted artists, whom he bracketed with homosexuals as corrosive. Art was not allowed in the house, nor was there a radio, for Martin's father thought that pop music was a weapon sent by the Russians to corrupt the young. If Martin returned home just one minute after 10 p.m. he was savagely punished with a prolonged gating. Unsurprisingly, having done his best for years to survive this horribly oppressive environment, at the age of seventeen he escaped to Amsterdam, where he trained in nursing and worked for six years, marrying the most beautiful female nurse on his shift. He also spent much of his free time visiting the main museums, where his devotion to the work of old masters began to take shape. This pastime grew into a driving urge to work among them, so he wrote to the chief restorer at the Rijksmuseum in Amsterdam, the country's leading national gallery, suggesting that they should meet. Along with specific ideas about his approaches to restoration, he laced his letter with humorous asides. Fortunately the chief restorer both had a sense of humour and liked Martin's ideas and at the ensuing meeting he offered the young man, much to his delight, a traineeship.

This life-changing break immediately brought with it severe practical problems as it meant Martin had to give up his day job as a nurse at a time when his wife had stopped working as she was pregnant. Yet he had no doubt whatsoever as to where his destiny lay. Rather like Ernst van de Wetering, he fell back on his alternative resources for survival, finding work as a male catwalk model and as a part-time translator for the local football club during the European Cup.

One of his first tasks at the Rijksmuseum was to touch in the paint losses in a portrait that had been terrifyingly torn down the middle, including the face. He acquitted himself with skill and after two months was offered an unsalaried post within the department. Two years later he began a permanent job at the museum and his career as a restorer took off. He spent the next two decades at the Rijksmuseum, the second as its chief restorer. In January 2000 he made the decision to start out on his own, bringing the benefits of his prodigious experiences to a wider art world and market.

Bijl had used much of his time at the museum to get to know other departments, realizing that only by assiduously studying the artists he was working on and getting to know the broader issues of art history, as well the preoccupations of the other experts and specialists, would he be able to make the progress in his work that he so wanted. It was an exciting time of change in the world of restoration. As well as a growing culture of reversing the effects of overpainting and damages so as to get closer to the artist's original idea, there was an increasing desire to fathom the nature of the original paints, how they were applied and what they were made from, in order to understand the atmospheric effects sought by the great masters, which had, however, become obscured by the accidents of history and the passage of time. He recalls explosions of black smoke and oil as he and his colleagues strove for greater insights into the chemical constituents of the painters' mediums. Under

Van de Wetering's supervision he made a menu from what they discovered, thereby adding considerably to the understanding of old-master techniques. Bijl's particular interest was the base supports for early pictures, in particular the use of wood, and this gave him a useful extra dimension when it came to Rembrandt, who habitually used wooden panels for moderately sized paintings.

'It was a very special occasion when the picture arrived,' Bijl told me. He had taken me along a dimly lit corridor through the disguised façade, and we were sitting in his office with its many shelves of art books, Rembrandt's name featuring prominently on their spines. I was fascinated to behold the other side of the Van de Wetering process: dressed from head to toe in black, Bijl leaned back in his chair with relaxed composure, the technocrat, the off-duty Dionysian, the man with guts who had paired up with the philosopher to push the boundaries of research. This is what made the whole undertaking so novel and edgy. An academic can theorize as much as he likes about what might have been, what could be, what should be, but the combination of Van de Wetering's penetrating insights and the efforts of a man dedicated to putting theory to the test - with irreversible consequences - was spectacularly original. Like the professor, Bijl was disarmingly fluent, practically igniting when talking about his abiding passion for his work.

'Ernst had told me that he was going to send me a painting, and when it arrived, and partly out of the crate, I thought, what on earth has he brought me now? What has he done this time? Before I began to recognize passages of high quality, I

remember my response being one of confusion, particularly as I looked at its very strange eye, making me even wonder whether it was seventeenth-century at all. Ernst phoned me the next day, urged me to continue my analysis, and I expressed to him my highest and lowest expectations.'

This strange new arrival now sitting on an easel in his studio, Bijl began to collect his thoughts and amass the research. Page's painted additions, or touching-ups, as well as those from the earlier restorer who had removed the hat, made it difficult to read what lay beneath those areas. Using the microscope, Bijl also noticed manifestly ancient overpaint covering areas of the face and that the garments appeared to be have been repainted at the same time. The committee's collaborators had furnished him with a file of technical data which included X-rays, reflectograms (to pick up drawing lines beneath the surface) and dendrochronology reports, but as is sometimes the case, apart from providing confirmation that the panel was the appropriate date for a Rembrandt, none of this information was of great assistance to the challenge ahead. What had been applied to the eye and dress was so early, so thick and so indivisible from the lower layer that it had resisted radiographic investigation.

The turning point in Bijl's deliberations came when Van de Wetering sent him photographs of the picture before Page had owned it, elucidating a narrative of changes to which he now saw how he might respond. His mission up until this point had been to try to understand why it had been treated in this way, and by studying the photos he could see how these amputations of the hat and hair were crude attempts at moving the painting towards a mainstream concept of what a Rembrandt

should look like. It also licensed him to embark on the first, and uncontroversial, stage of removing the twentieth-century overpaint to reveal how these operations were achieved. His findings were telling: the hat had been entirely removed using solvents, the earrings and hair had been barbered with a blade: the scar tissue of both campaigns remained.

These 'unthoughtful actions', as he described them, did at least offer an important ethical argument for anything he might consider doing next. As he looked at it now, stripped of its twentieth-century cosmetics, it was clear to him that these early attempts at paint removal had reduced its appearance to a hybrid caricature, a clumsy anomaly, which both he and Van de Wetering felt they were increasingly justified in addressing. Its present state did not of course answer the fundamental question of what lay beneath the rest of the early additions: it could have been left unfinished, for example, or horribly damaged, but at least he could now work out how it had suffered during the twentieth century.

Indisputably the most ecstatic, energizing and occasionally horrifying occasions for me as an art dealer are when a picture that has been overpainted or partly hidden by opaque layers of dirty varnish is first 'opened' to provide a glimpse of what might lie beneath. The hours that I have spent looking over my restorers as they work must add up to many months. At such times I witness the destiny of paintings which I may have bought with a strong hunch, sometimes for very considerable sums, gradually unfold with the insistent application of solvents and scalpels. The big question in the case of overpaint is always, why has the picture been treated in this way in the first place,

and what possible frights or surprises lie hidden? I once had the shock of discovering that beneath the overpainted body of an eighteenth-century soldier by Reynolds, for which I had paid dearly, there was nothing but the pumiced remains of his red uniform, rendering it near worthless. The process of overpaint removal itself can be highly perilous, and one reason why the areas of the eye and face of this portrait, as well as the dress, might have been left untouched was possibly, wisely, because Page and the previous owner were scared. Facial features are often finished in vulnerable glazes that can be lost with the slightest excess application of scalpel or chemicals.

The restorer, being both a sensate human and someone with a professional reputation to guard, can also be susceptible to these emotional traumas, and in the case of so major an artist as Rembrandt Bijl was rightly nervous. The last thing he would have wanted was to turn, by his irreversible actions, an already wounded picture into an even more critically damaged one. Not only was he answerable to the owner of the picture but there was the broader ethical issue of removing early overpaint in the first place, for this could, after all, have been applied under the instruction of Rembrandt himself. Bijl told me of spectral establishment figures who would attempt to 'slaughter him' for even contemplating such a thing, branding him and his colleagues 'money-makers and hunters of honour'. These he had encountered all too often and knew that such critics rarely wished, let alone bothered, to read detailed reports, preferring instead to listen 'to their own noise'. Had the painting been in good condition, replete with all its hair and hat, he would not have countenanced the removal of these, and nor indeed

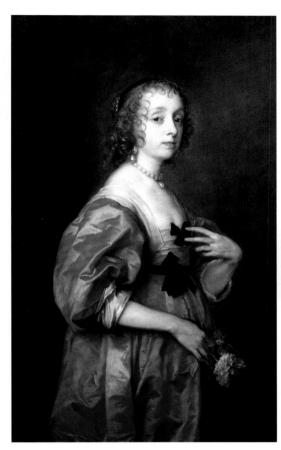

Sir Anthony Van Dyck (1599–1641), *Lady Mary Villiers*Oil on canvas, 101.6 × 83.8 centimetres (42 × 33 inches),
© Philip Mould Limited

Hidden behind the relined canvas of this distinguished Van Dyck portrait we found the royal brand which proved unequivocally that it had belonged to King Charles I, whose art collection was dispersed after his execution in 1649.

Royal brand on *Lady Mary Villiers* by Sir Anthony Van Dyck
Oil on canvas
101.6 × 83.8 centimetres (42 × 33 inches)
© Philip Mould Limited

Art 'angel' © Alfred and Isabel Bader

The activities of Dr Alfred Bader CBE as a behind-the-scenes 'angel' in art purchases have had a great impact on the fortunes of a number of dealers, myself included. Bader's childhood as a Jew in Vienna in the years leading up to the Second World War, his subsequent rise to prominence, and the twist and turns of his enduring romance with his wife, Isabel, might be the stuff of an epic novel.

Rembrandt van Rijn (1606–69), Hidden self-portrait Oil on panel, 70.8 × 55.2 centimetres (28.87 × 21.73 inches) © Stichting Foundation, Rembrandt Research Project

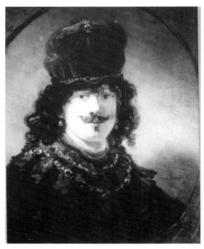

The Page portrait as it began life, from a photograph taken at the beginning of the century, when the painting was replete with additions made in Rembrandt's studio.

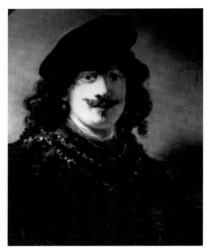

The painting as Page bought it. As can be seen, the previous owner had already begun to remove some passages.

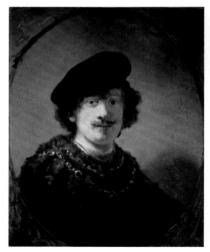

The portrait after Page had removed the earrings and some of the hair.

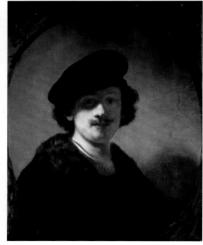

Martin Bijl's intensive restoration revealed an almost unsaleable hybrid, with its unappealing fish eye, to be a work executed solely by Rembrandt which later sold for £7 million.

Ernst van de Wetering and Martin Bijl © Justin Jin/New York Times/Redux/Eyevine

Professor Ernst Van de Wetering, one of the academic art world's most respected and influential connoisseurs, is head of the Rembrandt Research Project. On his left is the Amsterdam-based Project's eminent restorer, Martin Bijl, with whom he has worked and collaborated on many Rembrandtian researches, quests and discoveries.

Above: Ernst van de Wetering (1938–), Portrait of My Father © Ernst van de Wetering

Turning momentarily from art connoisseurship to creation, Professor van de Wetering produced an intriguing picture in which he is seen as a child watching his father painting.

Right: Ernst van de Wetering (1938–), Portrait of My Father (detail)

© Ernst van de Wetering

Pompeo Girolamo Batoni (1708–87), Count Kirill Grigor Jewitsch Razumovsky Oil on canvas 298 × 196 centimetres (117.5 × 77 inches) © Sotheby's Picture Library

The trail that led to the discovery of this masterpiece by Batoni began when Christopher Wentworth-Stanley simply searched through the telephone directory of his adopted home city of Vienna.

Dedicated pursuit, © Stefan Olah

Christopher Wentworth-Stanley stands before a painting by the Hungarian artist Philip de László (1869–1937), whose portraits he has tirelessly tracked down in the homes of the sitters' descendants as well as in obscure European museums.

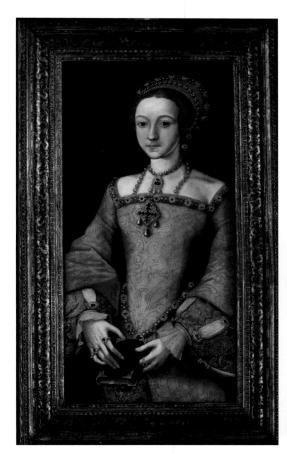

Sixteenth-century English School,Young Elizabeth c.1547–58 Oil on panel

 76.2×38.1 centimetres (30 \times 15 inches)

© Philip Mould Limited

Formerly thought to be a later copy, this contemporary portrait of Princess (later Queen) Elizabeth was, through painstaking restoration, dramatically revealed beneath several campaigns of later restoration.

Above right: Dr Bendor Grosvenor, © Philip Mould Limited

Historian, indefatigable researcher and my crucial collaborator in numerous picture-hunting and buying ventures.

Left: Historian and art detective, © Hever Castle Limited

Dr David Starkey at an unveiling in Hever Castle, Kent. A man of independent and sometimes controversial views, the academic, writer and broadcaster has been responsible for several important advances in the identification and interpretation of early portraits and other works of art.

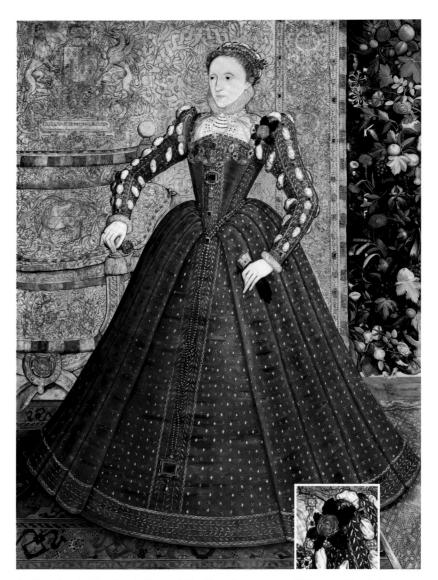

Attributed to the Dutch artist 'Steven', The Hampden Portrait of Elizabeth I, c.1563, Oil on panel, laid onto canvas 196 × 140 centimetres (77.25 × 55.25 inches)

© Philip Mould Limited

Our great purchase after cleaning. Following removal of unnecessary overpaint, the portrait thrillingly regained much of its lost lustre, quality and detail. Subsequent research added the rest, including a new appraisal of the artist 'Steven'.

This rose with oak leaves, painted by a different hand and at a later date than the original work, sparked intriguing conjectures.

© British Library, Lansdowne manuscript 94, art 15B, f.30

Queen Elizabeth I's handwritten manuscript for a speech she gave to the Lords in 1563 in which she referred to tree blossoms, fruit and ripeness. These themes are echoed in the portrait attributed to 'Steven'.

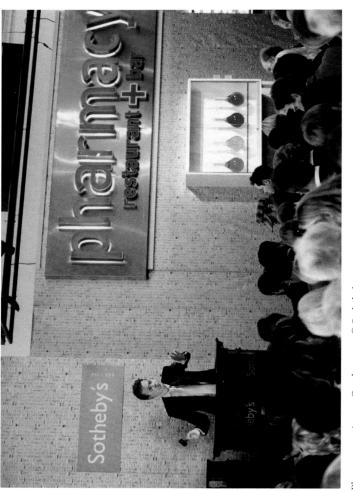

Pharmacy auction, 19 October 2004, © Sotheby's

Auctioneer Oliver Barker in action at Sotheby's much-publicized Pharmacy sale. His wife Vanessa watched from the fourth row as he sold the contents of the iconic restaurant designed by Damien Hirst. Objects that might otherwise have ended up being dumped, skipped or demolished astonished the commercial art world by making millions. would Van de Wetering, even if they had been convinced that a fully authentic Rembrandt might lie beneath.

'But this situation was not normal,' Bijl stated emphatically. 'We struggled for months with the problem. But all the time, however we considered it, there seemed to be only one way: straight forward. There were no remains of the hat, extended hair, or the earrings, and therefore nothing I could restore back. I could not have totally reconstructed them either, as the black-and-white photos were insufficient to work from, and anyway that would have been unethical too. Leaving the picture in its present state also felt unethical, given that as a caricature it would never be taken seriously and would quite possibly return to anonymity despite its potential qualities.'

His arguments exhaustively considered and rehearsed, his position ring-fenced with moral reflection, but also deeply mindful of the professional hazards, Bijl unwrapped his blades, mixed his solvents, took a deep breath and began by addressing the eye. What concerned him most was that the eye had been painted mainly in strong lead white, a notoriously hard and impenetrable pigment that had also defied the X-ray. He likened the initial prospect to surgically removing a tattoo from a face without damaging skin tissue.

During an investigative process that took many weeks, he began by creating with the point of a scalpel a tiny bore hole in the top-left corner of the eye socket, just large enough so that under microscopic analysis he could glimpse the layer beneath. The procedure was harrowing, requiring minute control and precision, but ended with the restorer striking oil. He revealed a prospective dark and complex pigment that

proved to him, in that area at least, the existence of something authentic and preserved. Encouraged, but admitting that the trauma he risked causing to the picture sent a hot, sweaty feeling all through his body, he proceeded to do the same investigations to the other three corners of the socket. Each revealed, in a similar way, a shadowy area of pigment. The prognosis was improving. More enthrallingly than that, however, when he compared each revealed area he noticed that the pigments lightly varied in tone and consistency, suggesting some sort of graded treatment.

He cautiously advanced by widening the bore holes to a millimetre in diameter to create what he described as 'peepholes'. I now fully understood what the professor meant when he said that Bijl had guts, and the excitement of Bijl himself could still be felt as the restorer recalled what these exposed: 'Each opening exposed a slightly different tone of this dark underlying paint from which we could draw the conclusion that there was a complete, well-preserved, and modulated area beneath – in other words an eye in shadow!'

Emboldened, Bijl created connecting canals between each peephole. These further affirmed the existence of a well-preserved eye beneath: no technical, human or ethical constraint now harnessed him from taking it to its conclusion. Having removed all the main overpaint around the eye, he embarked upon the unenviable task of picking out the remnants in the grooves left by the hairs of the original brush. His work was now totally dependent upon a microscope and he needed to use over five hundred scalpel blades because after just a few applications each blade would lose sharpness. The

exotic added costume called for a different approach, first the use of solvents, then blades, a time-consuming procedure that gradually stripped away the later garments to reveal another form.

Bijl could almost feel the eyes of the art world looking over his shoulder, but there were other interested parties who were more directly preoccupied with the outcome of the painstaking operation. In the interests of scholarship Professor van de Wetering and the rest of the RRP committee were watching carefully, but George Gordon from Sotheby's in London also made a number of visits to Alkmaar to chart the progress of what could ultimately become an important business proposition. Nicolas Joly, as the link with the owner, was in regular contact by telephone. He would then diligently report back to a lady who was by now naturally most interested in how her father's bequest was developing, particularly as the good news started flowing from the Netherlands that there was something exciting beneath the added layers of paint. She had said that she was in no particular hurry, but the auction house meanwhile waited in a state of heart-rending anticipation for the 'good surprise' that she had promised would trigger her decision to consign it to them for sale.

Throughout the process the restorer remained totally absorbed in what he was revealing, for it would benefit not only his clients but also the cause of Rembrandt scholarship. He liaised frequently with the professor, particularly when his archaeological penetration of the picture's depths exposed anything of consequence. It was during the latter stages of paint removal that he unearthed a compelling technical

confirmation of his colleague's hypothesis. He managed to deduce that whoever had overpainted the picture in the seventeenth century had scratched a line in the hair with a sharp point, copying a technique Rembrandt himself often employed to add surface texture and animation to such areas. In so doing, that person had scored through to the layer beneath, which bore the indent in such a way as to reveal that the paint in that area had not dried. This neatly validated the professor's belief that the studio had updated such paintings for the market relatively soon after their completion, probably two to three years after they had failed to sell – not long enough for some of Rembrandt's darker pigments fully to dry.

The whole restoration process took two years. This would be an inordinately long time for an unproblematic picture most such works are cleaned and restored within a few days but in this case it was entirely explained by the complexities and enquiries with which Bijl was occupied. Van de Wetering followed the process intimately. In characteristic fashion he exhaustively conferred, argued about, weighed up and pondered upon all the painting's traits and attributes as they emerged. He was later to publish details of these, summing up his tortuously considered arguments with the portentous words 'the conclusion reached ... is that we are dealing with an autograph work by Rembrandt'. His blessing verbally given at that stage, in July 2003 the owner kept her promise. I, together with hordes of others from the nether regions of the art world and beyond, came to the Sotheby's old-master preview in Bond Street to pay tribute to the rebirth of a hitherto entirely unknown painting by the young genius.

The image Bijl had uncovered was little short of miraculous. Replete with characteristic, moody shadowing, a more conservative fur-trimmed gown in place of the exotic paraphernalia and a penetrating look of intensity, it had mutated from a ham hybrid into an original Rembrandt – the master himself inspecting his reflection in a mirror and recording it, as he did so often in a tireless voyage of introspection that lasted four decades.

When the auction opened, in mid-morning on 10 July, it was standing room only in a saleroom densely packed with the trade, private buyers, onlookers, television crews, journalists and Sotheby's staff on telephones.

For one man, however - who was at the sale in all but person - it was 5.30 a.m. According to George Gordon, who was liaising with him, he had taken his telephone into the bathroom so as not to wake his wife. Steve Wynn, the Las Vegas gambling and hotel colossus, was already well known to Sotheby's, and indeed the rest of the art world, for his prominent collection of paintings that mainly straddled the late nineteenth and twentieth centuries, beginning with the Impressionists and concluding with Andy Warhol. They were on show in the headquarters of his casino operation, where visitors were given the opportunity to be led around with an audio guide recorded by Wynn himself which revealed his thoughtful and informed insight into his revered possessions. Given his interest in what he saw as key moments in the history of art, a Rembrandt self-portrait offered the perfect justification to leap into the seventeenth century with a particularly spectacular splash.

Sotheby's had estimated that the picture would sell for in excess of £,5 million. In today's market this would be considered cheap but there were also others around, myself included, who were aware that its having been overpainted and this modification subsequently removed, however expertly, may have diminished its original impact a little. Even with the attentions of a superb restorer, a painting that had been ministered to as much as this was bound to reflect a degree of postoperative trauma. As it transpired, the bidding was brisk, and out of earshot of his sleeping wife Wynn managed to secure the painting against an unknown telephone bidder for a total, including commission, of just under £,7 million. It is worth adding that had this picture reached the market without all its subsequent enquiries, attentions and restoration, looking as strange as it had done, it could quite easily have turned up in a minor sale having been valued at just a few thousand pounds.

For Bijl the picture's recovery was not only a vindication of van de Wetering's hypothesis that this was an autograph original by the artist which, failing to find a buyer, his assistants had exotically refashioned – but another hugely valuable experience of the workings of an artist he adored. And now another emotion was readable in the grin across his face, a look that had replaced the angst of seeking to convey the technical feats and academic challenges he had faced. Having finished his exhausting travelogue through the picture's restorations, he briefly mused upon the risks he had taken, concluding with boyish directness: 'Privately I have always wanted to be one of the best, to be highly respected. I know this when I play football: I'm a bad loser.'

'What would your father think of you now?' I could not resist asking.

'At the end of his life he appeared to be proud of me. I only know that because my mother told me. But it's not for him I do this – it's my internal motor that drives me,' he said.

As he smiled broadly and lay back in his chair, I picked up the same ironic indomitability I had noticed in Ernst van de Wetering. It was difficult to put my finger on exactly where it came from. Success was part of it, the feeling of being part of a top team was clearly in there, and so too was the acclaim and regard they had enjoyed. But about both of them there was also a degree of self-awareness which diluted their pride. Both men knew that they were far from being Rembrandt. They had devoted large portions of their lives to understanding one of the greatest artists in the world, in the case of Ernst more than anyone might ever have been expected to do, and yet ultimately they accepted their limitations. They were wise enough and war-weary enough after years of academic struggles to know that attribution relies on the power of argument and that although they had advanced the subject of attribution with extraordinary clarity and insight, Rembrandt himself would never be around to give them a reassuring thumbs up.

'Oh, and there is another aspect to this when I consider it,' Bijl then added as if surprising himself with a sudden realisation. 'Doing what I do can be such fun as well: you really have no idea.'

It was until then an unstated component I now realized I had picked up on in both men. What they had done and will no doubt continue to do, despite the rigorous demands of scholarship and the stringent risks, was partly motivated by the thrill of the chase – something to which I could instantly relate. This very human impulse is as essential to scholarship and academia as it is to commerce and dealing, providing a zest that fuels the pace of discovery and revelation in the world I occupy.

Postscript: in or before May 2008, after this chapter was written, Steve Wynn sold the Page self-portrait via Otto Naumann. It was bought, perhaps needless to add, by Tom Kaplan.

THE POWER OF HISTORY

There is a lot of fulfilment to art dealing: the investigation that leads in an unforeseen direction, the revelation when a hunch is confirmed, the first moment of re-presentation, the vindication of risk when a sale is completed. In my own specialization there is also a delightful added kick that comes from focusing on portraits of significance when they make their way out of our hands, and those of our restorers, into the arms of a historical institution. To stand back and watch your rehatched item being deemed, not just by yourself but also by the art establishment, to be something of enduring importance provides that warm feeling of a job well done, giving added reason for choosing a life devoted to dealing in second-hand goods.

It was in a downstairs room at Hever, the former childhood home of Anne Boleyn, the second of Henry VIII's hapless queens, that a particularly memorable historical coming together first took place. Those around the breakfast table, including myself, had arrived at the castle the night before. Scenically positioned in the rural Weald of Kent, Hever Castle reascended to prominence in 1903 when it was bought and lovingly restored by the statesman and financier William Waldorf Astor (great grandson of John Jacob Astor, said in his day to be the first millionaire in America), who affirmed his affection for England by adopting British nationality. His desire for security and secrecy was such that he never let guests stay at the castle itself, he and his family seeking refuge behind the moat and drawbridge. Astor's descendants sold it in 1983 to a Yorkshire-based company called Broadland Properties Ltd, who radically reversed the trend by professionally opening it to the public: John Guthrie, the company's chairman, his wife Faith and their daughter and two sons were our hosts that morning.

Also in the room was Bob Pullin, Hever's manager, and a crucial figure in the castle's changed function. A fit and well-groomed golfing enthusiast in his early sixties, Bob had at one time been Lord Mountbatten's house manager and before that a school teacher. With flair and punctilious desire to communicate authentic history, he had taken great strides, with his employer's support, to bring back to the castle a smell of Tudor England, including building up a collection of early portraits of national stature for the edification of the 300,000 who visit the castle each year. The latest and most important recent acquisition, a portrait of Arthur, Prince of Wales, Henry VIII's brother, was to be unveiled that morning. I had been invited to attend as the man who had sold the picture to them.

As television, radio and newspaper journalists gathered in one of the castle's upstairs rooms, Bob was pacing. Although around the table was nearly the full complement from the night before, including Sir Timothy Clifford, the recently retired Director of the Museums of Scotland, and the eminent businessman Sir Angus Grossheart, there was no sign of Dr David Starkey, the man that the press had come to watch perform. His partner James Brown (who had made it to the table) had begun by explaining to those around him, including Bob, how a freak east wind running down the ancient chimney breast of their otherwise luxurious bedroom had howled all night. Sleep had thus largely eluded them. Bob, with an unblemished record for running this type of event with logistical precision, was now contemplating the gloomy prospect of their star turn being either well and truly knackered or, worse still, fast asleep.

The picture that was creating a stir that morning was in some ways the most important I had ever had the good fortune to discover, although the revelation had happened close to a decade earlier. Arthur, Prince of Wales, died at the age of fifteen shortly after marrying his Spanish bride, Catherine of Aragon. Although not a historical heavyweight like his brother Henry, he was nonetheless the first heir to the Tudor throne and the implications of his premature death for English history were substantial, not least because Henry then married Arthur's widow to safeguard the diplomatic advantages that she brought. The rest is a familiar tale. Henry's subsequent divorce from Catherine to marry Anne Boleyn led to the Reformation and England's break with Rome, changing the nation's religious orientation and character for ever.

I had discovered the portrait overlooked in a London auction house, where it had fallen under the hammer as a rather

different-looking work. At some point in the past four centuries someone had decided to turn it into a larger painting with more impact by adding side panels, usefully (from my point of view) disguising its diminutive early appearance. What made the picture pre-eminent was that we had been able to prove - having removed the later additions and the copious overpaint - that this portably small panel, originally from the Royal Collection, was the only contemporary portrait of Arthur and was probably painted for his marriage negotiations at the end of the fifteenth century. Miraculously it had survived the vicissitudes of restoration surgery, history and changing ownership, and although I had sold it nine years earlier (buying my London townhouse with the proceeds) I had recently managed to buy it back from the owner and then sell it on to Hever. This was deeply satisfying, for now I knew it could be assured both a public and - given that this was the childhood home of Arthur's doomed sister-in-law - a historically apposite setting where it could function with meaning.

David Starkey had been invited to unveil the prince, and for those who had witnessed him in live action before it was as good a prospect as having Arthur himself. To the British documentary-watching public, Starkey's is a face as familiar as that of Henry VIII, a persona created not just through constant broadcasting but some twenty books, an eminent reputation as a historian (he is a Fellow of Cambridge University and a specialist in, amongst other things, the social etiquette of Henry's household), and a foxy delivery style that oscillates between pulpit thumping and backstairs gossip. Delighting in controversy, if not deliberately seeking it, he embodies an

engaging brand of academic inquiry that moves seamlessly from the nuances of the British constitution to the impact of human foible, igniting the interest of his readers and viewers. The prospect of anointing Arthur at his new seat had appealed to Starkey, not least because some years earlier he had engaged in the analysis of an unknown portrait which he convincingly proved to be none other than Henry's fifth queen, Catherine Howard, and he understood the inestimable value of putting faces to history. I was personally delighted that this lost picture of Arthur, which we had had the good fortune to rescue, was now going to be given the breath of life by a historian of famous communicative power.

With ten minutes to go before the press briefing, and to the conspicuous relief of those gathered, Starkey entered the breakfast room through the Gothic door leading from the bedrooms. I had had the opportunity to see him at work the night before. A compact and neatly built man with sharply adversarial eyes, horn-rimmed glasses and a faultlessly cut suit, he possessed all the presence of a well-known character actor, the difference being that the role he plays and writes is *himself*, which gives him the capacity to adapt and perform in most social contexts. That morning as he entered the castle's breakfast room, however, he had the bleary look of a lesser mortal, his head slightly bowed.

'I suppose at least the wind was an authentic Tudor experience,' he said wearily as his cooked breakfast was placed before him.

Although he had taken the seat next to me, apart from brief pleasantries I left him undisturbed until I noticed the angle of his head lift and his eyes flicker with signs of life. Bob, who also had been eagerly looking for indications of recovery, and was deeply heartened that his guest was at least upright, now restlessly hovered, waiting to escort him away. I decided to test the waters.

'Do you know what you're going to say?' I asked timorously. Starkey had by now drained his coffee and pigmentation was returning to his cheeks.

'Oh, just the normal old stuff,' he responded with a wolfish smile. The performer inside had also clambered out of bed, dealt with his ablutions and was readying himself for his public.

I have attended many unveilings of paintings, both contemporary and historical. They follow a fairly standard pattern: introductory speech of welcome; address by the guest of honour (or sometimes by the subject of the painting); ceremonial lifting of the veil; murmurs of polite approval; and then the publicity shots of the individuals next to the work. These events normally take place in large public rooms, but Bob had wanted to give the press a more sensuous sixteenth-century experience. The castle's cabinet room, where Arthur was to be hung in the company of other Tudor royals, is markedly small and intimate for such an occasion, as well as dark, and as we all walked up the narrow staircase and past Astor's meticulously refurbished panelling, much of it bedecked with tapestries and portraits, I noticed that a number of people had decided to wait outside in the light. I found room to stand near the door, from where I could observe the expressions of the fifteen or so photographers, journalists and cameramen, as well as the assembly of some twenty guests.

John Guthrie then entered and introduced Starkey, adding a few words about the collection before standing aside to allow him to draw back the curtain. There was a cacophony of clicks as the cameras captured the unveiler and the unveiled. It felt distinctly odd to see the small portrait, the repository of so much emotion and sense of risk nine years earlier, now on its own. People often ask whether it is difficult to let go of pictures, and the answer is that the art dealer can feel like a redundant midwife on these occasions. But, seeing Arthur up there in his gold robe and emerald-green background in the context of his extended family (the castle's collection includes portraits of Henry and all his wives and children), I drew comfort from the fact that at least he was now functioning as his maker — in this case an anonymous artist — had intended.

Starkey began with Napoleonic confidence, his familiar donnish diction seizing attention. As he turned to the portrait I had a clammy fear that he would say something waspish – he has been known to give no quarter to pictures that don't pass muster – but I was spared. Instead, in the best academic tradition, he went loftily to the crux. Arthur, he proposed, was a strong and lusty young lad by contemporary account, far from being the weakly child unable to consummate his marriage. He then went on to cite the contemporary herald who testified that the couple made love on the wedding night. Having dealt with the close-ups, he moved to give us wide shots of Henry VII (Arthur's father) galloping through the woods to gain a sneak preview of his son's bride and the lavish arrangements for the power wedding. Within the first few minutes not only had he brought in sex and provided cinematic colour, but he had

challenged his audience with a historical contention — the academic in him was enjoying the power of argument. Sleeping with a brother's 'consummated' widow was defined as incest by a strict application of the Bible. Proving that his brother was up to fulfilling his marital obligations was thus of paramount importance to Henry, a king scrabbling around for justifications to divorce his consort following her failure to produce a male heir (and given his growing ardour for Anne Boleyn). The 'did he or didn't he' argument over Arthur's priapic powers still prospers among historians, and Starkey was adding his view, bolstering it with contemporary evidence.

I could see the reporters ignoring their writing pads and with smiles allowing themselves to be unprofessionally swayed. The more Starkey explored the human and historical dynamics – while adding the odd contemporary aside, such as to the marital challenges of our present Prince of Wales – the more the portrait's presence grew. By the end of his address this late-fifteenth-century oil-on-panel portrait had mutated into a pulsating teenager, heaving under the weight of dynastic expectation. I left the room convinced that Arthur was well and truly launched and that I could now leave him to fend for himself.

The unveiling was to be followed by a small reception and as I made my way downstairs I overheard a journalist discussing with one of the castle guides what he had just learned, 'Why didn't I have a guy like that teaching me history at school?' he lamented. 'My life could have been so different!' I was also aware how Starkey could add something powerfully useful to the whole process of *re-identifying* lost faces using primary historical research. The first to do this in a dramatic way was

Susan James, who had debunked a portrait that had been hanging for thirty years at the National Portrait Gallery. I recall reading about the picture with astonishment. It was thought to represent Lady Jane Grey, the teenage claimant to the English throne following the death of her cousin, EdwardVI – an ambition which ended with her execution. By carefully studying the surviving inventories of Tudor jewels and comparing them with those that the sitter was wearing in the painting, James managed conclusively to prove that the National Portrait Gallery's picture couldn't be the ill-fated 'nine-day queen' – she was wearing the wrong jewels. A portrait that had become the school-book image of Lady Jane was instead proved to be of Henry VIII's sixth and last wife, Catherine Parr. The label was duly changed.

In 2003 Starkey tackled a miniature portrait of an unknown lady with the same forensic rigour. It belonged to the Royal Collection, acknowledged to be by Hans Holbein, the great Northern master who settled in London during the reign of Henry VIII. Starkey had a hunch that it represented the flirtatious and unfaithful Catherine Howard, for which proclivities Henry had her beheaded. She certainly had an errant look about her – her cognizant quarter-smile placed it among Holbein's most suggestive characterizations – but as no other image of her was known for comparison it needed proof. Here Starkey had an advantage. What she was wearing was portrayed in brilliantly readable detail – Holbein was also a jewellery designer and knew his way around stones and their elaborate settings – and Starkey had just been studying the inventory of Catherine's jewels, a detailed list compiled by the Clerk of the

King's Wardrobe, Nicholas Bristowe. It was clear that a besotted Henry had lavished beads, pendants and stones upon his new bride: some belonged to her deceased predecessor, Queen Jane Seymour, and inconveniently included her initials, but the majority (and there were scores) were more up-to-date, exquisitely wrought and highly valuable tokens of his esteem, power-jewellery intended to ensured that no other outshone his chosen one.

Starkey got to work scrutinizing the descriptions line by line and testing them against the miniature. He did not have to spend long at this, for he found to his gratification that the first of the listed items – a carefully described gold hood set with diamonds, rubies and pearls - was the very one she was wearing. On her shapely bosom covered by a translucent chemise hung a most elaborate and chunky necklace, and again it matched precisely another described in the inventory in consisting of idiosyncratic clusters of four pearls interspersed with twenty-four rubies. To round off the identification, there was a description of the pendant hanging from the necklace, made up of a 'fair table diamond' and a 'very fair Ruby'. There could be little doubt: the sitter was proudly sporting that too. An anonymous face had been transformed into a recognizable queen and history given a new visage. The irony was that in its early history it had been called Queen Catherine Howard but had subsequently been demoted, for no particular reason, and it took Starkey's simple piece of forensic proof to re-establish it.

Over drinks an hour later I suggested that there may be opportunities to consult with him in the future – he with his desire to illuminate history and we with our pursuit of lost

faces. His response was guardedly encouraging. If anything interesting emerged, he suggested, I should let him know. If he could add anything, he would.

In late 2006 we took the doctor at his word after we decided to hold an exhibition of our discoveries in Tudor art and to widen it into a general overview of the subject with a more academic purpose in mind. Given that Starkey had guestcurated for others, most notably an exhibition on Elizabeth I at the National Maritime Museum, I asked him whether he would like to do so for us - and also to include some examples of his own. He and his partner James Brown, a publisher and, among other things, specialist on Tudor badges, rose to the challenge with vigour and over the course of a year we put together a significant show, with a catalogue edited by my researcher Bendor Grosvenor, entitled Lost Faces. There are some events which can be described as quantum leaps in the history of a business, and this was certainly one: the public poured into our gallery - over two thousand visitors in all - and although some were disappointed not to meet Starkey himself, the Tudor queens and sovereigns amply compensated. A number of leading international collections lent us their works, and one portrait in particular, a miniature of a hitherto unknown lady on loan from the Yale Center for British Art in New Haven, Connecticut, became a star turn. Starkey ingeniously argued, with the assistance of Bendor, that it could represent Lady Jane Grey, a claimant to the throne, on the basis of floral emblems, jewellery and birth date. Since the great debunking by Susan James there had been only one new contender: an out-of-period copy. bought by the National Portrait Gallery from a London dealer, a picture which Starkey had mercilessly laid into, stating the grounds for identification to be flimsy and unconvincing. Having waited for his moment, the affronted dealer launched, in the *Antiques Trade Gazette* shortly after our exhibition, a bilious attack on Starkey's championing of Lady Jane Grey. Amply rebuffed by Starkey, it added an amusing diversion to what was an extraordinary two-week enterprise during which we proposed new identities for portraits of two other Tudor queens, Anne Boleyn and Catherine Howard. The exhibition has helped stimulate interest in an area that has been bedevilled by iconographic confusion and overpaint. In holding it I got to know Starkey's working techniques, and the friendship that followed has led to further collaborative advances, one of which took place as I was writing this book.

Bendor's driving ambition, apart from fulfilling his role and duties as a director of the company, is to find and discover pictures. He is an irritatingly accomplished combination of distinguished historian and fast-developing connoisseur who can recognize signature strokes and condition better than most people I know. Whenever he alerts me to a picture he has found in some distant location I look carefully. The one he dropped in front of me that morning was closer to home, however, in the form of a large colour illustration in the Sotheby's preview magazine highlighting forthcoming attractions. A man who does not articulate his emotion demonstratively and is highly economical with his words, Bendor often uses no more than implication and body language to convey intent. His laconic style of communication is one that I have seen him use to great effect on gallery suppliers who fall short of the mark.

'This is something we need to consider,' he said quietly, folding back the page and placing it before me.

The illustration was of a full-length portrait of Elizabeth I which was to go under the hammer in a couple of months time. At first glance it was easy to see why he was captivated. Not only are full-length contemporary portraits of the Virgin Queen inordinately rare, but this appeared to be the earliest. By tradition it had been presented by Elizabeth to Griffin Hampden, Sheriff of Buckingham, with whom she was staying at his fine mansion on one of her royal processions. Richly attired in a red dress with puffing white slashes, and festooned with pearls and embroidered x-shaped crosses, she was both spectacular and other-worldly. In her hand she held a gillyflower, or wild carnation, a traditional symbol of betrothal. She stood before a highly ornate gold cloth of state, her hand resting upon the cushion of a throne, and beside it was a thicket of fruits, flowers and vegetables, clearly intended to impart meaning. She also appeared oddly unassimilated with her background: her hand seemed not to connect properly with the throne, while her bell-shaped dress and hips were silhouetted to give the appearance of an ornamental figurine.

Portraits of Elizabeth are the ultimate trophy to collectors, museums and enthusiasts of the period. Although desirable as the records of a famous sovereign, they are also testaments to a semi-mystical cult surrounding an extraordinary woman who dared walk on a stage of men. About 160 are recorded from her lifetime – many in a poor state of preservation – commissioned and sometimes given to those who wished to express a loyalty and association with the crown, as well as for diplomatic

purposes. They reveal her as empress, figurehead, goddess and heroine, providing a window into her times as well as any manuscript. Sometimes they are suffused with complex symbols relating to wisdom, virginity and power. On a deeper level they consoled a population starved of religious art following the Reformation: she was the nation's Virgin Mary, stripped of her halo and reconditioned with the trappings of earthly wealth and power. As she got older, and her resolve not to marry grew more obvious, her image evolves into Gloriana, a desexed and almost abstract figure embodying and guiding the nation's fortunes. Today it is not just those susceptible to the intrigue and aesthetics of the later Tudor court, or the literary world of Spenser and Shakespeare, who are drawn to these icons, but a broader art-buying public enthralled by their impact, and including on one occasion a collector of Andy Warhol pictures. In my career as a dealer I have handled or owned six prime examples and each has been a high point.

One in particular remained in my thinking that morning. It had appeared two years earlier at a sale in Christie's South Kensington and was described as a copy of the famous portrait of Elizabeth in the Royal Collection – the-Queen-to be as a precocious, scholarly 13-year-old in a radiant crimson dress beside a learned book. It had an estimate of $\pounds 6,000-\pounds 8,000$. During much of that time she lived a life of uncertainty and fear, a feral existence in which she relied upon her wits to repulse the accusations of inquisitors that she was plotting to take the throne from her half-sister, Mary. Given the fate of her mother, Anne Boleyn, portraits of the marginalized bastard princess were thus not in demand at that stage of her life. No

certainly contemporary painting (other than in group portraits as a child) of Elizabeth as a princess was known to exist apart from that in the Royal Collection.

I took a taxi to Christie's in a less than optimistic mood, for the chances of the picture being a contemporary version were remote, and I felt no more upbeat when I laid eyes upon her among the other offerings upon the wall. Vast quantities of overpaint clouded her head, hands and dress. I also noticed the later addition of two side panels (the work was painted on oak panel), replacing ones that had probably existed originally.

However, the longer I stayed with her and the more I looked, the more I gained promising glimpses of another form. There were a few passages which the relentless later paint had failed to cover, particularly in the fingers, where I could detect a reassuringly granular, marble-like finish. It is here that art dealing gets closest to archaeology, putting me in mind of how hidden remains can be re-revealed as a result of surface clues. Although I did not anticipate the emergence of a slice of lost civilization, I was nonetheless excited by the picture's possibilities and therefore very pleased when it was knocked down for £43,000, an entirely manageable sum for a speculation with a potentially very exciting upside.

Later that week, under the restorer's ruthless lights, it was possible to diagnose not one but two layers, or campaigns, of overpaint. The upper, much of it on her face, was relatively easy to remove. It was clear that it had been applied in the past 100 years, and the process of removing it was like scraping jam from a piece of bread. The lower layer was more tricky and required the insistent use of solvents and scalpels to pick away and

dissolve encrusted pigment which could have been as much as two centuries old. After the side panels had been removed and the losses touched in, there emerged an arrestingly beautiful image with the honest, solemn look of a contemporary portrait – the blue-stocking princess impressing the viewer with her evidently fine mind, her body and her famously elegant hands. The overpaint had most probably been added to cover up localized damage as well as the join marks of the added panels, and might well have been done in the face to pretty her up – in a bizarrely inappropriate manner.

Dendrochronology proved that the Baltic oak which supplied the panel on which it had been painted could have been felled as early as 1546. This finding supported a dating which we had arrived at anyway, partly on grounds of technique but also because Elizabeth as a princess would have been a most unsuitable image to circulate after her succession to the throne.

What added to the picture's status was that we had managed to determine from a Christie's inventory number on the reverse (historically applied to all pictures the auction house has sold or considered since the nineteenth century) that in the early twentieth century it had been owned by a direct descendant of the Duke of Somerset, a family known to the princes, not least through Protector Somerset during the reign of Edward VI. Subsequently it had been acquired by Spanish collectors who, we later deduced, were the last owners.

With great fanfare we exhibited the picture for the first time at the Grosvenor House Art and Antiques Fair in London, considerably increasing the footfall to the annual event following its prominent coverage on television and in national newspapers. In three days we had sold it.

But although the memory of this revelation was still fresh in our minds, the painting that Bendor was now recommending to me was a very different proposition. For a start it had an estimate of between £,700,000 and £,1 million. It had been marketed across the world through Sotheby's magazine. From the illustration it seemed that overpaint was minimal, although subsequently we radically revised this view. The portrait also had the huge advantage of a firm attribution to a known artist, Steven van der Meulen, initially proposed by the art historian Sir Roy Strong after close comparison with two other works believed to be by the same hand. Described in his day as 'the famous paynter Steven', Van der Meulen settled in London in 1560 and had subsequently been perceived by art historians as the most important court painter of the early 1560s. To round it off, Sotheby's had also made an impressive attempt to establish its purpose and function.

Speculating that the Queen most likely had had herself painted as an advertisement for marriage, they drew attention to her youth and the profusion of flowers and fruit. An important figure among the earlier suitors that they latched onto was Erik XIV of Sweden, whose portrait attributed to Van der Meulen is believed to have been presented by one of Erik's marriage envoys to the Queen in 1561. Could this have been painted as the return offering? They also listed other contenders who, like Erik, failed to make the matrimonial grade, such as Archdukes Ferdinand and Charles of Austria. Both of these were favoured by William Cecil, Elizabeth's adviser, but their

resistance to converting from Catholicism ruled them out in the Queen's eyes. They also proposed, very plausibly, that the portrait could be related to a proclamation of 1563, preserved as a draft in the State Papers, intended to prevent unflattering images of the Queen. The proclamation effectively sought a painter with sensitivity and public-relations skills to project in paint what could not always be put into words. For, although imposing, she was not a conventionally beautiful woman, having her father's small mouth and hawk-like nose, and images of herself she did not like she is known to have smashed into pieces and hurled into a fire. There was also the more ethereal, symbolic resonance she sought in her depiction — a task well beyond the wits of a jobbing inn-sign painter.

It did not need much imagination or scholarship to understand that what was being offered could be of unprecedented importance: a seminal full-length portrait of a monarch more identified with the history of Britain than any other – a hugely elaborate piece of statecraft with all the impact of theatre, the significance of a state paper and a sovereign human presence. Given that the work fell squarely into our area as dealers we had no option but to look at it very seriously. And yes, from the illustration and description, it also looked very cheap.

A few weeks before the sale Bendor and I walked up the road to Sotheby's. Although it was a month before public sale viewing, the saleroom had accommodated us by offering an informal preview, as all the main rooms do for serious potential buyers who express enthusiasm. After making our way along a series of corridors, down steep staircases and through security-coded doors, we found the picture propped up on

blocks in the auction room's basement, a cavernous, subterranean storeroom stacked high with innumerable framed canvases destined for forthcoming sales, surrounded by worktops piled with books and papers relating to work in progress.

On the floor next to the portrait was a high-powered torch plugged into the mains. The catalogue assistant, a fresh-faced internee in his early twenties, looked on as I moved forward to scrutinize the surface of the dress, using the torch to illuminate detail. At the level I was looking, from above the Queen's waist down to her groin, my gaze hit a wall of shocking disappointment. Oceans of overpaint covered almost everything before me. Many of the x-shaped embroidered crosses I had seen in the photograph and which so distinguished the design of the fabric consisted of no more than perfunctory scribbles on a coating of disingenuous red. Overpaint on a sixteenth-century painting has a soupish, coagulated appearance, in contrast to the mineral-rich, cracked surface of the real thing; the poor woman was covered by the stuff.

Standing back, I looked at the image as a whole and noticed that, rather than the marble-like texture I was seeking, the surface had a dull, waxy smoothness which seemed ascribable to the transfer process and the leaching through of underlying wax or glue. I knew that the picture had been transferred from panel to canvas because it had said so in the Sotheby's write-up, and now it all made sense. The picture had been deadened. The perilous business of transferral to canvas, gladly no longer practised, was much favoured by the Hermitage Museum in St Petersburg in the first half of the twentieth century, and the fashion spread. Instead of attempting to stabilize a panel picture

whose planks had worked loose or were partially rotted – common afflictions in early British portraits – conservators would sometimes plane down the reverse of the oak panel till it was paper thin and then apply it to canvas. Not only did the adhesives sometimes adversely affect the texture of the paint surface, but during this hazardous act of carpentry the plane could sometimes tear through to the surface, causing irreparable loss and the need for copious repair and patch-up.

I indicated to Bendor that it was not what it should be, but he had started looking at the portrait at his eye level. He is close to 20 centimetres (8 inches) taller than me and was more occupied with what was going on at her cleavage. By this stage I had all but written it off, but he was keen to point out that where he was looking there were some very fine passages in the jewellery and face. To my shame, however, the doors were shutting, my interest terminating, and I asked to see another picture that was on offer, a portrait by Joshua Reynolds of the eighteenth-century beauty Kitty Fisher. Trying to salvage portraits that have largely perished is often a grim and thankless business, tantamount to giving cardiac massage to a cold corpse, and I just didn't have the enthusiasm. I had also now twigged why the estimate was so low. A portrait like this in fine condition would be worth millions, a picture that would fly at auction, chased by bidders from both sides of the Atlantic, particularly if one could convincingly unwrap its history. Its dismal physical predicament had effectively grounded it.

Bendor continued to mention the portrait from time to time over the next few weeks, for it had never quite left his mind, but I had largely forgotten it by the time we went to view the entire sale on the first public viewing day. It was then that something unexpected happened. I thought I was beyond being impressed by the skills of mere presentation, but I will admit that she now looked rather different. Now that she was hanging upon a large wall, evenly lit, a carpet beneath her, it was as if her time in the basement had been one of confinement and she had now ascended to her public function. There was no doubt that even with the swaths of overpaint she retained the bones of an affecting royal presence. When considering a painting at auction one of the many tests to which you put it is to imagine how it will look in your gallery and what sort of impact it may have on your colleagues, friends and, above all, clients when they see it there. A telling foretaste of this can be gained by watching how the public respond to it at the auction preview. Even though that morning the preview was sparsely attended, there was hardly a moment when someone was not standing before the picture, waylaid by its monumental presence and drawn to discover more by reading its label. I began to question my initial response, mindful also that Bendor had never quite let it go. In a low whisper we discussed it further and I ended with the suggestion that she deserved a second look - this time with an ultraviolet lamp that might show up some or all of the overpaint. He was off sorting it before I had finished the sentence.

Leading off the main viewing room is a small, cell-like space without windows which, with the overhead light turned off, provides complete darkness. Two porters unhooked the 2-metre (6 feet 6 inches) high canvas from the wall and for the second time we now came face to face with it in unprepossessing

surroundings, subjecting it to the type of inquisition which its subject herself had endured while a princess. It had struck me as ironically comparable: our purpose was not very different from that of those who had imprisoned the 20-year-old Elizabeth in the Tower of London and sought to discover the truth behind her reported actions and words. She probably *had* been plotting to overthrow her Catholic sister Queen Mary, but her brilliant advocacy both concealed and outwitted attempts to prove it. If we were going to establish the truth beneath the sham, and consider paying the sort of money that was being suggested, our own inquisition needed to be ruthlessly incisive.

A retired American radiologist who was viewing the sale and had seen the portrait being manhandled into the tiny room asked whether he could join us, pointing out that this was the type of scientific analysis and diagnosis he had done all his life, but on people. Quite why he used a UV lamp on his patients might have explained his retirement, but as he appeared anything other than a prospective bidder, I was happy for him to join us. Thus, as we were plunged into darkness, it felt rather like a cramped séance as the blue light flickered on, the radiologist (his wife had remained outside as she disliked small spaces) standing behind and breathing rather heavily, Sotheby's specialist in British paintings Emmeline Hallmark on my left, Bendor on my right, and the Queen's luminescent body and face taking form under the lamp's strengthening beam.

The first area I homed in on was the one I had first seen in the basement, around her waist and lower skirt, and the result was predictable: it fluoresced bright purple, revealing an area not unlike the shape of the Atlantic and about 46 centimetres (18 inches) square. Moving the lamp above and below this area revealed similar but smaller passages of overpaint, and it began to become clear that they loosely equated to where the panels had obviously once split, a notorious cause of paint loss, and that the conservator had spaded on huge quantities of pigment to conceal the repair work around the joins. The face had even more conspicuously fluorescing dabs and flecks, but these, Emmeline pointed out, were works that they had recently commissioned from a restorer to rectify some conspicuously distracting blemishes for the sale.

I handed the lamp to Bendor, who carefully studied the jewellery around her neck and cleavage, noting another large area of daubed-on later paint on her right shoulder, before moving to the throne and the gold cloth of state. This was more tricky because of the way the shell gold (an early form of applied gold that takes its name from the mussel shells used to store it) deflected the beam, but it appeared that much of the design had been strengthened in a later hand too, large areas of the metal either lost or covered. He passed the lamp back and I cast its light on to the backdrop of vegetation. In radical contrast to the other troubled passages it appeared pristinely free of later paint. Apart from minor sprinkled in-fills, the fruits, flowers and peas retained the fresh, lush physical presence of produce harvested that morning. Their contrasting state of high preservation was both striking and uplifting. It also got me thinking. Could the rest of the picture have been similarly spared but unnecessarily smeared over? If, just if, the areas of overpaint were clumsily excessive, and the paint layer beneath largely intact, there was hope.

'So what can you see, and what's the diagnosis?' asked the radiologist, who, apart from his noisy inhalations, had all this time retained a professional silence.

'A queen in distress – with an uncertain prognosis,' I replied. He seemed unexpectedly satisfied with that flippant answer and we then piled out of the dark hole, he to his waiting wife and we to the gallery for further reflections.

Bendor normally tells me straight if I have overlooked something he considers to be of importance. This time, given my lack of delectation for the portrait in the first place, he was more subtle. He emailed me, which, considering my office is barely ten paces from his, carried a certain weight. I had till that point been more interested in the Reynolds of Kitty Fisher, a swift, poetic, unfinished sketch of a seductive courtesan, but the Queen's emerging allure was fast displacing these affections. Given that the Reynolds was estimated at $\mathcal{L}1-\mathcal{L}2$ million, it had to be one or the other. Registering my growing enthusiasm, Bendor acknowledged it and added, 'I find the prospect of Elizabeth more enticing.' It was his courteous way of telling me that – finally – I was doing what I was told.

I picked up the telephone and called Alfred Bader in Milwaukee. If our enquiries into the picture's potential over the next three days were to prove positive, I was going to require the big guns and so I needed to warm him up. I had mentioned the picture to him some weeks earlier, but had also told him I preferred the Reynolds. Now, rather awkwardly, I needed to switch his focus. I decided to sell it to him hard — I knew I could back out without a problem — and laid it on about how exciting it *could* be.

'What do you think it will cost?' came his immediate response, brushing aside my hyperbole.

'Over the estimate,' I replied, although I had not given this calculation much thought.

'That's a lot of money' – his usual first response to almost everything I suggest.

'What about the condition?' he then asked.

'I shall have to get back to you,' I replied.

'As you know, I have the funds. Let me know how you go.'

He went on to tell me about a £300–£500 painting he had spotted in a sale in Sussex which involved as much, if not more, expenditure of brain power than the £1-million-plus Elizabeth.

I felt in need of art history, or more particularly, history. Bendor had already put aside his other tasks and gone straight to the London Library, and I spoke to him that evening. Given that he had already been quietly harvesting and baling information over the previous weeks, all he needed, he told me, was a few more hours for a first hypothesis. It would be ready in the morning.

My next call was to Katherine Ara, a restorer known to Alfred Bader and with great experience in Tudor portraiture (I had also spotted her looking at the picture earlier in the auction house). I commissioned as thorough a diagnosis and prognosis as she was able to provide. I also told her I needed it as soon as possible. The request was simple even if the task was not: tell me if you can, I asked her, what lies beneath the later paint. The painting's monumentality and detail, combined with what I knew about the aesthetics of Tudor portraiture, were beginning

to suggest to me that, although now hampered by overpaint, and possibly even irreparably damaged beneath, it was likely at one time to have been an image of almost superhuman impact. Ara's technical insights could get us a few degrees closer to the truth.

The next day, having marshalled his thoughts, Bendor was ready to deliver. His office desk was awash with articles and books. Sitting at his screen with a further book in his hand, reading glasses latched to his nose, in characteristic sotto voce he incisively began the case for the prosecution. Every bit a modern historian, and not unlike Starkey, his approach is first to understand the playing field and the rules of engagement, and to then apply common-sense psychology. What had particularly interested him was a crucial series of events that befell Elizabeth four years into her reign, in 1562–3, a period of intrigue, insecurity and ambition as compelling as any fiction, with a febrile atmosphere in which propaganda and artistic statement could readily generate.

When Elizabeth came to the throne in 1558 the universal expectation was that she would marry. In contemporary eyes she was in dire need of male support, financially, morally and physically. Not only was Elizabeth a woman, but she had once been declared illegitimate and was now the last of the Tudor line. She rebuffed all approaches to marry with teasing evasion, but by 1563 matters had come to a head: she had narrowly avoided death from smallpox the previous year, not least because the medical advice she was given (a hot bath followed by a cold walk) was inept. With the court convinced she was about to die, she stunned them all by stating that Robert

Dudley should be appointed Regent. Dudley, the Master of the Horse, was the Queen's favourite and believed by many to have been her secret lover, manipulating his way into royal trust, and office, with a combination of aristocratic pedigree and sex appeal. Surviving portraits lucidly suggest the type of man Elizabeth had fallen for: a cosmopolitan, languid, beautifully attired ladykiller - possibly literally. Two years earlier Dudley's wife had been found dead with a broken neck, having fallen down the stairs of her house, and although cleared of any involvement he was widely thought to have murdered her. The son of an executed traitor (John Dudley, Duke of Northumberland, mastermind of Lady Jane Grey's brief reign), Dudley was viewed with deep concern and hostility by the rest of the court. Elizabeth's cousin Mary Queen of Scots summed up the prevailing perception with icy directness: 'The Queen of England is going to marry her horsekeeper, who has killed his wife to make room for her.'

Following her recovery the big question was, who would succeed the Queen if she died without child? By statute it was the younger sister of the executed Jane Grey, Katherine Grey, who suffered from debilitating anorexia. By blood it was Mary Queen of Scots, a Catholic, and the country had only just recovered from Mary I's violent attempts to get the country to readopt the old religion. To the Tudors the baffling choice of two unsuitable queens, for a country that should anyway be ruled by a man, was little short of terrifying, embodying the hideous prospect of returning to the civil wars of the previous century. The court and assembly therefore made renewed efforts to get Elizabeth to marry. In the meantime they

requested that she name an heir, not least because there were rumours that she was now sterile following her illness. But although the Commons and the Lords sent petitions, she sidestepped their intent with sophistical evasion.

Surely, Bendor argued, a portrait of this magnitude must have something to do with this pivotal stand-off? Yes, the image was laced with symbols of fertility and union appropriate to her sex and broader destiny. But for a highly sophisticated woman, steeped in scholarship and guile, there had to be a lurking Shakespearean sub-plot. Although the idea of a marriage portrait could not be ruled out, Elizabeth had bigger fish to fry – namely her own independence, sovereignty and desire not to be shoehorned into a constitutional solution.

'There is something else you should be aware of,' Bendor added with the suggestion of a smile after we had finished our ruminations on the historical events. He began to tap at his keyboard. 'You know the rose she is wearing, pinned to her left shoulder?'

'Yes,' I replied. You could hardly miss it. It was the most conspicuous single ornament to her attire, a large red flower symbolic of the red rose of the House of Lancaster. Although slightly crude and stylized compared with the inflorescences in the backdrop, it stood out like a pennant.

'Look at it carefully,' he said. He then flashed it up, filling his screen with red petals and green under-leaves.

'Does anything strike you as strange?'

I scrutinized the screen. The rose looked like a rose, but then it dawned on me that there was a botanical anomaly. Instead of toothed leaflets (correctly indicated for roses in the painting's backdrop) it had large, lobe-shaped leaves, arranged in a rosette. There could be no mistaking what they were: the leaves of an English oak. Although it cannot be entirely ruled out that the artist was intending to imply that the Queen had the attributes of an English oak, an expression perhaps of fortitude in love when combined with a rose, there was no precedent for the oak as a symbol for Elizabeth: it would be 100 years before it was informally recognized as a royal badge following the Restoration of Charles II, who during the Civil War had hidden, it is said, in an oak tree. There was one man, however, for whom the oak was a personal badge: Robert Dudley. This has been proved by a carved panel in the Tower of London, where he and his family had been briefly imprisoned, identifying each member of the family by a symbolic botanical witticism playing upon their names. Robert was labelled 'The Oak', a play on the tree's Latin name, Quercus robur.

An enthralling inference could now be that the oak leaves had been included, despite the formal message Elizabeth was sending to the nation at large, as a secret message to her lover. Bendor had been quietly progressing the theory over the past few days and was ready for my next question. Yes, he replied, Robert Dudley had indeed owned full-length portraits of Elizabeth – the two 'greate [full-length) tables [panel paintings] of the quenes maiesties pictures' cited in the 1578 inventory of his pictures at Kenilworth Castle in Warwickshire. An art historian a few years earlier had attempted to match the identities of these two portraits with two other known paintings, but the argument was inconclusive and Bendor felt that the picture at Sotheby's could still be one of them. It was more than possible

that the picture had initially belonged to Elizabeth, but, given her later desire to show herself in portraiture as a desexed virgin queen, it would have been given away as being awkwardly off-message for the palace walls, laced as it was with outdated marital and fertile allusions. Although family legend suggested that it was given by Elizabeth to Griffith Hampden, a very minor figure, there was no documentary evidence for this, and experience has shown such hand-me-down stories to be more often than not unreliable. The family could have acquired it much later, any time following the dispersal of Dudley's collection after his death in 1588.

'Have you contacted Starkey yet?' I asked.

Bendor raised his eyebrows. I was underestimating his initiative.

'I emailed an image and details this morning – as well as my first thoughts about the constitutional crisis.'

Thank goodness Bendor works for me, I reflected.

I left him to ruminate and dig while I considered other issues, namely the condition and the price. The following day I received a written report from Katherine Ara. She had minutely analysed selected areas of the picture's surface and her inquisition ended with the conclusion I wanted to hear: 'The restoration covering [the] areas of loss is unnecessarily extensive, crudely applied, and in places confused. The extent of wear to the areas of shell gold is more difficult to establish owing to the extent of the repainting. However when viewed in raking light the underlying ground appears to be largely intact ...' She had done as much as could be expected in the circumstances, and her conjectures concurred with my most optimistic hopes:

we were closing in on a painting that, should we acquire it, and it fulfilled our expectations, could turn into a career event.

By the afternoon before the sale I was confident that we had enough insight to risk a very substantial amount of money. How much was still the question. It was unlikely that we would progress the research before the following morning's sale at 10.30, and it was also time to make a recommendation to Alfred Bader, who was on Milwaukee time and would be asleep during the sale. I had no option but to run with what I had. In response to Bendor's email Starkey had not produced anything of significance except that the picture greatly intrigued him, and a request for more time. He fully understood the relevance of seeking insight from the then current state of affairs, in particular the deputation of the House of Commons in January 1563 asking Elizabeth to name an heir - but her response to it was unrecorded. Speculation therefore remained, and in this respect the picture was no different from thousands of auction prospects I had considered before. The big difference was the stakes, which were giddily high. Although every painting is unique, I tried to remind myself that this one had the potential to be more unique than others. In perfect condition and with full provenance and documentation - which we did not have - it would be an artefact of crucial historical stature, a work of art of transcendent significance and value to a range of sophisticated collectors and museums. With what we had been able to establish about its condition it was already likely to be worth more than three million, but I did not fancy having to wrestle a bid out of Alfred Bader at that level without more solid information. Although the final figure I was able to secure

from Alfred has to remain commercially confidential, assistance of sorts came in the form of a phone call at around 5.30 p.m. that evening, and from the most unexpected quarter.

Journalists are key to our business. Among many other functions they flag big sales, report on them, reveal the names of buyers and sellers, and promote the wares of auction houses and dealers. One particularly keen reporter had decided that Elizabeth I was a picture to follow and so was calling to squeeze me for any indication that I might wish to buy it. Sensing that he might have more to divulge than I was prepared to give, I reversed the process and instead tried to squeeze him. Treating it as an opportunity to barter, he responded by telling me that he had just spoken to a prospective buyer who had claimed that he was going to buy it and, what was more, was preparing to bid £,2 million. So certain was this unknown prospective buyer that he would buy it that with impulsive confidence he had spilled his heart to - of all people - a journalist. I traded back some anodyne thoughts about the uncertainty of the condition, and the pool of likely buyers, ending by telling him truthfully - that I had made no clear bidding decisions.

I now had something directly to report to Alfred; and, in a sense, the auction had begun.

In comparison with auctions of modern pictures and old masters, those offering British pictures generate less heat, and that day the auction room was only half full. I had seated myself in an empty row four from the front, an optimum position to view lots as they mount the easel and retain uncluttered distance from the standing throng at the rear. Bendor, on the other hand, placed himself among the throng, where he could

observe a different part of the action. A good deal taller than most of the ten or so dealers around him, from where he was standing he could both pick up on trade talk and enjoy a commanding view of the arena. With three lots to go I noticed a number of telephone bidders were already chatting to prospective buyers. To avoid mishaps they normally contact their clients a few minutes in advance, and their timing was instructive. It was also more than likely that one of those standing at the rear next to Bendor would be secretly bidding via a member of their staff while looking on with apparent indifference – a seasoned ruse to throw the competition.

The auctioneer, Mark Poltimore, a colleague on *Antiques Roadshow*, had been skipping through the lesser lots. A consummate professional, Poltimore has honed his rostrum skills with thirty years' experience in the art world. First at Christie's, followed by a spell as a dealer, and now chairman of Sotheby's Europe, he combines puckish charm with all the auctioneer's dexterities, playing and reading the room with a conductor's confidence. Ominously he slackened his pace to announce the Elizabeth, catching my eye as he did so. When he opened at $\pounds 500,000$ a lady in the front row turned to smile. She looked familiar. Looking carefully at the companion with her I realized it was the radiologist, a bidding paddle in his hand.

There is an optimum time to enter the bidding, and it requires judging the hidden or anticipated actions of others. I duly waited. Poltimore gradually raised the increments, his smooth body language and glances keeping the room guessing. At £700,000 one of the telephones flagged him and he snatched the bid. Now that we had hit the lower estimate I

knew we definitely had real bidders, and that the sale was live. I saw the radiologist speaking to his wife, but before he could lift his paddle – if indeed that was his intention – a bid came whistling over my head. I resisted the urge to turn and instead watched Poltimore bounce between the phone and the new bidder, rhythmically lifting the price. At £1.2 million it faltered.

The telephone bidder was spent and I could also see the radiologist, who had yet to commit, locked in conversation with his wife. I waited until Poltimore fished his gaze across the room a second time and then met it with a nod. I had entered the game. Swiftly he swung back to the rear of the room, hooked another bid, and then returned to me for more. I remained locked on Poltimore's face, meeting each return with a further bid. From where I was sitting I could hear the phones urgently relaying the escalating price, but the speed with which our increments were moving, at £50,000 a pop, left no space for interlopers; in less than a minute we had reached £2.1 million, and I was being asked for more. OK, I thought, we have broached the psychological hurdle of the 'Big Two' and now we shall see. I threw a further nod at Poltimore, who shot back a glance above my head. This time he did not immediately return. The opposition appeared to be wavering.

The auctioneer switched to seductive mode, craning forward and lowering his voice to lure a further increment. The rest of the room were now no more than observers. Just as I was expecting him to start winding up, his expression brightened. He had secured another bid and returned to me with a sprightly smile. Without even a momentary hesitation I punched back with another £50,000, and its speed had the

bone-cracking effect I intended. Poltimore lifted his head, and then, failing to induce more from my adversary, cast his eye around the assembly, over to the telephone bidders, and then back again to the under-bidder for signs of life. All challengers had been thwarted. After what felt like an indecent pause, he raised his hand in what seemed like slow motion, and then clunked down the gavel. With auction commission the painting sold to me for £2.6 million.

Bendor gave me a brief sketch of the back-room antics after the sale. I had been under-bid by another dealer and he had noticed that at a lower level there were others about to enter, but the momentum was such that they had failed to break into the contest. Alfred Bader, whom I had telephoned that afternoon, was pleased with my success but characteristically occupied with the payment terms, the cost of the restoration, how long it would take and what I would do with it next. As I read on Reuters that afternoon, I had paid the highest price for a British royal portrait at auction. Alfred had reason to be mindful.

When the picture was delivered that same afternoon, ushered through the doors like some visiting head of state, we all reverted to type. Bendor, animated by success, and still immersed in the portrait's historical challenges, proclaimed it the meatiest thing he could have hoped for. Tony Gregg, our South African in-house craftsman, and known for taking his own line, was fixated on the frame. Emma Henderson, the gallery manager, fretted about our escalating insurance bill but found herself unable take her eyes off the Queen's dress and jewels; while our front-of-house gallery assistant, Tamsin

Evernden, was carefully processing her aesthetic response, as well as pondering the logistics of having so big a thing photographed. My wife Catherine, who won't even buy an article of clothing unless it is sold at a discount, and who had sat with me at the sale, chronicled its arrival with pale anxiety.

I could barely lift my gaze from the image, feeling both triumphant and impatient – impatient to know how great a transformation would take place with cleaning, and where our researches could take us next. I found myself particularly dwelling on the complexity of the fruit and flowers, which, under the gallery lights, were illuminated more strenuously than ever. Intriguingly, I noticed for the first time that each of these natural symbols was paired – each rose, fruit and bursting peapod had its partner somewhere within the thicket.

The next morning, a Saturday, I woke exhausted from the week's adrenaline. I normally escape to the Oxfordshire countryside each weekend but I was grounded in London by other engagements. I decided to take the dog for a walk and gain some space and air, and having picked up a cup of Starbucks coffee I led our working black cocker spaniel into Kensington Palace Gardens. Laid out in the classical style by George II, the park has as its focal point a round lake, which that morning was bristling with bird life. Flotillas of ducks and geese vied with toy boats and competed for bread; from some distance I watched a pair of swans plunge from the sky into the water, their bodies enveloped in a great spray from which they glided off with unflustered grace. Nature, even urban nature, can be a therapy from the weekly dramas of the West End, and I felt badly in need of it that morning. I had just bought the most

expensive picture of my life, it had been paid for by a man I wanted to do well for and there were still unanswered questions.

If I am honest, what first got me interested in art (and I had first done it with silver teaspoons and shoe buckles as a child) was the thrill of seizing upon things others might have missed or undervalued. As a result I got to love the paintings I later moved on to. I and my colleagues may occupy a world of the ultimate luxury goods, of cosmopolitan refinement and intellectual acumen, but beneath the varnished surface the competitive animal lurks. That same predatory urge had just secured me the portrait of Elizabeth. In the disjointed mood I found myself in that morning I found myself thinking as much as anything about my dog. All her instincts and joy, especially when she is in companionship with me, are to do with the chase. But, with the exception of the odd half-tame squirrel or unguarded picnic, there was no quarry for her that day and she was reduced to following me at a slow trot. In the park there was no deep grass or undergrowth, no stream or copse, no opportunity to follow a scent with tale-wagging fury, as she does to exhaustion each weekend in the country. I have rarely known her to catch a pheasant but the quest defines her existence, occupying her dog imagination, and I suspect providing her with those twitching, snuffling, squeaking dreams from which she occasionally wakes.

I too was now reduced to an unanimated trot in the cycle of this acquisition, anticipating a process that had every likelihood of being irksomely slow. The restoration of so complex a picture would take three or four months, and the historical research and its outcomes – well, they were anybody's guess. The hunting-instinct part was over and the picture now needed the specialist attention and consideration of others, which I could oversee but no longer control. As much as anything else, I suppose, I was suffering from a sense of anticlimax.

An Alsatian came bounding towards us and my spaniel froze in apprehension. The other dog then growled, and fearing a fight might ensue I bent down, attached the lead and marched her to the path for safety. In so doing my BlackBerry fell out of the loose top pocket of my tweed jacket, and retrieving and glancing at it I noticed I had a new email. It was from David Starkey, to both me and Bendor. When we had been working on the exhibition I had noticed that weekends were often his most productive times as then, in the sanctuary of his library in Kent, he could work with less distraction. I scrolled it down, wondering at first whether he was just asking whether we had bought the picture, but needless to say Bendor had told him. I quickly realized it was something of consequence and made for a park bench. Given that I value whatever Starkey has to say on historical matters, I have not deleted it:

Sorry not to have been able to get in on Thursday but ran out of time.

However, I think I've got the story. You were right about 1563. But we got the wrong bit. For there were TWO speeches on TWO separate occasions. We were thinking of the first, when a delegation of the Commons was received at Whitehall on 28 January. But it is the second that fits, when the Queen replied to the Lords on 10 April. She was present,

though as customary in the Lords, the speech was delivered by Lord Keeper Bacon. But Elizabeth had written it. Indeed her holograph survives. And what a Manuscript!

I had thought it had been so desired as none other tree's blossoms should have been minded or ever hoped ere my fruit had been denied you ...

'But to the last, think not that you had needed this desire if I had seen a time so fit and it so ripe to be denounced ...'

[BL, Lansdowne MS 94, art 15B, f. 30.]

I'd see the painting as the commemoration of this occasion. It makes sense of the chair and cloth of estate (the dominant feature of the Lords) ... and the fruit and popping peas. And the Queen rather oddly standing between the two.

Best Regards,

David

It was not till Monday that I got to discuss the email with Bendor, and he was already prepared. He had with him a photograph of the original manuscript, which also showed the Queen's mind changes and crossings out, and we stood again before the picture as the early-morning light from the gallery's front windows lifted its presence, amplifying the thrilling recent advance. Bendor had already discussed the speech with Starkey and had concluded that its purpose was unambiguous. She was roundly responding to the 1563 Lords petition, employing characteristically embroidered rhetoric to do so. The underlying message was plain, even if the wording was not: she had no need to name a successor; she was well able to produce one of her own. Given the date of the portrait's execution, quite likely later that

very year, this written evidence added a compelling dimension to the symbolic message.

One by one the visual sentiments proclaimed themselves like unfolding riddles. An affronted Queen, recently on her deathbed, was telling their Lordships, in as sovereign a way as possible, not to panic - that she could sort it out. This single assertion clarified all: the suggestively ripe background became a riposte to the rumours that she was sterile; the pairings within the vegetation a beckoning towards marriage - the only way a legitimate heir could be provided; her dress of red and white, the colours of the Tudor dynasty, a confirmation of readiness to continue the dynastic line, further affirmed by the throne and cloth of state; the gillyflower in her hand not in this case a symbol of betrothal but of a general willingness to commit. It could have been interpreted as a marriage portrait with specific grooms in mind, but this construction barely touched upon its underlying political urgency and topicality. This was an ageing (by contemporary standards) woman's clamorous assertion of self-determination - and with the benefit of historical hindsight its implicit promises were poignantly off target. The pomegranates, apples, pears, bursting pods and blossoming flowers were a pledge of progeny never delivered – a statement that would have increasingly undermined its subject in her succeeding years of spinsterhood. If it had belonged to her, as I had suspected all along, this alone would have been good enough reason quietly to dispose of it - and if so, why not to a past paramour for whom it would have been particularly emotive?

It was not just the painting's purpose but also the artist's identity that then evolved with research. The emergence of

such important works of art often prompts researchers and new owners to revisit the primary documents which have given rise to art-historical assumptions. With rejuvenated resolve now that we had bought it which principally involved enquiries at the National Archives in Kew, a remarkable resource offering 1,000 years of history from Domesday Book to the present day, over the next two months Bendor sifted through the relevant papers and wills to ascertain more about Steven van der Meulen, the Flemish artist to whom Sotheby's had attributed the painting. As an illuminating insight into a dark period of art history that still teems with mysteries, confusions and unsolved puzzles, his research revealed that there was in fact no portraitist named Steven van der Meulen working for the court in London at the time, and that art historians had for the past century confused the identity of two Flemish artists who shared the same first name. The correct identity is now far more likely to be Steven van Herwijck - another Steven who was often referred to in sixteenth-century documents simply as 'Steph. pictor', meaning 'Steven, painter' - and not the comparatively obscure Steven van der Meulen.

The picture actually took five months to clean and restore, but the transformation was remarkable. It turned out that the surface was much better preserved than earlier feared, and although 40 per cent of the image had been covered with overpaint, three-quarters of it was unnecessary and covering original paint. The gold began to shine, the dress and jewels returned to their former brilliance, the clouding film of leaching glue to lift. The Queen regained her background with convincing attachment. In the process of cleaning the possible

Dudley connection became more conspiratorial. Paint analysis on the oak leaves surrounding the rose showed that while it was contemporary with the picture it was a different type of green from the foliage in the background: the oak leaves were of azurite (ground glass) mixed with lead-tin yellow; the foliage leaves in the background of copper glaze with an upper level of lead-tin yellow and greenish blue. The intriguing likely conclusion was that a different artist, using different compounds, had added it, but, to judge by its degradation and technique, clearly not long after the painting had been completed. Whether this was at the command of the painting's subject, or its recipient, or indeed someone else, may one day emerge.

A postscript is required here also. It has since been acquired by a financier and art collector who has assured me it will hang in the hallway of his country house. However, at the time of writing, in Spring 2009, he has allowed it go on exhibition at Hampton Court Palace, the first port of call in what I suspect will be a century of new royal processions for the benefit of her public.

DISCOVERING OPPORTUNITY

Oscene. Before him was a bristling sea of prospective buyers, a host of familiar faces, both trade and private, as well as a preponderance of unknowns' pouring through the doors and crowding into the next-door rooms. He drank in the expectant faces of art and news journalists and the television cameras which were already recording from the corners of the room. Lined behind desks on each side of the room were more than thirty Sotheby's staff with telephones locked to their ears, giving notice of imminent action.

Habitually groomed and smooth, Barker considered for a moment whether his nerves were showing. He had attended a good many major sales and watched hundreds of millions of pounds of art being sold but this was the first time he had faced the senior art world with a gavel in his hand. He had done all to placate his nervous system that his seasoned colleagues had suggested – been for a run, completed his breathing exercises,

had a massage, psyched himself up. He briefly caught the eye of his wife Vanessa sitting in row four. She had been with him when the idea first dawned, and they were both aware that what could happen next would not only influence Barker's future, but possibly that of the contemporary art market. He had confided to her the night before that he was fearful: this was not just the 33-year-old's first big auction, but the art world's big experiment — a sale devoted entirely to a major living artist in a style that had never been risked since the painter William Hogarth had tried it in the eighteenth century. For an organization known for its profound conservatism over two centuries this was commercial pioneering.

Barker's baptism in the auction arena was by no means without ceremony of its own, however. For rarely had a client — and an auction house — taken such pains to ensure that the items for sale were offered in so conducive a setting. If the odd uninitiated person had concluded that they had accidentally walked onto a film set during the viewing days, they could be forgiven. This was commercial theatre of a new kind. At the launch party Barker and his colleagues had entertained their guests in a recreation of the venue from which this art had come, a decision which in itself was dizzily innovative. Even the catalogue was fast becoming a collector's item, and the artist had been accommodatingly signing copies for his disciples.

Barker looked down to his auction book, then checked his watch. The sale had been timed to start at 6 p.m. but so many new clients had registered their bidding paddles that it was already twenty minutes late. This was hardly good professional form. He eyed the description of the first lot. It had been

carefully placed as an opening teaser but given the tumultuous interest the sale had engendered it might at least give a glimpse of what was to come. Time to get on with it, he resolved. Clearing his throat, and lifting his gavel, he called the room to order. The burble ceased. As he heard his words through the speakers, words he could not have conceived of uttering a year earlier, he had to remind himself they were his own.

'Lot 1: a pair of Martini glasses. I shall start the bidding at £50.'

It was when Barker was travelling to work on the number 94 bus with his wife that this legendry art-world story begins. The bus goes from near the couple's home in Shepherd's Bush to the northern end of Bond Street, where Oliver had been working for the previous year in Sotheby's contemporary art department. When the auction house had written to him with confirmation of his appointment, it had done so with the new style of auctioneer in mind. Barker's background is not unusual among the new generation of experts: his mother was in advertising, his father an accountant, so he was no progeny of the crumbling aristocracy or a collecting dynasty, the timehonoured recruitment ground for auction staff a generation earlier. After studying art history at Manchester University, he returned to his home town of London to take an MA at the Courtauld Institute, regarded by many as offering the best training in art history in Britain. Next came art-trade experience in Paris, where he helped catalogue the estate of the deceased modern master Man Ray, after which he slipped into a job as cataloguer in the Modern and Impressionist

department of Sotheby's, an auction house that was fast catching on to a new approach to business.

Barker's winningly classless manner, congenital financial instinct and knowledge of art history were ideally suited to a contemporary market that had begun to heave with new buyers from a myriad of different backgrounds and educational profiles. He spoke a language they could potentially understand and delivered it with youthful authority. The financial management of the company also needed specialists who could share an understanding of new products such as price guarantees for vacillating prospective vendors, or financial loans for those wishing to buy art, and Barker had the potential to take it in his stride. Sotheby's felt they had recruited a man who could weave the terms 'post-modernism' and 'viral marketing' into the same sentence, and who, in time, could assume a front-line position in the quest for new business and money.

The 94 bus passes along Notting Hill Gate. Given the expansive view an upstairs window seat can offer of the world below, combined with the sedate pace of London traffic, he had at least a minute to observe the men in white overalls going about their business. They were dismantling the interior of Damien Hirst's iconic yet short-lived restaurant Pharmacy. The genesis of the idea for this radically offbeat eating establishment came from the PR sage Matthew Freud at a stealthfully set-up meeting in 1997 at the Groucho Club in Soho organized by the broadcaster and writer Mariella Frostrup. Freud had confided to her that he wanted to harness Hirst's talent and reputation in a concept that combined food with art. A friend of both men, and aware of Hirst's arch-resistance to conformity, not least

formal meetings, Frostrup reckoned the only way Freud could get to bend the artist's ear was to 'ambush' him with an accidental meeting. Having lured Hirst to the bar, she telephoned Freud, casually introduced them, then withdrew, leaving Freud to pitch his idea. After an initial collaboration involving Hirst at the Soho restaurant Quo Vadis which ended in acrimony with their chef-partner Marco Pierre White, two years later they opened Pharmacy with Liam Carson, a founder of the Groucho Club, and Freud's business partner, Jonathan Kennedy.

Within days of its opening the restaurant was the new venue for Cool Britannia in New Labour's New Britain. A week did not go by without a tabloid reference to its scintillating comings and goings. Frostrup herself (who was given a 'spot painting' by Hirst in recognition of her services) became a regular diner, not least because she lived very close by She has starry-eyed recollections of celebrities flocking to Pharmacy with their managers and agents, publicists, assistants, make-up artists, hairdressers and lawyers. On her last visit she watched Martine McCutcheon clamber over four tables to meet George Clooney.

As Barker surveyed the two parked lorries outside the defunct restaurant he experienced both a pang of sentimentality and a whiff of opportunity. He had dined there himself, for which he was inordinately glad now that its end had arrived barely four years after it had opened, and had luxuriated in its holistic vision. It had been an art form on an unprecedented scale. Hirst had insisted on designing and overseeing himself every aspect of the exterior and the interior down to the pepper shakers and ashtrays, rejoicing in the fact that it was an

'incredible amount of work for an incredible place'. I ate there myself on two occasions in the early years and although its clinical witticisms made me feel slightly queasy I could entirely understand why Barker's commercial sensibilities were on high alert. The artist, then in his late thirties, had been given free rein to explore themes of life, death and medicine—subjects he had frequently visited in earlier works. From the outside the clean, modernist façade with its sign saying 'Pharmacy' in green letters so plainly indicated a dispensing chemist's shop that passing shoppers called in with their prescriptions. The Royal Pharmaceutical Society considered the sign so misleading that it threatened legal action. The owners responded with characteristic ingenuity by using anagrams such as 'Army Chap' until the decision was finally made to adopt the more prosaic name 'Pharmacy Restaurant and Bar'.

Inside it was triumphantly surreal and gave the seasoned diner with a strong constitution an unprecedented experience. Hirst and his team took infinite pains to exploit every aspect of medicine that the interior could bear. Walking past hanging skeletons I can recall beautiful female waiters looking like surgeons from a disaster scene, flitting between the tables in Prada-designed medical gowns, authentically fastened with strings at the back. A chillingly professional barman served up, in test tubes, cocktails with names like 'Anaesthetic Compound', 'Cough Syrup' and 'The Formalin'. But it was the fixtures and fittings that really left diners agog. Many were based on the shape of a pill – a motif which lies at the core of Hirst's belief that medicine is a modern religion – and they featured as ubiquitously as haloes in an altarpiece. Most striking was a

set of 2-metre (6 feet 6 inches) high stained-glass panes of cascading pills set into the ground-floor windows, as artistically impressive as any you might find in a twentieth-century cathedral. Signature Hirst installations of pill packets and boxes hung in wall-mounted cases, pill motifs were set into tables and floor-boards, repeated on the wallpaper, and lent their shape to bar stools and ashtrays.

Clinical and scientific references extended to the wine labels, the food and, most prominently, an impressively free-standing molecular sculpture of Hirst's DNA, originally designed for the façade. If you wanted the loo you had to know the difference between the scientific symbols for male and female: some puzzled patrons could be seen pondering their options, gathering resolve and then boldly committing to the unknown. Most significant, to me at least, were the hanging spot paintings, seeming to depict pills, and the ethereal butterfly collages, which touched upon Hirst's attachment to the themes of mortality and metamorphosis. So complete was the eating experience at Pharmacy that it was difficult not to be drawn into a Formalin-induced state of willing disbelief, passively carried along by its crazily argued world view.

It is not easy to fathom what went so badly wrong, except perhaps to wonder whether a certain type of art does not mix with food and wine. Many views have been put forward, including simply that the restaurant lacked a decent chef, but within two years of opening Pharmacy was floated and then merged with the property and restaurant chain the Hartford Group. Hirst then appears to have fallen out with Freud, dining fashion moved on, the value of shares in the Hartford Group

(which the owners had been paid in) dropped radically and the partners' interest either waned or relocated to new pastures. The buzz subsided almost as noticeably as it had begun and the restaurant unceremoniously closed on 22 September 2003. As an indication of the straits they had begun to find themselves in, when I managed to win a dinner for two at Pharmacy in a raffle at my son's nursery school it turned out to be third prize.

One important thing remained. However bitter a taste lingered in Hirst's mouth, there were still the contents. Contrary to popular belief he was never director of the restaurant, just its designer in collaboration with the architect Mike Randall, and in his contract with Hartford Hirst owned the major art works on the wall, which he rented to Pharmacy for $\pounds 1$ a year. Wasting not a second, his business manager, Frank Dunphy, sent removal men in white overalls to the restaurant. He himself was also present, and the deal he did as he walked back and forth along Notting Hill Gate that day was to lay the foundations for a new culture of art selling.

Erskine Francis Dunphy's office in Welbeck Street in London's West End is as clinically white as the rest of the headquarters of Science Ltd, the company that oversees Damien Hirst's vast studio practice, and all the better for that. There are very few ways that skulls and 'spin pictures', as well as free-standing installations, can work in a mid-nineteenth-century, stucco-ceilinged townhouse, but modernist white worked a treat for them as well as setting off the plaster bust of Dunphy himself which sat in the corner of his capacious office. Larger than life-size, it showed the broad-faced, 70-year-old Irishman swathed

in robes, laurel leaves crowning his white hair. On its integral base was a chiselled inscription in Roman lettering: 'ERSKINUS – FRANCUS – DUNPHYUS.' Dunphy's expensive designer glasses, plastered geometrically over the eyes, pricked its formal classicism as neatly as any red nose.

Monumental busts are not commonplace. They belong to an idiom which is both ancient and aggrandizing. It is an artistic formula for portrayal that has never fallen from fashion as a way of acknowledging authority and achievement: it pedestalled the Romans, was re-employed in the Renaissance and has since remained a symbol of historical accomplishment. As the official art adviser I have been involved in a number of confidential dicussions at the House of Commons on the subject of upon whom to bestow the honour of a bust, and what sculptor to choose, and it never fails to engender fervent views. Underlying Hirst's art, however gallingly ephemeral it might appear, is an innate understanding of the language of symbol. I had often wondered how the dollar-billionaire artist, the foulmouthed bad boy, the ex-shoplifter and now astonishing businessman with 130 staff, three art factories and a thrumming marketing machine, held it all together, and the mute bust of Dunphy was more articulate on the subject than any press release or string of sound bites. However ironic its purpose, when he caused this bust to be, Hirst was acknowledging reverence.

'Damien got the factory to make it for my seventieth birthday,' explained Dunphy. They did a wonderful job, and it sat in an empty niche of nearby Home House, where the party was held.' The flesh-and-blood Dunphy sat behind a narrow, asymmetrical white desk the length of a small skiff, and although it did not exude the traditional language of power, in that Hirstian sort of way it did the business. Busying herself behind me as I sat facing Dunphy at his desk was his PA, Minky, a well-spoken, elegant blonde through whose portals I'd first had to pass to get to the big man. Although it was five years on I had told her that I wished to hear something of Pharmacy's tale from Dunphy's perspective and also how he and Hirst had got it together. It had taken a couple of months and two post-ponements to pin down the interview, but at least this had allowed me to get more of a grip on the back story.

Dunphy and Hirst had met at the Groucho Club thirteen years earlier, back in 1995. Named after the American comedian who said he would never want to join a club that was prepared to have him as a member, it was an appropriate venue for such disparate figures to link up, as it had also proved in the case of Hirst, Freud and Frostrup. Dunphy recalls it was Hirst's mother who effected the introduction, telling him that she had a son who needed sorting out; Hirst's version is that they used to play pool together and when the artist needed to get the Inland Revenue off his back a friend reminded him that his pool mate was an accountant. The Hirst story is already pickled with artistic licence. It is an interesting comment on the speed with which facts become blurred history that even such recent happenings are now shrouded in myth. It also has something to do with the speed of events in Hirst's life, particularly after he was taken up by Charles Saatchi in 1991 with the £50,000 commission of the installation The Physical Impossibility of Death in the Mind of Someone Living – a hapless shark caught by an Australian angler, which, when suspended by the artist in a vitrine of formaldehyde, became the worldwide symbol of Britart.

What I do have on good authority from Frank Dunphy himself is that he was born in Portrane, County Dublin, and, from what he implied, swamped in Roman Catholicism. His mother, an occasional actress, was a member of Cumman na mBan in the 1920s, the female branch of the old IRA, and Frank served as an altar boy at many IRA funerals in the 1950s. He was schooled by the Christian Brothers, a ruthlessly strict and occasionally brutal monastic brotherhood, and by the time he arrived in England in 1958, met off the train by members of the Legion of Mary, whose job it was to oversee the moral and spiritual well-being of Irish immigrants, he had decided that his first calling was not religion, politics or his father's profession of nursing, but accountancy. He found lodgings in a Highgate guest house where the landlady had five daughters that she married off one by one to her young Irish lodgers, and one of them ended up as Mrs Dunphy.

Frank never completed his exams but instead found himself in gainful employment with the Bertram Mills Circus, where he worked advising visiting foreign artistes on tax compliance. His clients were some of the best jugglers, magicians, tightrope walkers, unicyclists and clowns in the world. I was also kneedeep in dwarfs, he recalled, all looking for their tax returns to be done. The close-knit family culture of the Big Top meant that he was introduced to other performers in quick succession and he soon established his own practice. Frank was no normal

numbers man but a paternalistic non-conformist with an empathy for misfits; Nicolai Poliakoff OBE, alias Co-Co the Clown, became a particular friend and client.

'I loved Co-Co,' Frank reminisced.' I knew his daughter and grandchildren. I did have an unusual function in those days, which had a little of the father-confessor about it, and it was a world I admired and adored.' To this day he remains a member of the Circus Fans' Association.

'When it came to Damien it was the same type of thinking and insecurities that brought us together. I was able to offer something he needed. What is so exciting about him is that he is perpetually on for, and up for, change.'

When they first met, Hirst (a lapsed Catholic) was a hard-drinking, druggy libertine and in need of more than just financial help. To use Hirst-speak, you might have described him in those days as a fucked-up Catholic with a taste for death, but in Dunphy he had found a man who could ride his excesses. There was also something salvationary about Dunphy's arrival for a man who had never known his real father, whose step-father walked out when he was twelve and who courted self-destruction. Trawling through some of Google's million-plus references to Damien Hirst, and picking my way through his expletives, I had managed to find a line of his that was touchingly unguarded: 'I'd still be drinking and I'd probably have found some way to fuck it all up if Frank hadn't come along.'

Dunphy's finely tailored dark suit nicely contrasted with Hirst's street gear, which I had glimpsed earlier when he had belted past me up the staircase like an excited teenager, throwing out a salutation to the receptionist. Dunphy struck me as

one of those placed on earth to put people at ease. He looked like what I had begun to work him out to be - the component of calm, strategy and corporate respectability in the extraordinary Hirst phenomenon, and its part-progenitor too. His distinctive, wide-bridged glasses and exquisite hand-painted blue tie set against a white shirt flashed up the art-world credentials. Early on in our conversation, as he began to cast his mind back over a recent career that was as eventful as that of the most newsworthy head of state, I noticed something else too: he was economic. This was not immediately apparent from his fluent, smiling Irish manner, but I soon gained the impression, having discussed what he felt I needed, that there was little time left for dawdling. Although big-hearted in outlook, he was precise in his agenda. Beneath the apparently unguarded amicability was a man who measured his time and monitored his thoughts. I had heard him described by dealers as the most skilful negotiator the world of contemporary-art dealing has yet encountered, and it fitted.

After starting as Hirst's business manager, Dunphy had ascended, he now explained to me, to the position of overall manager, cutting the deals, renegotiating, advising and guiding the artist as adeptly as he might have done for any world-class clown. He had also helped Hirst build up a property portfolio with very considerable investments in London, Gloucestershire and Mexico. Latterly on a generous cut of every transaction (a little under 10 per cent), as Hirst's fortune swelled, Dunphy saw his do likewise. Given that Hirst is valued (by Dunphy) at \$1 billion, it requires little arithmetic to understand why Dunphy soon became a serious art collector, amassing works not just by

Hirst but also by Picasso and Warhol (another artist with a profound grasp of the value of brand production and management). Dunphy's favourite object is a small painting by Warhol of a dollar sign. 'Every time I look at it, it reminds me of what I do,' he stated laconically.

And so it was that Dunphy, the artist's alter ego, came to oversee the collection of paintings and art installations. That morning he had met up at Pharmacy with the Hartford Group's CEO, having been told that the whole interior was to be removed in two days' time in preparation for Marks & Spencer, the site's new tenants. Dunphy entered the empty building and surveyed the inside, now devoid of business and people save for the art handlers. How about if I try and buy the floor and the ceiling? he considered, aware that there must be some residual value in what now struck him, as he surveyed the empty premises, as examples of creative thought. He then noticed the signs, in particular the one with the restaurant's name, a nostalgic witticism from the days of ebullience. Surely these are works of art of a sort, he thought, rather than builders' refuse? 'I then got carried away,' he recalled. 'I turned to the doors, the windows, the furniture, the urinal, the glasses, even the banisters. I felt there had to be a use for this. It was too important to let go so I decided to go for the lot.'

Dunphy chose to carry out the negotiations on foot and he and the Hartford CEO walked up and down the busy street as they talked. While the company appeared to have no purpose at all in mind for the place, there was, on the basis that a man who wants something is worth negotiating with, a need for money to change hands. In the end a deal was reached but it

did not solve the problem of how to pack everything up and transport it away before the deadline of two days. This was a major 'unfitting' job and it had to be handled with care. Dunphy telephoned a team he trusted but was told they could not get round to it for a week. 'How much will it take to come and do it now?' he asked.

He got his way, and ended up with the entire contents being shipped to him within two days. They had cost him £30,000 – *inclusive* of VAT, he pointed out with some pride – together with an unusually steep removals bill.

Unlike old art, the work of living painters rarely has the potential for discovery or revelation. The problem is that it is normally fully comprehended and documented. Instead the quest can take the form of how it is re-presented or reexpressed, particularly as a lot of modern art occupies the realm of concept rather than craft. Oliver Barker had seen an opportunity from the top floor of the bus which others had not, but how could he persuade those involved to see it too? He telephoned Dunphy that day, before he had even formally broached the subject with his employers, and began by explaining that, although they had never met, Sotheby's might be able to lay on something truly spectacular for them around the restaurant's fittings and art works. The response was distinctly underwhelming. Hirst had an inclination to hold on to works that form major parts of his development, and now that (on the spur of the moment) Dunphy had bought the whole damn restaurant they had begun to speculate that there might be a museum - they had in mind a particular French one – that would buy and install it as a permanent display.

What Barker was proposing was also unprecedented. The major auction rooms simply did not hold single sales of living painters – they liked them commercially leavened by a good few years in the grave – and this would also have meant Hirst departing from the tried-and-tested route of selling through an established dealer. He harboured a deep distrust of the saleroom process, saying that you should 'stay clear of the auction houses ... it's like going to a second-hand shop to buy your clothes'. But what he also had to consider was that, although he could sell the major butterfly paintings and medicine cabinets through – or to – any number of major dealers, including the likes of Jay Jopling and Larry Gagosian, big dealers did not have the sort of operational set-ups to sell the menagerie of other, medicinally inspired fixtures and fittings that came with them.

So initially the answer was of the 'we'll call you' type. This was frustrating for Barker, who now had to deal with a combination of inertia and the prospect of dealers circling in an attempt to carry off the finest pieces. The main auction houses' hunt for the big sellers (and the battles between themselves and dealers to secure consignments for sale) is well established. They work as hard at, and apportion as much energy to, business getting as they do to selling. The occasional dealer works in this way but rarely has the time or corporate infrastructure to afford it as much strategy and finesse. In previous generations it involved little more than weaving the odd conversation in the right direction over lunch at a gentlemen's club, and keeping a vigilant eye on *The Times*'s obituary column, but on occasion

it has now mutated into ruthless gamesmanship, particularly between the major auction houses, as nasty as any in the corporate culture. This less fragrant strain of business can vary from balletic schmoozing to unethical salesmanship. In the first category, specifically aimed at old wealth, there exists a type of rarefied thoroughbred (I am thinking of one in particular) who can drop names as opulently as ripened fruit and who lingers in the corridors of the British upper classes, displaying an addictive fascination with genealogy and an almost sexual interest in senile aristocracy.

In the *really* nasty category – and some cross over from one to the other – are the unprincipled bounders who combine unrealistically high pre-sale estimates with finely honed back-stabbing skills. I rarely encounter it directly at my level, not least because I am a dealer rather than an auctioneer, but I gained a glimpse recently when I agreed to sell a picture to a national museum on behalf of a client. After nine months of tireless fund-raising and public-funding applications by the museum an unnamed auction figure swooped in, with just weeks to go before the nation was expected to complete the purchase, to suggest to the vendor that they would achieve a better price. We saw them off, but I and the museum were smarting with annoyance and bemused by the brazen attempt at gazumping by an establishment auction house.

As far as he knew, Barker had nothing to fear from rival auction houses, and dealers who know him, while acknowledging his boundless ambition, describe him as a fair player. The main issue was how to persuade a major living artist to use an auction house as his primary point of sale. To do so would of

course risk hacking off the dealers who had formerly provided this function, but what Barker was proposing was more in the realm of a commercial innovation than a direct attack on the competition. This was a young auction man, unburdened by tradition and experience, proposing to add a new twist to business getting; and now that he was latched onto his prey, and fearful that it might escape him, he energetically looked to his advantages.

The big auction houses have an illustrious history of selling the collections of both big names and big houses and with a little refinement this now became Barker's main tack. If he could convince Dunphy that Pharmacy and Hirst were no different from some of the celebrities and stately homes they had more than proficiently handled, then there were precedents that could be persuasive. Occasionally the auction rooms have achieved results of such momentous proportions around an individual or a monumental location that even the most seasoned dealer in art or antiques is lost for words. I have certainly been rendered eye-wateringly silent on occasion with the potency of their 'viral marketing' to platform a cult, together with the logistical skills to capitalize on it.

For example, in 1998 Sotheby's New York secured the belongings of Edward VIII and Mrs Simpson that the couple had kept in their exquisite Louis XVI-style villa on the fringes of the Bois de Boulogne in Paris. Everything was on offer, from abdication papers to linen hand towels. For weeks, indeed months, beforehand it was impossible to open a magazine without some editorial on the epic romance between the abdicated king and his divorcee. By the time of the sale

Sotheby's press and marketing department had made sure that there was barely a prospective buyer in any part of the world who had not been alerted to the chance of owning a memento of the greatest love story of the twentieth century. As a result the sale turned into an acquisitive broil, massively exceeding estimates. The most remarkable result was a boxed slice of the couple's wedding cake, which reached \$28,600. Similar euphoria was generated by Sotheby's for other celebrated personages, such as Jacqueline Kennedy, Elton John, Prince Ernst of Hanover and Rudolf Nureyev: with the mere levitation of a paddle the public were invited tangibly to connect with the legend. And they did.

Why, Barker argued, could they not create the same lather of excitement around Hirst and Pharmacy?

Dunphy continued to take Barker's calls, and they had occasional breakfast meetings, but Hirst and his canny Irish business master remained uncommitted. Short of an act of God it did not look as though they were going to agree to anything in a hurry, despite Barker's most persuasive pitches. But turning points do happen in this business, and without them the sale of art would be nothing like as fluid as it is. The three D's – death, divorce and debt – are among the most common instances, but what happened in the early hours of Monday 24 May must rank as among the most definitive. I first heard about it on BBC Radio 4's *Today* while in my bath and throughout the day it was manically discussed in the art world and beyond, regarded by some as one of the greatest contemporary–art disasters ever, by others as a heaven–sent thunderbolt from a just God sick to the back teeth with contemporary art's immoral excesses.

Burglars had broken into the warehouse of Momart, then one of Britain's leading fine-art storage companies, with clients including the Saatchi Gallery, the National Gallery and Tate Modern. It is thought that the fire was deliberately started to conceal a burglary of watches and cordless phones in the adjoining section, and it spread with catastrophic consequences through the storage depot in Leyton, north-east London. The initial heat caused by the ignition of highly flammable plasticrich goods took the temperature to 1,100 degrees Centigrade. The fire blazed for a day, the situation complicated for the firefighters by the fact that there were highly explosive gas tanks in adjoining areas. When they finally extinguished the flames all the art, with the exception of a group of bronzes, had been reduced to ashes. Hundreds of works by many leading twentieth-century names, including not only Hirst, but Rachel Whiteread, Gary Hume, Helen Chadwick, Patrick Heron and Tracey Emin (a version of her highly controversial tent installation Everyone I Have Ever Slept With 1963-1995) were lost for ever. Hirst himself lost £5 million worth of art, and this included two of the dismantled windows from Pharmacy.

On the morning of the fire Barker received a call from Dunphy. The instructions were clear. Hirst had been so shocked by what had happened to so many significant contemporary works (he personally owned a number by other artists as well) that he was not prepared to risk the same fate for the rest of the contents of Pharmacy. Furthermore they had not managed to close a deal with the French museum. Sotheby's was to arrange a sale with immediate effect. Barker was overjoyed. By this time his bosses and colleagues were entirely up for it, and the great

machine immediately went into action. But Science's commitment was not without conditions.

The main distinction between this and other single-owner sales was that Science collaborated intimately with the auction house at every stage to ensure that the event conformed to their exacting brand. On such occasions Sotheby's rolls out a man who has been with the organization for several decades and knows the challenges, pitfalls and emotions as well as the practical diaspora involved in organizing such an event. Marcus Linell, the auction house's senior project manager, provided regular counsel during the present venture but it is tempting to speculate that nothing in his esteemed career to date had prepared him for some of the resultant creative departures. Everybody involved from Sotheby's had their opposite number in Science - the cataloguers, sale designers, marketing, press, technical handlers. The luxurious catalogue, now a muchsought collector's item, was as suffused with Hirst as the restaurant itself. For the cover, a selection of pills floated against a cloudy blue sky imprinted with the titles; inside were sheets of pill-shaped stickers to allow owners to personalize their copies. Chemical boxes, spot pictures and butterfly pictures flapped out of the main body on double gatefolds and the lot titles were lit up in the green lettering favoured by pharmacies. Never before had Sotheby's departed so daringly from their establishment trademark.

When the sale was announced, Barker recalls, it drew a mixed response from the trade. Larry Gagosian was broadly supportive, but Jay Jopling of White Cube was initially restive, believing that the 166 lots Sotheby's had planned would saturate and

undermine the market. There were also those who could not believe that an auction house was now acting so brazenly as a living artist's agent. Unabashed, Sotheby's press and marketing teams made sure that by 18 October 2004 there was barely a periodical or newspaper-reading human alive who had not heard about it. Dunphy recalls that before the sale one of his friends had cashed in her pension in order to have the funds to buy at least something but failed to acquire anything. Hirst himself, although appearing at the pre-sale party a few days beforehand to sign catalogues, chose to stay away and play pool.

Barker worked hard that day, but the buyers worked harder. Lot 1, the cocktail glasses estimated at f, 50–f, 70, rocketed so fast that many intending bidders could not even get their hands up, making a hammer price of £4,800 and setting the tone for the rest of the sale. Vanessa could read the exultation in her husband's face as he then tore ahead with triumphant confidence, inveigling the room into further excesses. The highest price of the evening was a large medicine cabinet, entitled The Fragile Truth, which fetched £1,237,600, establishing a new auction record for the artist. But what was more newsworthy was the cache of fixtures, fittings and oddments, which took on the status of holy relics. A clutch of undistinguished ashtrays were hammered down for £2,000, twenty rolls of Pharmacy wallpaper made close to £,16,000, four bar stools raised £,18,000 and the neon 'Prescriptions' sign, which had so nearly ended up in a skip, made over £,70,000. When a set of Pharmacy chairs reached £,2,500 they elicited an anxious cry of '£,10,000' from a fretful female bidder. 'That's just what I want!' cried Barker, now at full tilt, who then sold them to her for a hammer price of £12,000.

The sale doubled the estimate, making a total of over £10.3 million. Dunphy estimates that the objects he bought for £30,000 alone made close to £6 million.

I had chosen to write about Pharmacy a few months before Sotheby's announced, four years later in 2008, that they were going to do it again. This was entirely unforeseen by me, although in retrospect it was quite obvious. Dunphy, Hirst and Barker had tasted opportunity of a new kind with the restaurant's fixtures and fittings, but this time it was saleroom bespoke: Hirst and his studio had spent two years preparing art specifically for the event. Not only had the sale established that art hot from the artist was saleable at auction, but the Dunphy-Barker revelation had proved that even items with which Hirst was not intimately involved, items that he had simply designed for manufacture, were emotively saleable. This new auction was to be a rerun on a much larger scale, and without the cocktail glasses and pepper shakers. Hirst had become a firmly established international icon in the intervening years, and this time the estimates amounted to over f,100 million.

I had an invitation to the party and plunged into the swimming pool of Hirst followers, clients and hangers-on. Sotheby's had again risen to the zeitgeist challenge and the main room of the auction house was heaving with glamorous youth, money and eager-looking professionals, many of them invited by Hirst himself. Sotheby's ever-present party organizer, Joanna Booth, had been standing in the foyer when I arrived, eyeing the guests for gate-crashers as they queued down the street to attend the art world's party of the decade. Hirst and Dunphy were

holding court upstairs near the centre of the throng, with Barker close by and his wife Vanessa next to him.

To razz it up further and hail the new dawn a DJ played music and a glitterball sent rays of light over the exhibits. Henry Wyndham, Sotheby's chairman, at least a head taller than almost everyone around him, was seen walking through the room with a quizzical expression. 'Who are all these new people?' he asked the jewellery dealer Nick Silver, who had provided stones for some of the displays. They are your new clients,' replied Nick. It seemed that every other room of the auction house was filled with Hirst produce, a superstore of artfully presented drawings, sculptures and paintings as well as another signature shark in formaldehyde. One work in particular drew the throng, cordoned off and in a small room of its own. The Golden Calf was the carcass of a bull in formaldehyde with golden horns and hooves, and above its head a disk made of 18-carat gold. The estimates, labelled next to each item with its lot number, ranged from a few thousand pounds for minor works on paper up to £,8-12 million for the vaunted Golden Calf. If what had happened with Pharmacy had been a turning point, it appeared that this sale would make it history.

But there was one problem, a threat that over the previous three months had been growing ever stronger by the day: the artistic world may have looked healthily buoyant that night, but the economy was beginning to look ill. For many weeks beforehand Hirst, Dunphy and Barker had been entertaining clients and warming them up for the event, but the question being asked by all was whether the contemporary-art-buying

public could absorb so much new, bespoke art, especially now that the world was changing.

The morning of the first day of the sale Dunphy was greeted with the news that Lehman Brothers had gone bankrupt and that the expected credit crunch had officially started. When he came down to breakfast his wife suggested he go back upstairs and change. He had dressed in sombre tones as befitted his apprehension but, heeding the advice, he went back to his room and donned a pinstripe suit and pink tie. Never before had so many eyes across the world been upon the Sotheby's podium as when the trade and collectors gathered at the auction house that evening. I was unable to attend, being down the road with a client whose taste and interest in the art world petered out after the death of Charles II, but colleagues in the room kept me abreast with regular updates by email.

As the prices arrived on my hand-held screen it became clear that the forward momentum of Sotheby's marketing and press coverage, combined with the behind-the-scenes activities of the main players, had battered through the financial depression. It continued through the next day, when the lesser lots were sold. Although the 223-lot sale did not double its estimate, as it had done for Pharmacy, it raised £111 million, making it a successful and astoundingly profitable venture for both Sotheby's and Hirst (who had negotiated to pay no seller's commission). The Golden Calf broke all records, at over £11 million. There was, Dunphy informed me, a sweaty moment, which the by now seasoned Barker was able to overcome with his recently honed rostrum midwifery. One of the big lots, a shark in formaldehyde called *The Kingdom*, stalled at £3.5

million, well below its pre-sale estimate of £4–£6 million. It was amazing to watch him at work, Dunphy recalled, sounding as though he was describing a virtuoso circus performer. Oliver just kept calm and looked at the prospective bidder for what felt like minutes, psyching him with his stare. Eventually he responded and the price then escalated to just under £10 million.

The experiment had succeeded - the culmination of a daring auction innovation which had begun with the Pharmacy sale four years earlier. White Cube responded like a graceful mistress now obliged to share her affections with another: 'Once again,' the gallery announced in a statement to the press, 'Damien has shown he is a mould-breaker without equal and we are immensely impressed and proud of his achievement.'The question lingers as to whether this could ever be repeated. It is difficult to conceive of any other artist being able to pull this off on the same scale and with the same efficiency, or with comparable celebrity draw. Market conditions have also radically changed: this type of euphoria could be said to have graphically symbolized the final days of boom, and as Dunphy admitted to me, if the sale had been held a few weeks later the results could have been very different. I have no doubt about this.

Rumours were rife that Hirst and his entourage had rigged the sale: a man worth \$1 billion was hardly going to risk having his empire undermined for the sake of underwriting less than a fifth of that amount, some said, nor would his biggest collectors easily allow this, and for his dealers it would go without saying. Following investigations I have found no evidence to support this rumour. Not only would Sotheby's, a public company, have had far too much to lose (particularly following the criminal action it faced in 2001 for collusion with Christie's on buyer's premium, for which its Chairman, Alfred Taubman, served time in an American jail), but new clients from Russia, India and China were all reported to be active, and 30 per cent of the buyers were previously unknown to the auction house. Some of the lots were certainly bought by Jay Jopling, but those I have spoken to off the record at Sotheby's, as well as others in the trade, and indeed Frank Dunphy himself, have led me to the conclusion that there were real live buyers and, for the unleveraged, real money too – all the more remarkable given the financial turmoil that commenced that week.

It is interesting to speculate what will happen over the next 100 years to Hirst and his legacy, and in particular to those items from Pharmacy that were effectively discovered by Barker and Dunphy that month. I suspect that Hirst will endure in a form that art historians have yet to decide, if only as a radically successful turn-of-the-century phenomenon. And on this basis there will be a place for him in museums across the world until he is consigned – as happens to most artists – to the basement, to be rotated as space and exhibitions allow, a by then long-dead innovator in the unending saga of art history.

As for all the objects that were sold in the Pharmacy sale – the glasses, chairs, ashtrays, rolls of wallpaper and so on – of these a very small percentage, now sitting in the homes of proud owners, will lose their auction-room lot labels, get passed down a few generations and end up in the ownership of those who might not know their provenance, nor understand the

artistic ambition behind them. And one or two items will quite likely fetch up at minor sales, where they will be miscatalogued and someone, perhaps a dealer like me, will risk funds and then requisition science, art history and academic support to announce them as lost treasures from one of the most famous sales of the twenty-first century, devoted to the work of the Britart master Damien Hirst. If so, good luck to him. It's a great way to make a living, and there may even be a book in it.

GLOSSARY

Campaign

More commonly associated with military terminology, as an umbrella term for a single operation, the word 'campaign' retains some of its embattled and individualistic character in reference to restoration. In this context it means the work of one restorer or a team upon a single object – that is, any cleaning and retouching undertaken when focusing on that one piece. A modern restorer might end up removing several 'earlier campaigns', the handiwork of various practitioners who have treated a picture during the centuries since its execution. Often a campaign will reveal itself over time as its chemical shortcomings become visible for all to see – this is frequently the case with overpaint, which might age to a tonality different from that of the rest of a picture. Modern restoration takes this into consideration, employing sympathetic pigments which promise minimal transition over time.

Canvas

The most popular support for oil paint. It first gained credence in fifteenth-century Venice when artists turned to it as a portable alternative to fresco (wall painting) and wooden panel. Canvas has traditionally been made of linen but sometimes flax or hemp. In the twentieth century cotton canvas became popular. The weave, the criss-cross texture of the canvas, sometimes remains visible through the paint, but in thinner canvas it is almost imperceptible to the naked eye.

Catalogue raisonné

This French term, literally meaning a 'reasoned catalogue' in which each item listed merits its inclusion, describes a comprehensive survey of an artist's work. The aim of a catalogue raisonné is to include everything which is by or attributed to the artist in question, and most such catalogues include, in addition to fully authenticated pieces, works that are the subject of unresolved debate.

Condition

All works of more than a certain age suffer from deterioration in their condition, however minor. These issues fall into three main categories. In *natural degradation* the compounds which make up paint deteriorate chemically over time, particularly in response to environmental factors such as heat, light and damp. *Overcleaning* is the excessive use of chemicals by a restorer during the cleaning process, causing damage or abrasion to the paint surface. (Another form of damage caused by restoration can occur when excessive pressure is applied to the canvas in

the relining process.) Accidental damage describes the loss caused to a canvas or wooden panel such as an impact blow or by being dropped. Reading the core condition of a picture, particularly when damage of the kind described here has been disguised by overpaint, in order to ascertain its true or potential quality is arguably the most important, yet often most misunderstood, element in the appraisal of old art.

Craquelure

Over time a network of fine cracks develops on the surface of an oil painting as a result of the traction of the various materials and layers which form the work. Atmospheric changes, as well as time, also affect craquelure's appearance. The close inspection of craquelure can help in determining the age of a painting and the materials used.

Glaze

Most commonly used in oil painting, although it also occurs in watercolour, a glaze is a layer of paint laid upon another so that the base colour shows through. The paint must be thin – that is, with a greater ratio of oil to pigment than is usual – and translucent, and the term most correctly describes a darker applied over a lighter pigment. The effects are adaptable and subtle: for example, areas of the picture which are left unglazed might function as highlights.

Ground

The first substance applied to a support as a base for paint, and also known as primer. The further back in time, the more likely

it is that this was compositionally different from the paint itself. When artists started to paint on canvas in fifteenth-century Italy the ground they used was gesso: a greyish mixture of calcium sulphate and animal-skin glue that has a dense adhesive quality. By the nineteenth century grounds were chosen for their tonal as much as their practical advantages – the Pre-Raphaelites, for example, introduced a white-lead ground which lent their uppermost colours especial luminosity.

Infrared (IR) light

Infrared light has a wavelength which is longer than that of visible light. The word 'infrared' means 'below red', red being the colour of visible light and possessing the longest wavelength. Because IR intensifies human vision, it is used to examine canvases to reveal pentiments and underdrawing through varnish and glaze.

Overpaint

Just as it sounds, overpaint is paint added to an original painted surface either in an attempt to disguise or repair paint loss or abrasion, or sometimes to cosmetically 'improve' or even enliven the original. Sometimes it is applied extremely crudely, although when done professionally it is part of the essential infilling or restoration process for areas of lost paint. Rembrandt's assistants occasionally overpainted to 'enrich' their master's work (with results that have been widely debated) during his lifetime. The Victorians famously added drapery to naked flesh. Over the years numerous double chins and folds of flesh have

been covered to improve the saleability of portraiture, often hiding signature strokes of the genuine artist beneath and thus offering the chance of reappraisal.

Panel

A panel is a flat piece of wood, or a number of pieces fixed together, to act as a support for an oil painting. Various woods have been used for this purpose, notably oak, poplar, cedar and chestnut. Panel was the support most often used in the West before painting on canvas became popular in the early sixteenth century. Panel painting is an ancient tradition, dating back to Greek and Roman times, though few examples from these periods have survived. From early in the Christian era, religious images were painted on panels forming the front and back of altars and in crucifixes. Panel painting enjoyed great popularity between the thirteenth and the fifteenth centuries, particularly in Italy and the Netherlands, and in English painting is the most common support for early Tudor portraits.

Pentiment

A term derived from the Italian *pentimento/i* and meaning an artist's first or later idea, subsequently obscured by further brushwork. In an oil painting it is seen in brush strokes which, although initially hidden behind the 'skin' of final paint, become visible as the paint's transparency naturally increases over time. Several layers of pentimenti may be revealed.

Provenance

From the French *provenir*, 'to come from', provenance means the origin or source of an object. In art the chief purpose of tracing provenance is to establish the precise history of where a work of art has been since its creation. It can prove ownership, help assign works to particular artists, and prove that an artwork is neither a forgery nor stolen. The degree of certainty of an important work of art's provenance can make a considerable difference to its selling price, so the more documented a work is the better.

Recession

In painting, recession refers to an aspect of perspective by which objects appear to recede. The art of traditional painting is to create, through the tricks of artistry, a work in which the viewer perceives a determinable happening, scene, person or object(s), and recession is of central importance to the success of this illusion.

Signature strokes

Every painter has an individual way of choosing, mixing and applying paint, much as handwritten signatures differ. Although the distinctions between the resulting signature (brush) strokes might be too minute to be detected by the untrained eye, they are, when considered along with other elements such as subject matter and provenance, one of the most revealing ways of identifying the work of a particular painter.

Stretcher

A stretcher is the wooden frame on to which a canvas is stretched and attached. Nowadays factory-made stretchers are widely available, but until recent times painters often made them in house.

Support

The material, usually a flat surface, to which the artist applies paint. Paper, card, canvas, panel, board, copper, stone and glass have all been enlisted as supports, and each requires a different method of preparation and maintenance.

Ultraviolet (UV) light

Ultraviolet light is immediately adjacent to visible light in the spectrum but in contrast to infrared light it has a shorter wavelength than visible light. Inspection of a painting under UV can reveal where it has been retouched, by causing different layers to either fluoresce or phosphoresce. It needs to be interpreted by an experienced eye, particularly when a painting has been subjected to a number of campaigns of restoration.

Underpaint

The initial layers of normally neutral-coloured paint, sometimes called 'dead colours', which are applied to the base ground to establish a composition before applying the 'skin' of top colours. These are sometimes used more ambitiously as the under-colour for glazing.

X-ray

An X-ray reveals aspects of paintings that cannot normally be seen by the naked eye, doing so more deeply and dramatically than infrared light does. It can sometimes, but far from always, penetrate the opaque surface of paintings, potentially exposing the first intentions and pentiments of an artist. Because the opacity of a substance increases with its atomic weight, the use of heavy, metal-based colours, such as vermilion, lead white and cadmium, can be detected without difficulty. Non- or low-metal-based paints can be problematic to detect.

Glossary entries are shown in bold

accidental damage 293 Agnew's (art dealers) 28, 100, 101 Aldrich (Sigma-Aldrich) 158 Allen, Brian 29, 109 American School 21 Amsterdam Historical Museum 191 anti-Semitism 155-6 Antiques Roadshow, The 173, 253 Antiques Trade Gazette 232 Ara, Katherine 164-5, 245-6, 250 Arlington art group 119-20, 122, 129, 145, 151 art fairs 186; see also Grosvenor House; TEFAF Art Gallery of Ontario 162 art historians 30-31 communication skills 197 dislike of ignorance 190 weaknesses 31-5

connoisseurship compared 33-4

art history

industry 79-80

training 265

portrait 222, 223–5, 228
Arts Club 84
Astor, John Jacob 222
Astor, William Waldorf 222, 223
Astor Hotel, Milwaukee 158
Atherton, Jack 120
Attenborough, David 103
auction houses
blunders 95–6
gamesmanship 278–9
'viral marketing' 280–81
Austrian Jockey Club, Vienna 171
Ayres, Liz 129

Arthur, Prince of Wales 223, 227-8

Bader, Alfred 153–62, 188 biographical background 154–61 Elizabeth I portrait 244–5, 251–2, 255 Lady Mary Villiers portrait 162–3, 164, 166, 170 Bader, Danny 160, 161 Bader, Elisabeth 154, 155, 156, 157 Bader, Gisela 154, 156–7 Bader, Isabel (née Overton) 153, 159–61

SLEUTH

Bader, Moritz Ritter von 154 Bank of England 91, 92 Banks, Tony 12-13 Banksy 35-6 Barker, Oliver 263-6, 267-8, 277-8, 279-80, 281, 282, 283-4, 285, 286, 287-8, 289 Barker, Vanessa 264, 284, 286 Batoni, Pompeo 176 Razumovsky portrait 175-8 Beach, Thomas Banksy addition 35-6 Bell, Alex 205 Bennington Museum, Vermont 132 Bentley, Floyd 119 Bertram Mills Circus 273-4 Bijl, Martin 24, 183, 188, 195 biographical background 205-9 and Page Rembrandt 204, 209-16, 218 - 20Boleyn, Anne 221, 223, 228, 232, 234 Booth, Joanna 285

Booth, Joanna 285 bought-ins (BIs) 35–6, 45 Bristowe, Nicholas 230 Britart 273, 290 Broadland Properties Ltd 222 Brown, James 223, 231 Brown, Julie 111–12 Bruyn, Joshua 183, 191, 192, 202 Buckingham, Duke of 162 Buckingham Palace 194 Burlington, Vermont 40–41 Burlington Magazine, The 92, 195 Burroughs, Humphrey 73

Café Hawelka, Vienna 171–2 campaign 291 Campbell, Tony 115 canvas 292 Carson, Liam 267 Carter, Howard 142 Catalogue raisonné 292 Catherine of Aragon 223

Catherine the Great 175 Catholicism 155, 238, 247, 273, 274 Cecil, William 237 Chadwick, Helen 282 Chandos, Arabella 205 Charles, Archduke of Austria 237-8 Charles, Prince of Wales 228 Charles I 162, 163, 165, 169 Dobson portrait 16-19 Charles II 249, 287 Verrio portrait 100-101 chopped up paintings 26-30 Christie's, London 17, 18, 234, 235, 236, 253, 289 Christie's East, New York 45, 114 Christian Brothers 273 Churchill, Winston 157 Clarence House 173 Clifford, Timothy 223 Clooney, George 267 computer-screen art buying 88-9 condition 8-15, 33, 46, 55, 190, 232, 240, 250, 251, 292-3 Connery, Sean 91 connoisseurship 8, 33, 146-7, 195 art history compared 33-4 Constable, John 191 plein air sketch 61,62 contemporary art 35-6, 43-4, 263-90 Cool Britannia 267 Copley 57 Cornard Wood 103-9; see also Gainsborough, Thomas Corri. Adrienne 90-93 Courtauld Institute 265 craquelure 20, 293 Cromwell, Oliver 163 Cumman na mBan 273

Dallas, Dave 115
de Joudreville, Isaac

Bust of a Young Man in a Turban 194
de László, Philip 172–4

de László, Sandra 172
de Winkel, Marieke 195
dendrochronology 6–7, 210, 236
Dobson, William
Charles I portrait 16–19
downgrading 15–16
Doyle's Auctioneers 44
Duchamp, Marcel 37
Dudley, Henry Bate 85
Dudley, John 247
Dudley, Robert 246–7, 249, 250, 262
Dunphy, Erskine Francis (Frank)
270–78, 280, 281, 282, 285–6, 287–8, 289

Earle W. Newton Center for British and American Studies 63-4 eBay 21 economic downturn 286-7 Edward VI 229, 236 Edward VIII 280-81 egg whites 14 Eliot, T.S. pipe-smoking drawing 161 Elizabeth I 246-8 National Maritime Museum exhibition 231 portrait as a princess 234-7 portraits 233-4 van Herwijck (?) portrait 232-3, 237-46, 248-62 Elizabeth II 64, 101, 167, 194 de László portrait 173 Emin, Tracey Everyone I Have Ever Slept With 282 English Civil War 16, 165, 249 Erik XIV of Sweden 237 Ernst of Hanover, Prince 281 Evernden, Tamsin 255-6 Exeter Museum 29,30

Feke, Robert 54 Ferdinand, Archduke of Austria 237–8 Fisher, Kitty Reynolds portrait 240, 244 Foister, Susan 109 'follower' 69-70, 89 Fondation Custodia 182 Fonnereau, Claude 91, 92 Fontana, Lavinia 10 Fort Lennox internment camp 157-8 Fox, Henry, 1st Baron Holland Reynolds portrait 12-13 framing 132 Frank, Anne 189, 201 Franz Josef I of Austria 154 Freud, Lucien Rothschild portrait 174 Freud, Matthew 266-7, 269, 272 Frost, Robert 58, 68 Frostrup, Mariella 266-7, 272

Gagosian, Larry 278, 283 Gainsborough, John 72, 73 Gainsborough, Mary (née Burroughs) 72 - 3Gainsborough, Thomas (Tom) 57, 62, 79, 191 biographical details 72-6 Cornard Wood, early painting 69-72, 77-100, 102-3, 109-10 Cornard Wood (Gainsborough's Forest) 76-7,85-7 Cornard Wood (place) 105, 106, 107, 108-9 early self-portrait 90 juvenile genius 89-3 Letters 84-5 Mr eBay 21-6 tarnished portrait 9-10 The Cottage Door 84 Thicknesse's memoir 78, 81-3, 87 Gainsborough's House 103, 104, 109 Garrick, David 91 Garrick Club 84 George IV 100

SLEUTH

gesso 294 Hamilton, Dukes of 17, 18 Gillespie, Simon 18 Hampden, Griffith 233, 250 glaze 74-5, 293 Hampton Court Palace 262 Glazebrook, Charles 42-3 Hartford Group 269-70, 276 Hawelka, Leopold 172 glazing 75 Hayes, John 84-5, 89, 90, 109 Goethe, Johann Wolfgang von 199 Gordon, George 115, 205-6, 215, 217 Hayman, Francis 75 Graham, Billy 135 Richardson family portrait 28-9 severed self-portrait 27-30 Gravelot, Hubert 75 Great Henny Church 105-6, 107 Henderson, Emma 94, 255 Green Mountain Diner, Arlington 122 Henry (cartoon strip) 120 Henry VIII 221, 222, 223, 227, 228, Greene, Graham 171 Gregg, Rebecca 26, 28 229,230 Hermitage Museum, St Petersburg Gregg, Tony 255 239 Grey, G.W. 101 Grey, Jane 229, 247 Heron, Patrick 282 Hever Castle 221-8 portrait dispute 231-2 Grey, Katherine 247 Hilda (Bader's governess) 155, 156, Groen, Karin 195 157 Hirst, Damien Grossheart, Angus 223 distrust of salerooms 278 Grosvenor, Bendor 27, 29, 46, 83-4, 95, 115, 231 and Dunphy 274-6 and Cornard Wood painting 72, 77, Dunphy bust 270-71 78, 81, 84, 85-6, 87, 94, 96, 97, legacy 289 98-9, 99-100, 103, 109, 110 and Momart fire 282 Pharmacy 266-70 and Elizabeth I portrait 232-3, 237, second Sotheby's sale 285-9 238, 240, 241, 242, 243, 244, 245, 246, 248, 249, 250, 252-3, 255, Sotheby's Pharmacy sale 36, 37, 259, 261 263-5, 277-8, 281, 282-5, 290 Grosvenor House Art and Antiques The Golden Calf 286, 287 Fair 236-7 The Kingdom 287-8 The Physical Impossibility of Death in Groucho Club 266, 267, 272 the Mind of the Living 272-3 ground 293-4 Guthrie, Faith 222, 227 Historical Portraits Ltd, Dover Street Guthrie, John 222 42 - 3, 153Hitler, Adolf 156, 201 Haak, Bob 191 hits and misses 88 Haboldt, Bob 45 Hogarth, William 16, 264 Hagia Sophia, Istanbul 19 portrait of a middle-aged woman Hallmark, Emmeline 242, 243 55-6,60

Holbein, Hans

229 - 30

portrait of Catherine Howard 225,

Hals, Frans

115

portrait of an ageing lady 13-14,

Holyrood House 18 House of Commons 12–13, 251, 271 Howard, Catherine 223, 232 Holbein portrait 225, 229–30 Hughes, George 128 Green Herons 137, 142 Hume, Gary 282

Illustration House, New York 136, 137
impasto 15
Impressionists 43–4, 217, 265–6
inflicted damage 14–15
information technology 4–5, 40, 46
infrared (IR) light 294
infrared photography 6
'instinct' 101
Institut Néerlandais 182, 183
International Council of Museums 193
IRA 273

James II 164
James, Susan 229, 231
Janssens, Ben 185
Jenkins, Father 46
John, Elton 281
Joly, Nicolas 205, 215
Jopling, Jay 278, 283–4, 289
journalists 252
Judaism 155, 159–60

Kaminsky, Rachel 45, 114
Kaplan, Tom 37, 188–9, 220
Keating, Tom
fake self-portrait 145–6
Kenilworth Castle 249
Kennedy, Jacqueline 281
Kennedy, Jonathan 267
Kensington Palace Gardens 256
Kindertransport 156
Klein, Peter 6, 195
Kneller, Godfrey 56

Lamone, Louis 133
landscape styles 73–4
Legge family 163
Legion of Mary 273
Lehman Brothers 287
Lely, Peter 54
Letters of Thomas Gainsborough, The
(Hayes) 84–5
Linell, Marcus 283
London Library 80, 81, 245
long-distance buying 88–9
Lost Faces exhibition 231–2
Louis XIV portrait 45–6
Lugt, Frederik (Frits) 182–3

Marrakesh 124 Mary I (Bloody Mary) 234, 242, 247 Mary Queen of Scots 247 Massey, Daniel 91 Matisse, Henri 31 McCutcheon, Martine 267 Mellon, Paul 57 Metropolitan Museum, New York 20 Michelle (Don Trachte Junior's partner) 149, 151-2 Millar, Delia 167 Millar, Oliver 17, 164, 166-70, 190 Mitchell, Dara 148 Moffat, Laurie Norton 144 Momart fire 282 Monet, Claude 27 monumental busts 271 Moore Allen & Innocent, Cirencester 2-4 motive 124 Mould, Catherine 256 Mould, Oliver 104, 105, 106-7, 108 Mountbatten, Lord 222

Museum of London 84 'Museum of the Americas', Vermont 52, 53–7

National Archives, Kew 261

paint analysis 5-6, 262

National Art Library 78-83 National Gallery 13, 76, 77, 86-7, 109-10, 175, 282 National Maritime Museum 231 National Portrait Gallery 17, 18, 62, 84, 174, 229, 231 National Trust 175 natural degradation 11-12, 292 Naumann, Otto 3, 20, 188 Nazis 155, 201-2 New York old-master sales 114-15 New York Times 114 Newton, Bill 41, 49, 50-51, 53-4, 59-60, 61, 62, 66, 67 Newton, Earle 10, 39-42, 47-68, 114 Newton, India 52-3, 61 Newton, Jo 47, 49-50, 57-8, 61, 66, 67 Newton, Toni 62-3, 64-8 Noortman, Robert 185-6, 188 Noortman, Will 185-8 Norman Rockwell Collection 131 Norman Rockwell Museum, Massachusetts 111-13, 121, 130-35, 138, 143-4, 145 NSB (Dutch Nationalist Socialists) 201 - 2Nureyev, Rudolf 281

original paints 208–9
overcleaning 11, 14, 133, **292–3**overpaint 19–21, 28, 211–12, 232, 293, **294–5**Elizabeth I portrait as princess 235–6
Elizabeth I van Herwijck (?) portrait 239, 242–3, 245–6, 261–2
Gainsborough *Mr eBay* 21–6
Page Rembrandt 210, 211–16

Page, Ms (Paul's daughter) 183, 205, 215 Page, Paul 181–2, 183, 210, 212

paint degradation 11-13 Palm Beach art fair 186 Palmer, Samuel Keating counterfeits 145 panel 6-7, 179, 192, 209, 210, 224, 228, 235, 236, 243, 249, 295 transferring to canvas 239-40 Parr, Catherine 229 Paul Mellon Centre, London 109 Pelham, Gene 120 Pembroke, Earl of 162 pentiment 13-14, 295 Perkins, Diane 109 Pero, Linda Szekely 131-5, 140, 143-4 Pharmacy 266-70, 276-7 future of sale items 289-90 Dunphy deal 276-7 Sotheby's sale 36, 263-5, 277-8, 280, 282 - 5Phillips, Bond Street 162 physical assessment 101-3 Picasso, Pablo 31, 276 Pissaro, Camille 31 Plunkett, Stephanie 131, 143-4, 145 Poliakoff, Nicolai (Coco the Clown) 274 Poltimore, Mark 253-5 Postle, Martin 12 provenance 17, 18, 152, 153, 163, 171, 296

information technology 5 Van Dyck Lady Mary Villiers portrait 163–70 Wentworth-Stanley's genealogical searches 171, 172–8 Pullin, Bob 222–3, 226

Quo Vadis 267

Raeburn, Henry 96 Randall, Mike 270

Ransom, Mark 1-2 Rathbone, Peter 138 Rawson, Kim 144 Ray, Man 265 Razumovsky, Andreas 176-8 Razumovsky, Andrey 175 Razumovsky, Count Kirill Bartoni portrait 175-8 Reagan, Jack 120-21 recession 296 Reed, Roger 137 Reed, Walt 137 reflectograms 210 Reformation 223, 234 relining 14, 164-5 Rembrandt 37, 179, 294 18 cm self-portrait 185, 186, 187-9 art dealership 189-90 Page self-portrait 180-83, 195, 199, 200, 202-4, 205-6 209-18, 220 Rembrandt Laughing 1-4, 34 self-portraits 187, 188-9 studio practices 19, 203 van de Wetering's advocacy 197-9 'Rembrandt Corner' 197 Rembrandt House 189-90 Rembrandt House Museum 195-6 Rembrandt Research Project (RRP) 2, 6, 191-5, 206, 215 restoration author's foray 22-6, 181 changes and advances 208-9 Dobson Charles I portrait 18-19 Elizabeth I portrait as a princess 235 - 6Elizabeth I van Herwijck (?) portrait 261 - 2Gainsborough Mr eBay 26 Gainsborough portrait 9-10 Hayman severed portrait 28 inflicted damage 14-15, 17 Page Rembrandt 181-2, 203-4, 213-16

Rembrandt 18 cm self-portrait 187 - 8theory and ethics 193-4 Van Dyck Lady Mary Villiers portrait 164-5 Restoration 164, 249 reverse of paintings 100-101, 146, 165, 236 Reynolds, Joshua 54, 76, 212 Henry Fox portrait 12-13 Kitty Fisher portrait 240, 244 paint degradation 11-13 Richardson, Jonathan 56 portrait of his son 62 Richardson, Samuel Hayman family portrait 28 Rijksmuseum, Amsterdam 34, 207-8 Rockwell, Jarvis 133 Rockwell, Mary 133, 144 Rockwell, Norman 37, 115-16, 121, 122-3, 126, 128 and Arlington art group 119-20 Breaking Home Ties 118-19, 121, 127-8, 130-31, 143, 144, 145, 148-9 Breaking Home Ties (Trachte copy) 112-13, 116-17, 130, 131-40, 145, 146 - 7, 152Homecoming Marine 148 Marriage License 118 Shuffleton's Barber Shop 118 Rockwell, Tom 118 Rockwell Museum see Norman Rockwell Museum Rogers, Malcolm 17, 19, 166 rolling up paintings 135 Romantic movement 200 Romney, George 56 Rothschild, Jacob 174-5, 178 Freud portrait 174 Royal Collection 17, 164, 165, 166, 167, 168, 169-70, 173, 224, 229, 234, 235

SLEUTH

Rubens, Peter Paul Massacre of the Innocents 161-2 Ruisdael, Salomon van 69-70 Saatchi, Charles 272 Saatchi Gallery 282 Sanden, John Howard 134-5, 136, 137, 145 Sargent, John Singer 173 'satellite paintings' 196 Saturday Evening Post 112, 120, 129, 133 Savannah College of Art and Design, Georgia 63-4 Schaeffer, Mead 120 Head Tied 136 Schweller, Peter 115 Science Ltd 270, 283 Sealed Knot 165 Second World War 177 Serenyi, Count Johann Nepomuk 154 Seymour, Jane 230 shell gold 243, 250 signature strokes 22, 33, 70, 232, 295, 296 Silver, Nick 286 Simon, Robert 115 Simpson, Mrs 280-81 'sleepers' 34, 44, 46, 71, 110 Sleepers: In Search of Lost Old Masters (Mould) 4 Soest, Gerard 54 solvent damage 14-15 Somerset, Duke of 236 Sotheby's, London 161, 178, 188, 265 - 6Banksy piece 35-6 Elizabeth I portrait 232, 237, 238-9, 240-44, 252-5, 261 Page Rembrandt 205-6, 215, 216, 217 - 18Pharmacy sale 263-5, 277-8, 282-5

second Hirst sale 285-9

Sotheby's, New York 138, 186, 147-9 Edward VIII/Mrs Simpson sale 280 - 81Sotheby's Old Master Paintings department, Paris 205 Southern Vermont Art Center 121 Spaulding, Don 133 Spielberg, Stephen 118, 149 Spowart (stamp dealer) 157 St George's Hall, Windsor Castle 100-101 St James's Palace Gallery 163, 169 Stainton, Lindsay 109 Starkey, David 223, 224-8, 229-32, 250, 251, 258-9 Steigrad, Larry 44-5, 115 Stone, Peggy 44-5, 115 stretcher 297 Strong, Roy 237 Stuart, Gilbert 54 Stuart, Jane George Washington portrait 95 Suez Canal 154 support 297 tarnishing 8-10

Tate, Lottie 95, 153 Tate Britain 20 Tate Gallery 12, 29, 90 Tate Modern 282 Taubman, Alfred 289 technical analysis 5-7 TEFAF antiques fair, Maastricht 183-8, 200 terminus post quem 5 Theresienstadt concentration camp 156 - 7Thicknesse, Philip 78 Gainsborough memoir 78, 81-3, 87 Timken Museum of Art, San Diego 170 Titian

Noli Me Tangere 13

Today 281
toxic pollution 8–9
Trachte, Dave 126–8, 138–43, 145, 146, 149, 151
Trachte, Don Junior 120, 121–30, 134, 135–8, 140–44, 145, 146, 149–53
Trachte, Don Senior 120–21, 125–6, 127–30, 135, 137, 142, 145, 146, 147, 149–50, 151–3
Trachte family 147–8
tronie 203
Turner, J. M. W. 27

ultraviolet (UV) light 242,297 under-drawing 6 underpaint 75, 297 unveilings 226

Valls, Rafael 115

van Berghe, Maria 183 van de Wetering, Ernst 179-80, 187, 190, 195-7, 219-20 CV 192 family secret 201-2 own painting 204-5 and Page Rembrandt self-portrait 183, 189, 202-4, 206, 209, 210, 211, 213, 215, 216 Rembrandt advocacy 197-9 and Rembrandt Laughing 2-3 and Rembrandt Research Project 6, 191, 192-5 values 199-201 van der Meulen, Steven 237, 261 Van Dyck, Anthony 16, 57, 75 Lady Mary Villiers portrait 162 - 70Van Dyck Catalogue Raisonné 169

Van Dyck Catalogue Raisonné 169 Van Gogh Museum 191 van Haeften, Johnny 115 van Herwijck, Steven 261 van Hoogstraten, Samuel 198 van Mander, Karel 198 varnish, discoloured 8–10 Verrio, Anthony Charles II portrait 100–101 Victoria and Albert Museum 79 Villiers, Lady Mary Van Dyck portrait 162–70

Waddesdon 175, 178 Waldorf Astoria 117 Waldrop, Robert 119 Wallace, Paula 64 Warhol, Andy 217, 234, 276 Washington, George Stuart portrait 95 Waterloo, Battle of 174 Watson, Tim 165 Webber, Sandra 144 Weinz, Claire 128 Wentworth-Stanley, Christopher 171 - 8White, Marco Pierre 267 White Cube 283, 288 Whiteread, Rachel 282 Williams, Tara 94 Williams, Thomas 180 Williamstown Art Conservation Center, Massachusetts 134, 140 Wissing, William 45 Witt Library, Courtauld Gallery 62, Wood, David H. 132-3 Wright, Joseph 56 Wyatville, Jeffry 100 Wyld, Andrew 99, 110 Wyld, Martin 110 Wyndham, Henry 286 Wynn, Steve 217-18, 220

'X factor' 113 X-ray 6, 210, **298**

Yale Center for British Art 231